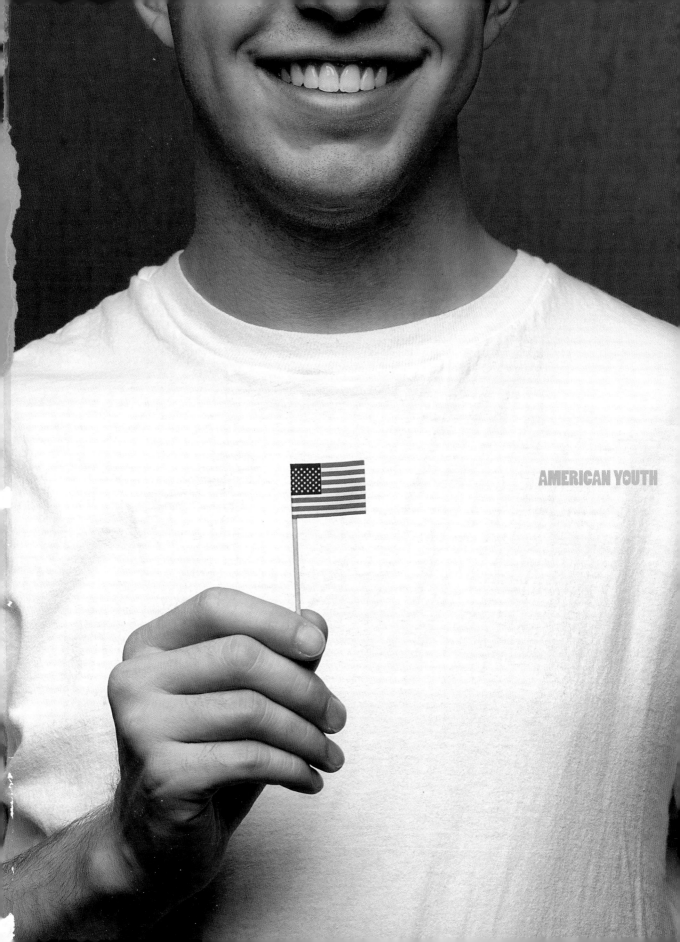

AMERICAN YOUTH

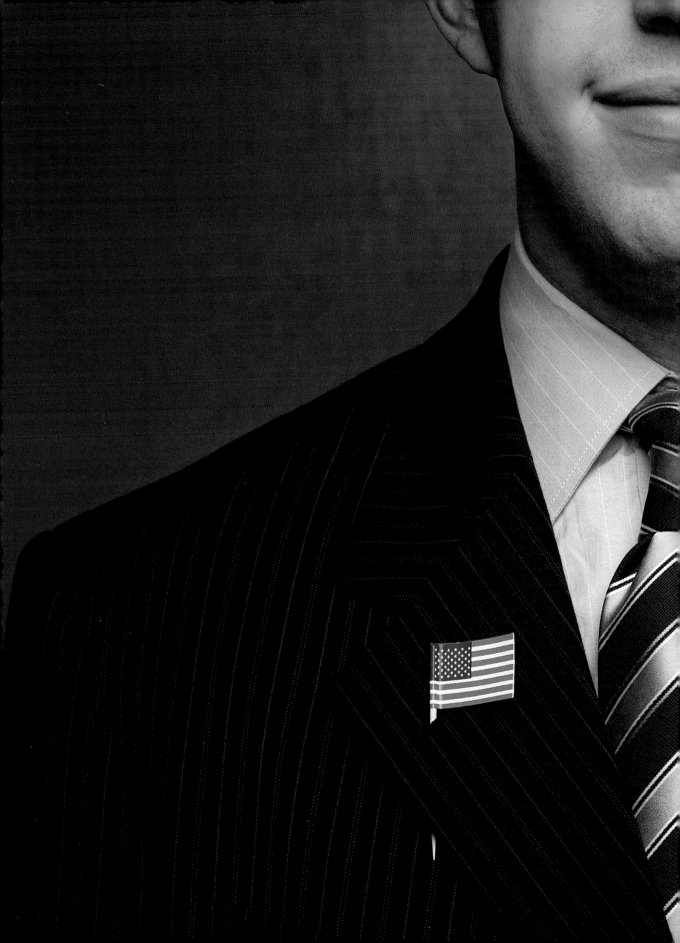

By the photographers of
REDUX PICTURES

# AMERICAN YOUTH

contrasto

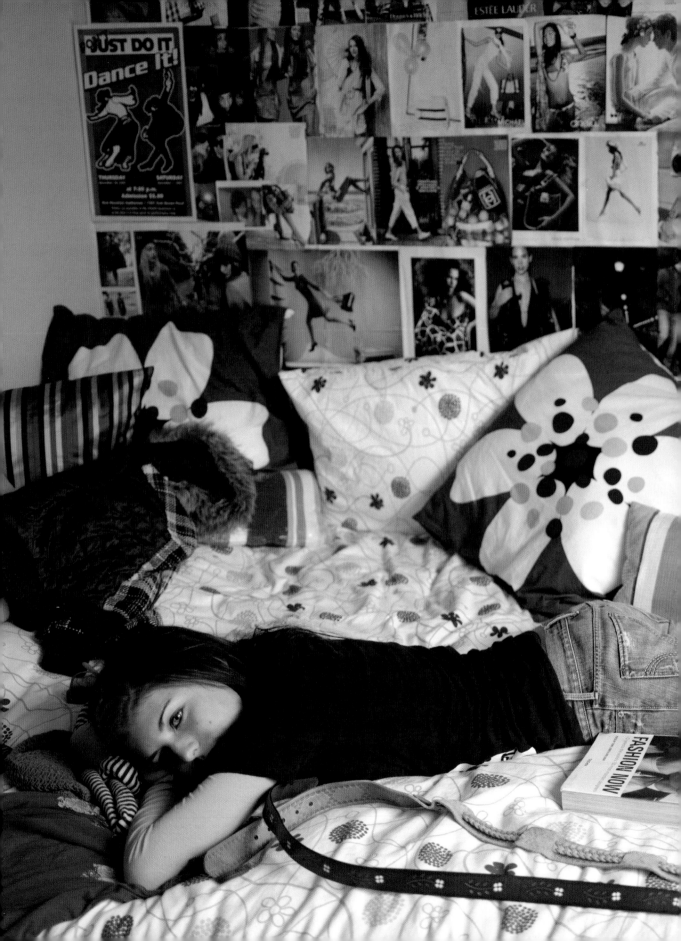

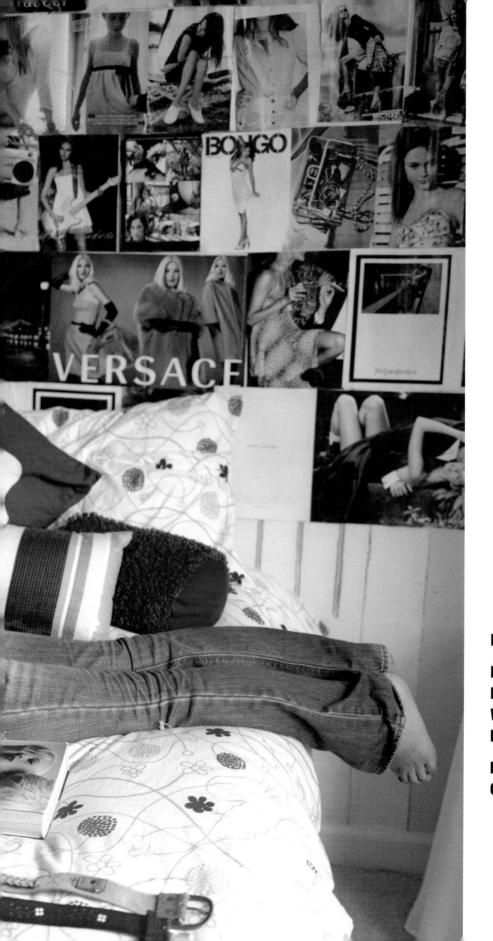

INTRODUCTION . . . . . . . . . 7

LIVE . . . . . . . . . . . . . . . . 18
LOVE . . . . . . . . . . . . . . . 74
WORK . . . . . . . . . . . . . . 108
PLAY . . . . . . . . . . . . . . . 170

IMAGE INDEX . . . . . . . . 226
CONTRIBUTORS . . . . . . 234

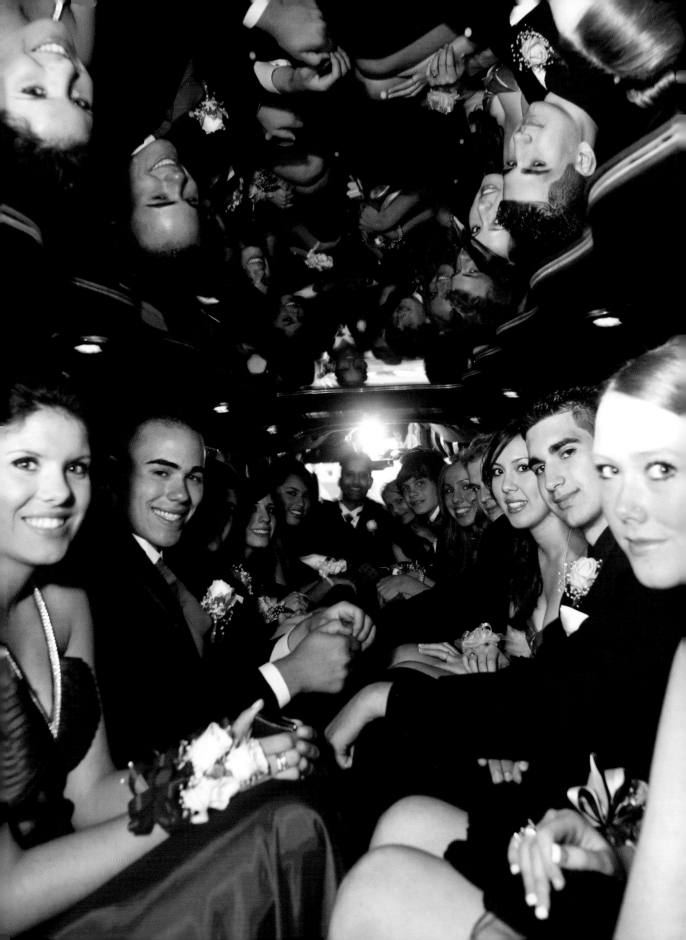

# FIRST STEPS OF THE iGENERATION

By Steve Appleford

**17 IS EARLY FOR A WEDDING.** But Angie had her reasons. Her boyfriend of five years had joined the Army. And now his military career was laid out in front of him, with life and work at Fort Bragg, outside Fayetteville, North Carolina, and then a trickier year-long deployment to Iraq. So it was either break up or get married, the only way Angie could stay with him until he left for Baghdad. Her parents knew she'd just do it the moment she turned 18. So they let Angie go, watched her walk down the aisle with Rob Santo in his Class A uniform; a couple of grown-up teenagers ready to make a home, until he was sent off to war.

Rob was deployed at the end of 2008, just in time to miss Christmas. He was an electronics specialist with the 82nd Airborne, helping to dismantle another base, one more step in America's slow exit from Iraq. Angie (née Chastain) was back home in Maryland with her parents, preparing to start nursing school, waiting and worried. It's a story that's centuries old: the wife and soldier separated by time and war. Except that Angie still talks to Rob every day, which is one benefit of coming of age in a new high-tech century. Each morning, she plugs into her webcam and Yahoo instant messaging for a 90-minute chat. Seeing his face from so many thousands of miles away, only makes the war more present in her life. "It kind of puts me in shock," Angie says of their conversations, still in the first months of her husband's overseas mission. The news is not always good. "I kind of go back and forth—*Don't tell me,* I don't want to hear about it. Then I flip-flop—*Do tell me,* I want to know what's going on. It's really scary." She hears about the bombs and destruction, the stories of American soldiers killed or wounded. "It makes me think, tomorrow it could be him. It just makes me cherish every day that I do have him and can talk to him."

There's a photograph of the young couple taken by Erika Larsen weeks before Rob left, and it captures them at a moment of calm amid the shady woods of Fort Bragg. By now, Angie is 18, blonde and gazing into the distance, and Rob is 19, handsome and contemplative in a dark red beret and green combat fatigues, sitting

on a stack of empty ammo boxes. Their story of young love during wartime represents one moment in history, as another generation steps forcefully into adulthood. That's the subject of this book of photographs: *American Youth,* created by the members of the Redux Pictures agency, headed by founder Marcel Saba.

The book's mission is to examine this newest generation of adults in detail, to observe young couples and Mormon missionaries, debutante balls and drunken tailgate stupors, war widows and B-boys, street kids and lobstermen. How are they different, and how are they exactly the same as the generations that came before? On these pages are Christian rock fans, lesbian gangstas and Obama volunteers. There are would-be pop stars waiting for a shot on *American Idol,* organic farmers living the hippie dream, and tattooed Cobra gang members brooding in the Window Rock jail on the Navajo Reservation. Another series of photographs asks young New Yorkers to think big: *If you had the chance, what question would you ask God?*

This is American youth in all its vivid detail and contradictions. At the macro level, is a series of portraits by photographer Ben Baker. They are organized into epic grids, each one lining up 40 young faces, representing either the surprising American demographics of today, or a projection of the future. Baker calls the grids "a sociological study," a graphic of a changing America, based on a study by the Pew Research Center. His first grid represents an exact breakdown of the current ethnicity of young Americans, each face photographed against a simple white backdrop. The second grid's collection of faces and ethnicities is a projection of where America will be in 2050, with far fewer Caucasians and a significant increase in Asians and Hispanics. "It really gives a sense of the country," says Baker, who collected the images during two weekends in multicultural Manhattan, setting up a photo booth in Washington Square Park, and another in Union Square. Virtually all of the young people he asked to photograph were happy to talk and sit for his camera, helping construct this roadmap of an era. "It's where we are now and where we're headed."

**EVERY GENERATION IN AMERICA GETS A LABEL**, some catchy name to call its own. The top prize is already taken (thanks to author Tom Brokaw), the very words "Greatest Generation" suggesting all kinds of heroic deeds and survival skills put to good use in the last century, the so-called "American Century," no less. They vanquished Hitler, survived the Depression and won the Cold War. What could follow that? But from this crowd emerged the Baby Boomers, a tidal wave of youth that came of age in the years after Camelot and in the time of Vietnam and rock & roll, eventually taking power in the form of Presidents Clinton and Bush. They were followed by the infamous Generation X, which hit early adulthood in the '90s, just in time to be the first to conquer the Internet and be identified with "heroin chic," grunge and a *Titanic* movie in equal measure.

What came after is harder to explain. After flirting with the unmemorable designation "Generation Y," the consensus of our most trusted thinkers and cultural critics is that the first to come of age in the new century shall be known simply as the Millennials. It's a label coined by authors Neil Howe and William Strauss in their 1992 book *Generations: The History of America's Future*, and generally refers to Americans born in the '80s and '90s. It's an epic phrase for an epic time of change and turmoil, of new possibility and lowered expectations.

This book is concerned with what could be called first-wave Millennials, in 2009 aged roughly between 18 and 24 years. They are still in early adulthood, and already they have been smeared by their elders as a super-race of spoiled cry-babies and fashionable zombies, plugged into the virtual unreality of Facebook, Twitter, YouTube, MySpace, BlackBerry, Blu-Ray, Bluetooth, PlayStation 2, Wii, Xbox 360, the iPod, iPhone, iBook, etc., etc. We are told they are too impatient to follow traditional career paths, trained by indulgent Boomer parents to expect easy rewards and a stress-free rise to the top ASAP. That is the cliché. As always, the truth is far more complex and fascinating, and as varied as any generation of Americans, some as rooted in old customs as they are in the sci-fi here and now. They are just the latest generation to be misunderstood by their elders.

They are also the largest generation in history, twice the number of Generation X, more racially mixed and uncompromising in regards to their own needs and ambitions. A 2005 Gallop Poll reports that about 60 percent have dated someone of another race. They multitask on an expanding global online playground, on the cell or the Instant Messenger, speed-texting with their thumbs endlessly and as effortlessly as if in their sleep, attaching digital snapshots of their pets, their friends or maybe themselves in wonderfully compromised positions. More enroll in college, with the 17.3 million undergraduates in 2004 nearly double that of 1970, according to the National Center for Education Statistics. And they just helped elect the new President of these United States, turning out in record numbers for Barack Obama.

One investment firm calculates that every year they spend $200 billion (some of it their parents' money), so there are many seminars and Web sites designed to ease the stress of marketing to this confounding iGeneration. Even so, they will face worse economic times than their parents or grandparents, and many move back home, "boomerang kids" unashamed to be back with mom and dad. They face many of the same struggles as their parents, their idealism colliding with lowered expectations. Some will land in the military, others will be teen mothers, debutantes, surfers, activists, farmers. More than a few will get drunk or loaded, and stay that way.

Most will remain plugged in, wherever they land, as Erika Larsen has found during her volunteer work at a homeless shelter in New York City. "Truly, truly homeless and everything they've gone through—maybe they're prostitutes or whatever, but they have their iPods," says the photographer, herself still in her

early 30s. "And even though they're staying at the shelter, they have to pick the cooler clothes to wear. It says something about being homeless in the United States. It's about different survival skills than maybe being homeless in India or Africa. It's a totally different thing. They have cell phones. Their values have shocked me. What's going on here? *I* don't have an iPod."

<p style="text-align:center">★</p>

RAMI MIKATI WAS LIKE ANY OTHER AMERICAN KID, born and raised in Northern Ohio, the second son of Lebanese immigrants. Being a Muslim was never an issue. He grew up mostly around white non-Muslims, went to public school, played soccer. That changed on the morning of September 11, 2001, as terrorist hijackers sent passenger jets crashing into New York and Washington, D.C., killing thousands and introducing radical Islam as America's newest enemy. Mikati was a freshman in high school as he watched it on TV with his geometry class. Everything stopped. Even sports activities were called off. "Thanks, Rami," one kid joked, "you cancelled our soccer practice."

Things only got worse after the U.S. invasion of Iraq in 2003. While still in high school, Mikati was driving home one night when he noticed he was being tailgated and followed. Back then, he still dressed like any other adolescent kid, and he didn't even have facial hair. He finally stopped at a light and looked back at the car behind him, pleading "What did I do?" The driver was older, a little rough around the edges, the kind of guy who probably yells at his TV. He shouted back at the teenager: "Are you *Arab*? Are you *Iraqi*?" Mikati couldn't believe what he was hearing, and when he soon drove past a police station, his stalker sped off. "That really hit home," Mikati says. "That was a pretty blatant, personal, direct form of racism."

He's 21 now, and studying economics at Case Western Reserve University in Cleveland, with plans to attend dental school. Mikati is also politically active, leading an advocacy group on campus called Students for Justice in Palestine. He often wears a black and white keffiyeh scarf around his neck, as well as a T-shirt with Arabic writing across his chest, right above the English translation: WE WILL NOT BE SILENT.

Coming of age as a Muslim-American in the time of post-Millennial conflict has been a lesson in dueling identities. His parents left Lebanon during the civil war there in 1986, a year before Rami was born. They sent him to local schools, but at home taught him about Islam and how to speak and read Arabic. "Here in Ohio, I'm seen as the Arab. And in Lebanon I'm seen as the American," he says. "I'm never seen as both." His occasional family visits there began during his childhood. "Before September 11, it was the coolest thing to be American. Everyone would try to speak English to you, and all the girls thought it was the cutest thing. All you had to do was say you're American and you'd be treated like a king. Then, after 9/11, no way. The resentment with our American foreign policy

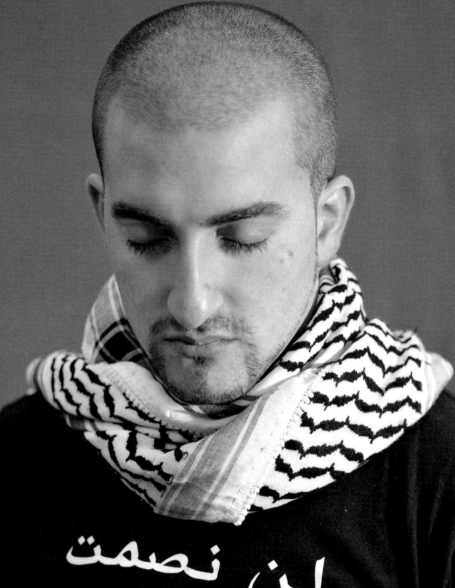

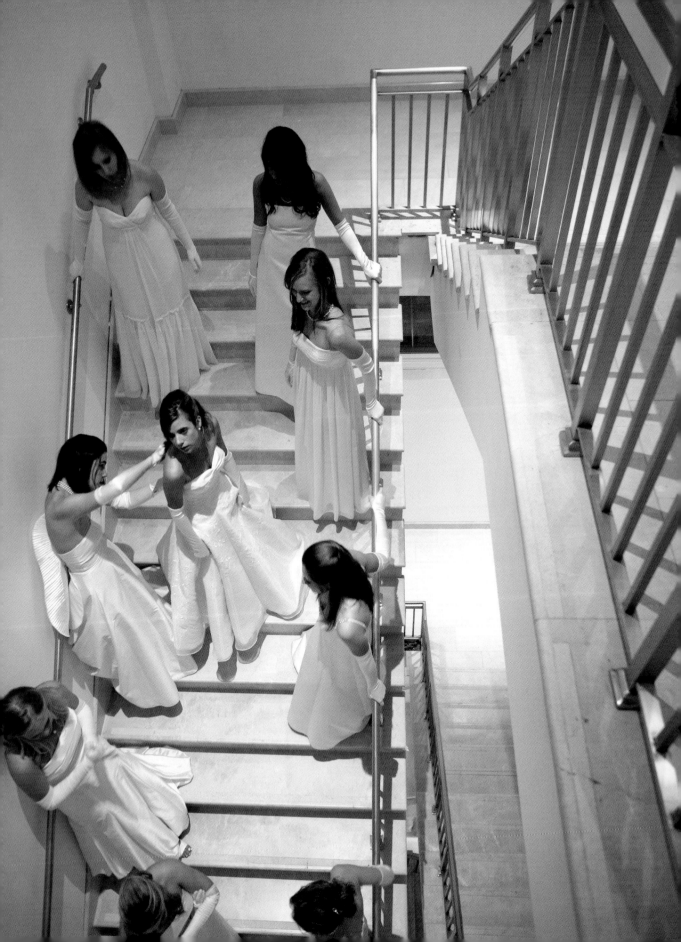

overcame that. You don't really want to boast and say *I'm American*. They'll go 'Fuck you!' Before that, it was cool."

In a portrait by photographer Greg Ruffing, Mikati is in his dorm room, kneeling on a green prayer rug beside his bed. On the wall are a Lebanese flag and a poster of Malcolm X. "I'm pretty confident in myself, and my identity is not as a Muslim but as an American," he insists. Mikati is like the young man playing guitar in another picture, Ahmed Aldoori, 20, who was born in Iraq and loves Metallica and Middle Eastern music equally; or the Arab-Americans quietly praying in their local mosque. The photographer found a small but vibrant community of Muslims in Ohio, as Sunni and Shiite share neighborhoods and mosques. In the pictures, they are living the quintessential suburban life, with backyard birthday parties, balloons, swing sets, and teenage girls who happen to wear the traditional hijab headscarf. But there is something else beneath the surface, a burden not shared by their neighbors, says Ruffing: "Something that came up with a couple of people was that, before 9/11, they just felt ignored, and they wished they could go back to being ignored. They wanted to go on with their lives and have nobody pay attention to them, and put their heads down and humbly pursue their lives and careers."

★

SIMON AND SIMEON MET AT THE BRONX ZOO. They had each arrived there alone one day early in 2008, then noticed one another wandering around, and finally started chatting and flirting on the subway back to Manhattan. True love. A year later, they are happily cohabitating as a gay couple in a Williamsburg, Brooklyn apartment, a pair of 23-year-olds beginning their adult lives in the city together.

Their emotional link runs deep, but anyone looking at their portrait in this book can see the connections. They look like twins, two short-haired young men in blue plaid shirts, embracing in the fading afternoon light on the roof of their building. "We were kind of intense from the minute we met," says Simeon, who works at a high-end cosmetics boutique on Madison Avenue. Simon is a student of fashion at the Parsons School of Design. "We were talking about marriage and homes, and we do talk about those things and the future. But especially now that we've moved in, we try to keep it in the present. This is my longest relationship, and I've just noticed that maybe when you put too much emphasis on the future, you also put too much emphasis on doubt. So we try to stay in the present tense and whatever happens happens. We're very young. But we have a lot of hopes and desires to make this a long-term functioning relationship."

When invited to participate in the *American Youth* project, with its focus entirely on men and women between 18 and 24, photographer Mark Peterson gravitated to the youngest adults, choosing among his subjects the formal settings of a New York debutante ball, and high school JROTC students going to their prom in Norfolk, Virginia. He recognized something profound in that moment of life and transition.

"I just remember that period in *my* life," says Peterson. "And that last month of high school is such a fun period, where you are trying to take in every amount of enjoyment with your friends, because you know everybody is going to divide up. I was trying to show this happy period. As photojournalists we're perfectly capable, and do over and over, of showing the sadness of life a lot of times, and I just wanted to show this jubilant period."

He was impressed with what he found. There was Javanda Williams, as a JROTC leader in uniform at her high school, or putting on an elegant red dress for a celebratory night out with her fellow students. She had pulled herself up from troubled beginnings, raised by her father, and has since moved on to the U.S. Naval Academy in Annapolis, Maryland. And there were the young debutantes he photographed in New York City, taking part in an old tradition of the wealthy, while also working hard away from the spotlight on their way to Ivy League schools. "All of them had done stuff like go to Africa and teach English for the summer in some school, or had worked in some clinic," Peterson says. "I mean, the public service they had done was unbelievable. It was just really, really amazing stuff to hear these credentials, what these kids had done by the time they were 18."

Others labor in ways identical to their parents and grandparents. Photographer Peter Frank Edwards found a handful of young lobster fishermen in Deer Isle, Maine. "Everyone kept saying that it had become an old man's game, that fishing had declined so much, young men didn't see it as lucrative anymore," writes Edwards, who had himself labored in seafood markets and on shrimp boats around Charleston, South Carolina, while in high school and college. He knew others were still at it. He photographed teenager Garrett Steele, raised on the island and just out of high school, standing in the mud in a T-shirt and cap, pulling a canoe filled with clam baskets, ready for another day of work and tradition.

Ben Stechschulte's photographic survey of young organic farmers in the Champlain Valley and Adirondack Region of New York State finds a new generation reversing the trend of new farmers in decline. For them, this is both a profession and a lifestyle choice. "In recent years, consumers have become more interested in the provenance of their food for political, economic, health and environmental reasons," writes Stechschulte. "Locally grown and raised food products are finding a larger market and have made small farms a viable business and integral part of the food supply."

For others, being young and American means being alone and desperate. At age 20, Pepper has lived on the streets of San Francisco for five years. She was raised that way. For her seventh birthday, Pepper's father gave her a "hand grenade" bottle of Mickey's Fine Malt Liquor, and eventually taught her how to squeegee car windows, panhandle and hitchhike, before abandoning the girl to her mother. She then became homeless at 15, "after my mother kicked me out—she uses drugs and is a speed freak," she tells photographer Darcy Padilla. "I'm just an alcoholic." She recently left a boyfriend who beat her, and now spends her conscious hours

begging for change in the company of her dog, Corduroy. "I don't think my life is extravagant."

Millennials numb the pain just as their parents did, imbibing their social lubricants of choice, some in moderation, others in spectacular, crushing excess. Drinking and drugging is a rite of passage endemic of every class and climate— from the hipster Portland bar scene to the drooling hedonists of spring break washing up on the shores of Florida and Texas. It's there in the ongoing ritual of binge drinking and random sex on the cliffs of Jumping Rock, some 40 feet above the Iowa River, just north of Iowa City. The kids get a little crazy. Booze, drugs, young men and women falling out of their clothes, doing nude double-back-flips into the muddy water below. "Some of them do have the intention of just getting completely out of control, getting as drunk as possible, and just acting out on whatever impulse, whatever sexual impulse, or partaking in the drugs that are around. Places like Jumping Rock bring that out," says photographer Danny Wilcox Frazier, who has documented the scene there for years, sometimes taking a dive into the water himself. This isn't the country club crowd. Many are the ones left behind after the best and brightest of their peers have fled rural Iowa for the Ivy League, the big cities, the left and right coasts. No hope, no future. But their need to escape is not so different from others of their generation, from disaffected suburban potheads to college freshmen weathering the new pressures of academia and adulthood. "That's what people do, they binge drink on weekends," says Frazier. "I'd like to say that I didn't do the same damn thing, but I did."

★

THE SUBJECTS OF AMERICAN YOUTH are just getting started, and have already been called the "next hero generation" (psychologist Dave Verhaagen) or just the latest wave of hedonists to be coddled and cooed by the newest "toys and gizmos" (comic George Carlin). Whichever is true, they are the front end of an accelerating society that is tech-fluent, beyond ethnicity and not easily dismissed. They are also connected to each another in ways unknown to their parents, with 21.4 million of them on Facebook alone. But, what of their interior life? The big questions that haunt every generation?

About a quarter of Americans between 18 to 24 have no religious affiliation at all, according to Pew Research Center, but photographer Nathaniel Welch had a simple question for the young men and women standing for a series of portraits in front of his camera: *What would you ask God?*

His approach with the pictures was conceptual, setting up a simple studio in the Fall of 2008 at the Redux office in Manhattan's Union Square and inviting people to pose. When they arrived, each subject was given poster-board and a marker, and then confronted with Welch's big question. "I wanted to spring the idea on them in person and not give them a ton of time to ponder what they would ask. Everyone was pretty taken aback by it. It really seemed to strike a lot of

them as a 'heavy' idea," says Welch. "Young people definitely ask the most inter-esting questions, much more interesting than older people. Young people are still wondering what it all means to be human and have lots of questions for everything, not just God."

The answers were wide-ranging, sometimes profound, or self-obsessed. One young man held up a sign that read, "God, can I bring my boyfriend to heaven?"

Others were equally serious, playful or confused:

> "Does everyone feel like this inside, or am I insane?"
> "When does life begin?"
> "Poverty, AIDS, war…really?"
> "Did you make me in your image?"
> "With the increase in poverty, how do you sit and watch?"
> "Why haven't you saved the world yet?"
> "Did perpetual happiness in the Garden of Eden maybe
> get so boring that eating the apple was justified?"
> "Is it selfish to want what is best for myself when so many
> people are suffering right now?"
> "Will I fail?"
> "Can you hear me?"

One of his subjects spent more time than any other writing down his question. He sat there for more than an hour.

When he was finally ready, he posed with the sign: "What would my life be like if my mother was still alive?"

There is pain in that question, and yet the look on the young man's face is utterly peaceful, as if simply thinking again of his late mother had brought him a measure of happiness. "He was definitely the education for all of us," says Welch. It's not unlike the collision of emotions and life-changing decisions reflected in other pictures on these pages. *American Youth* is a close-up study of one generation's life, love, work and play. Some if it is difficult to watch, just as it has always been. Growing up is hard. ★

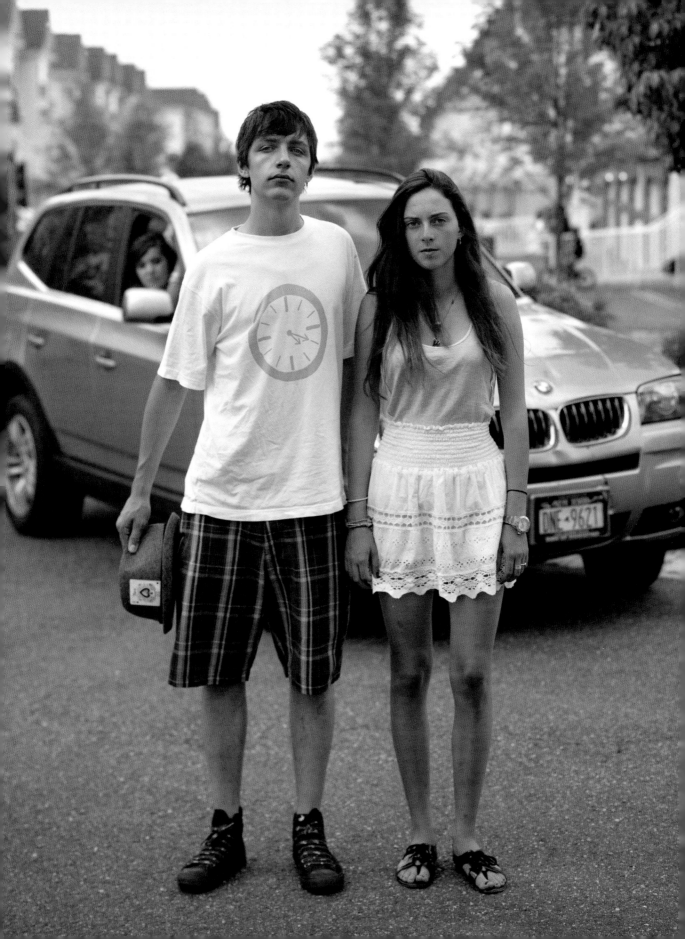

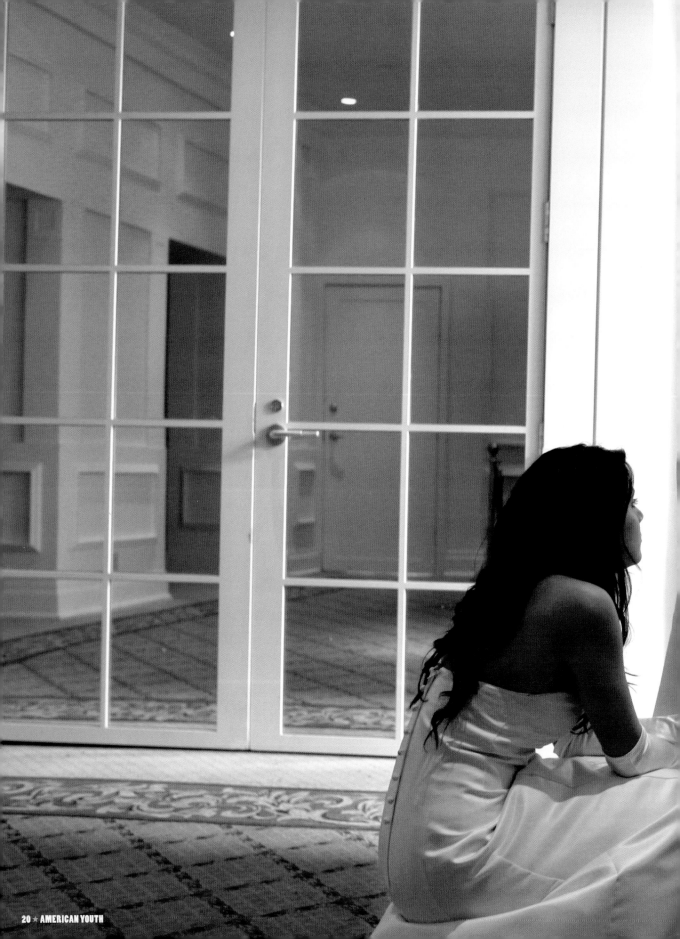

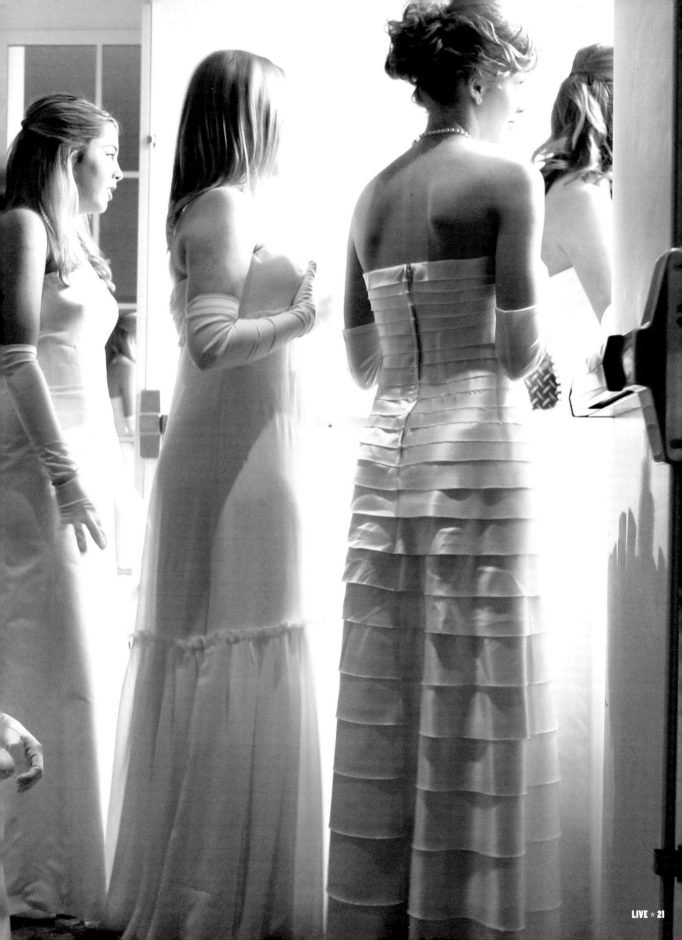

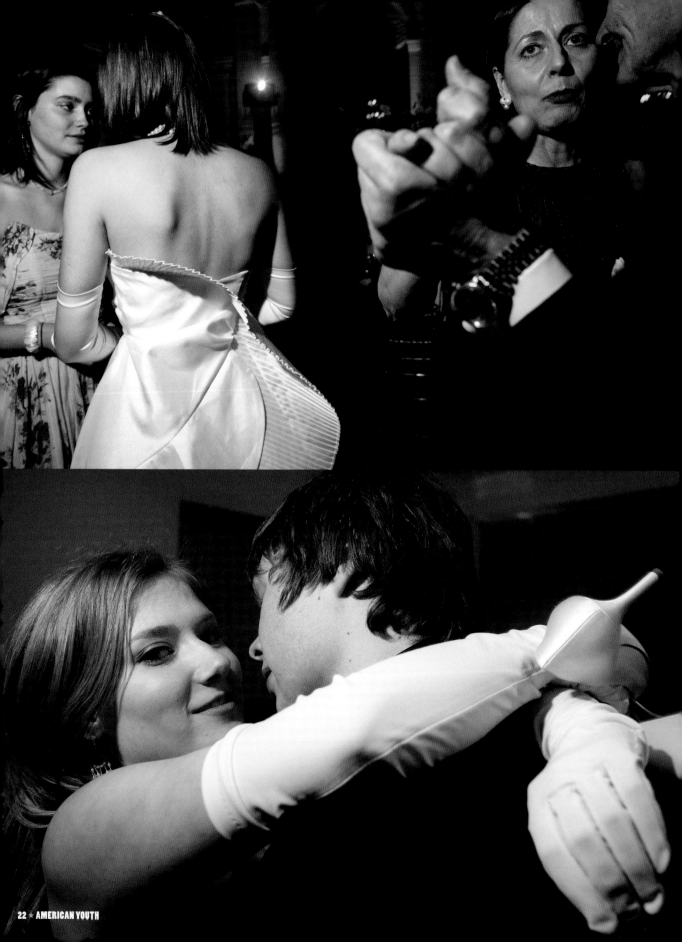

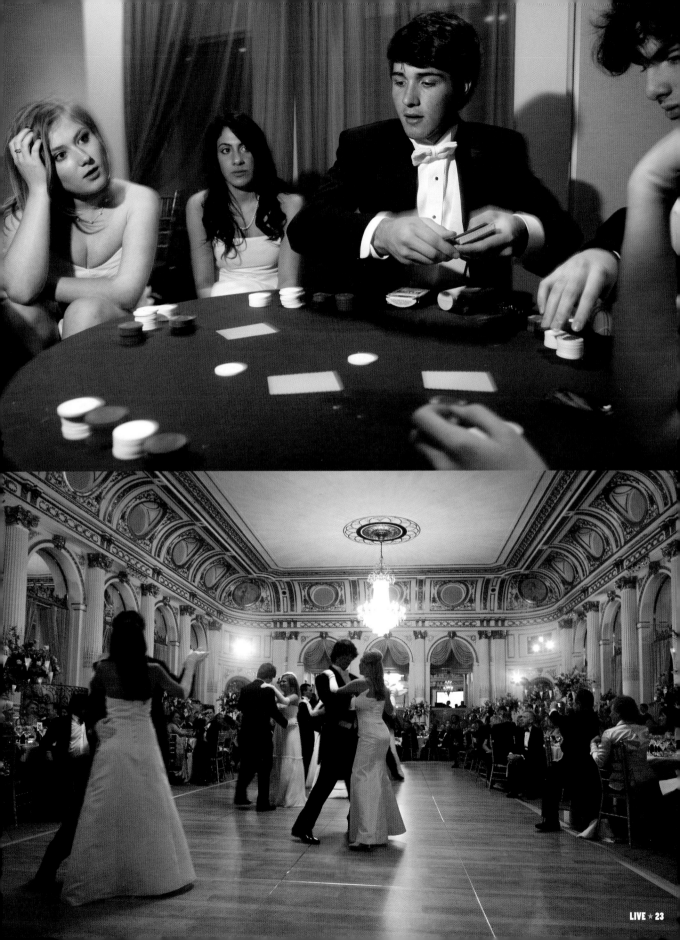

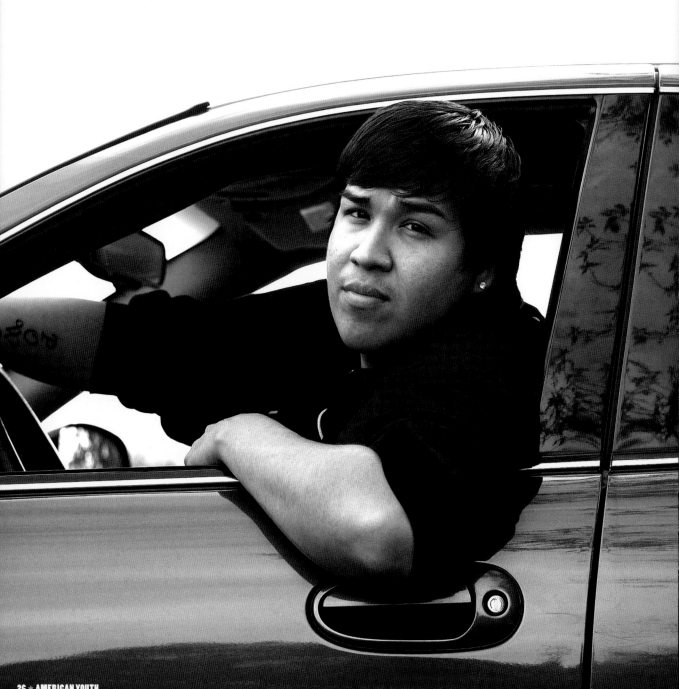

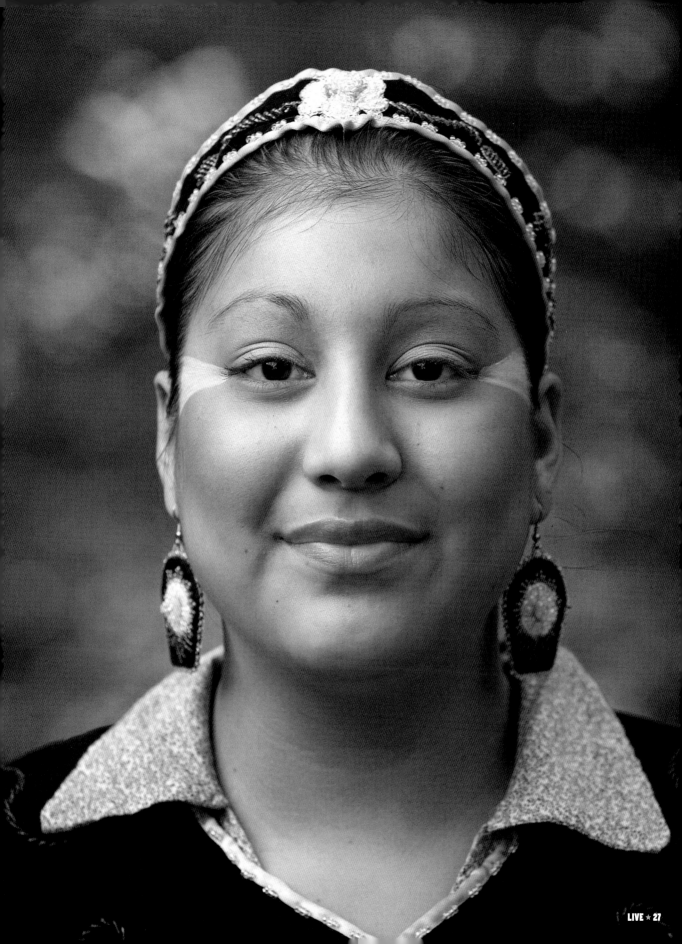

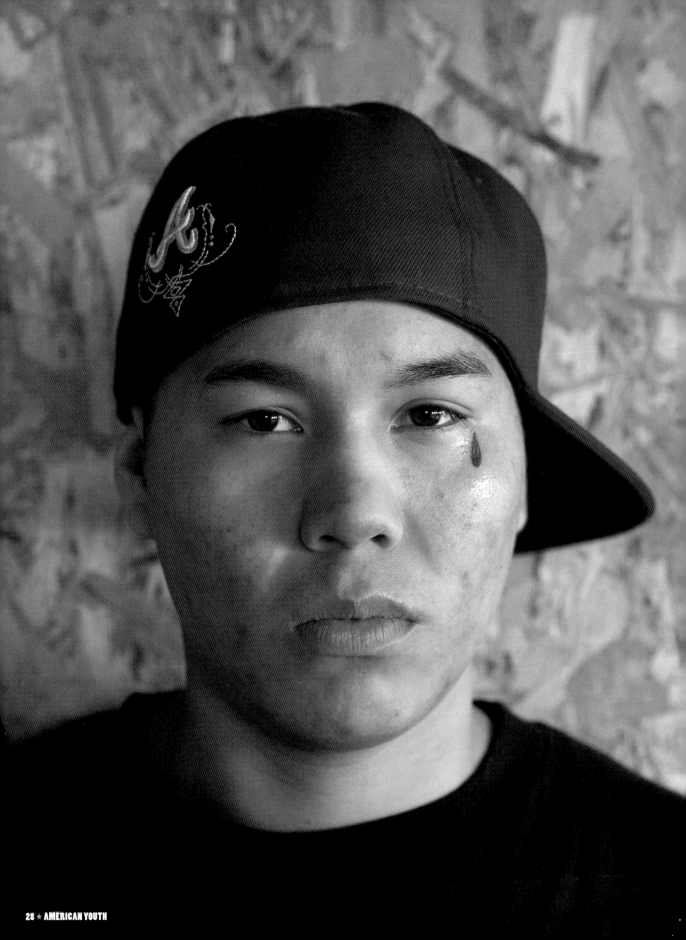

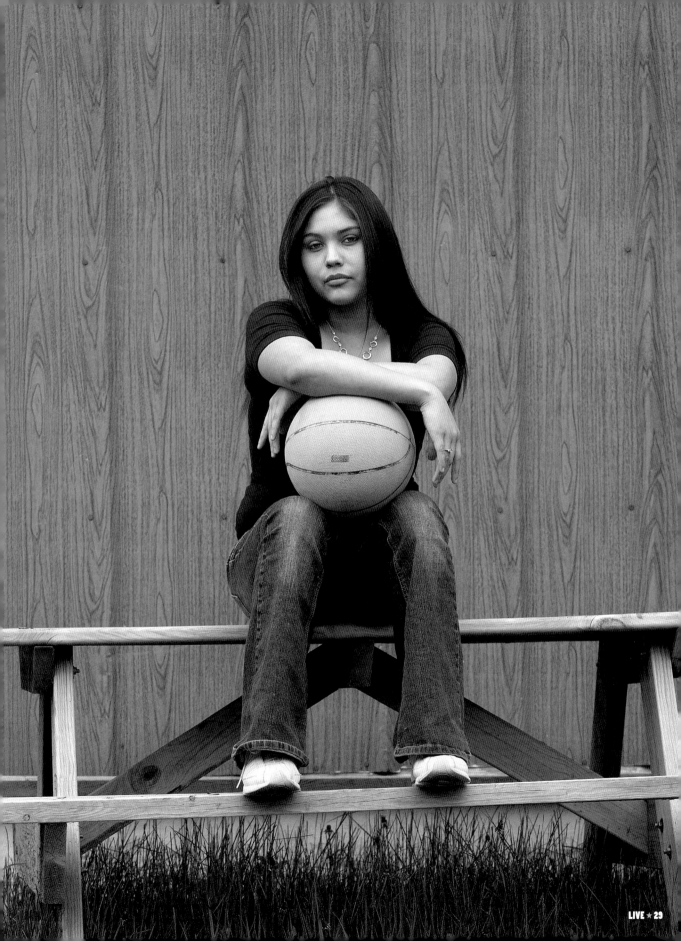

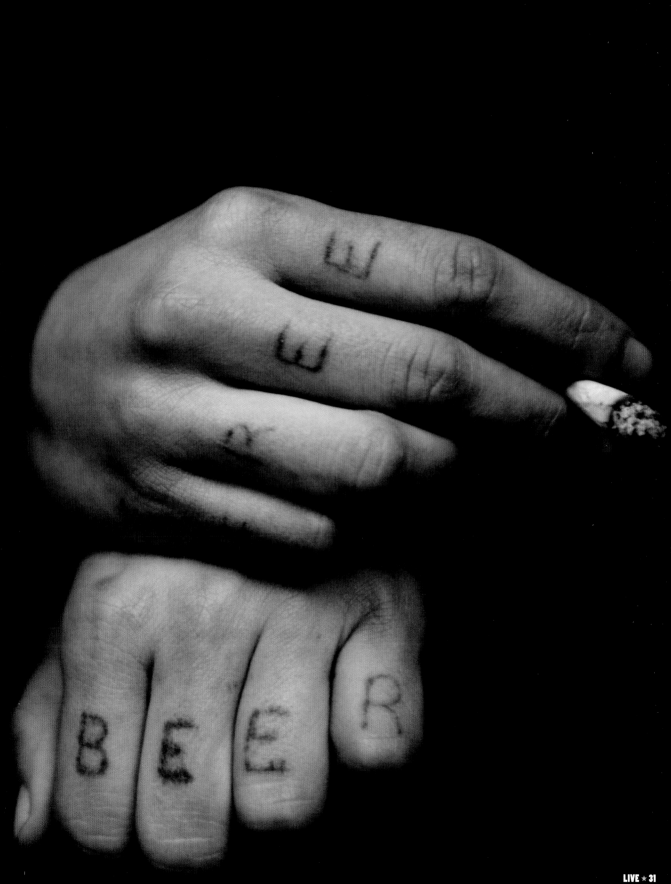

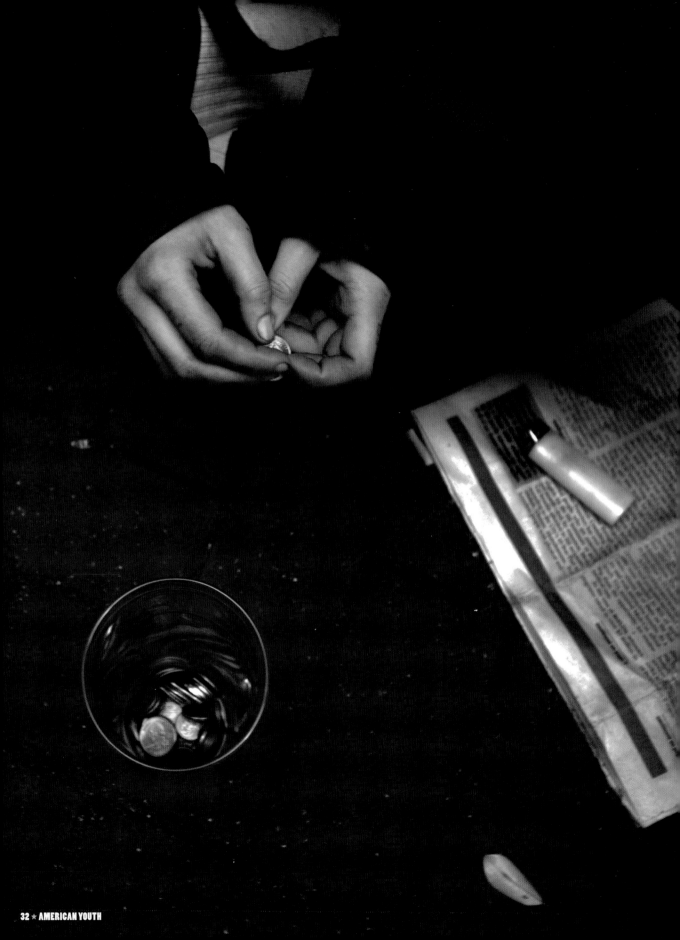

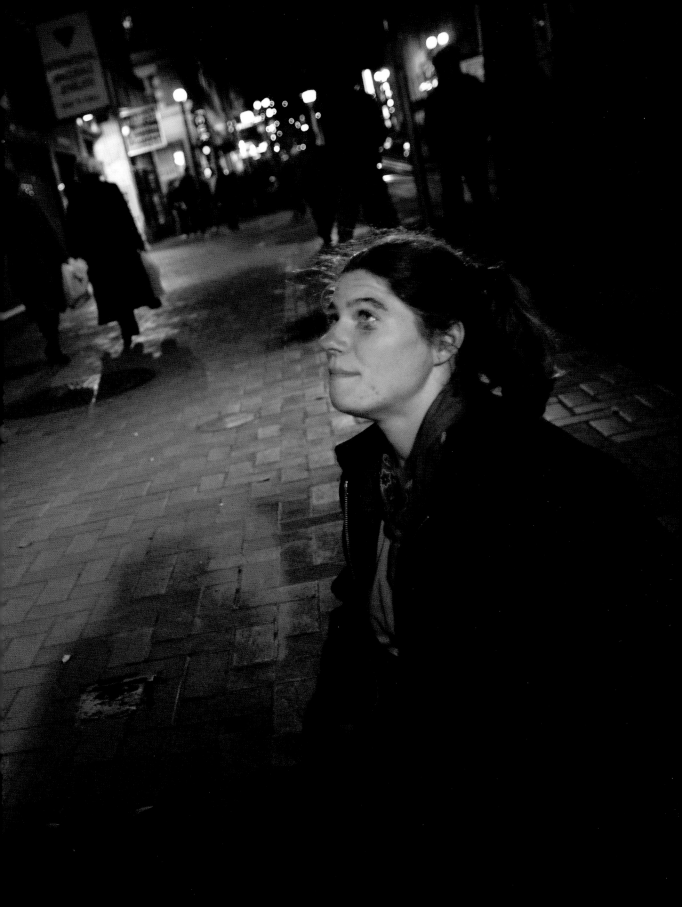

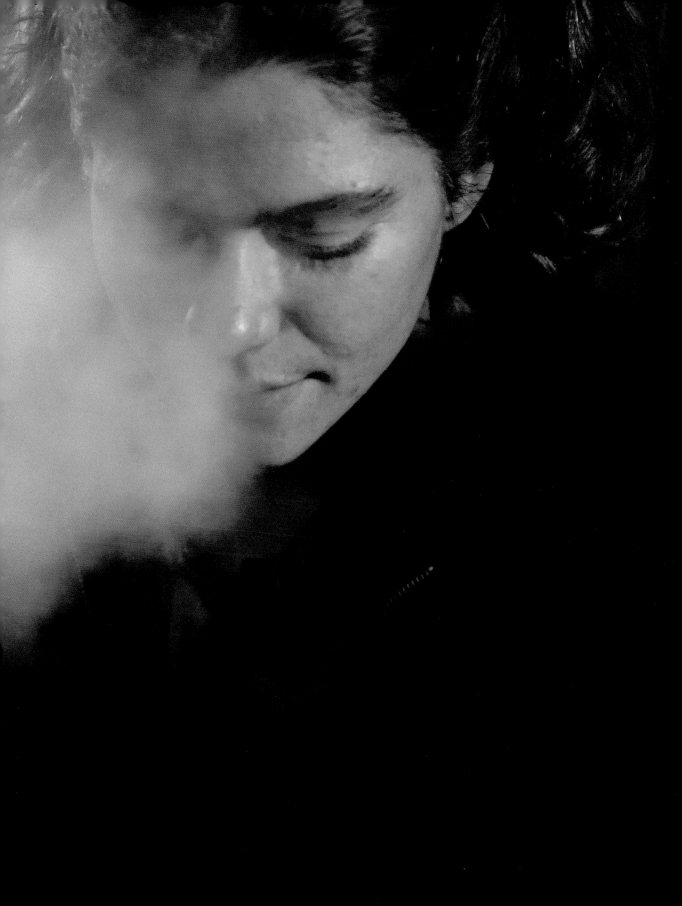

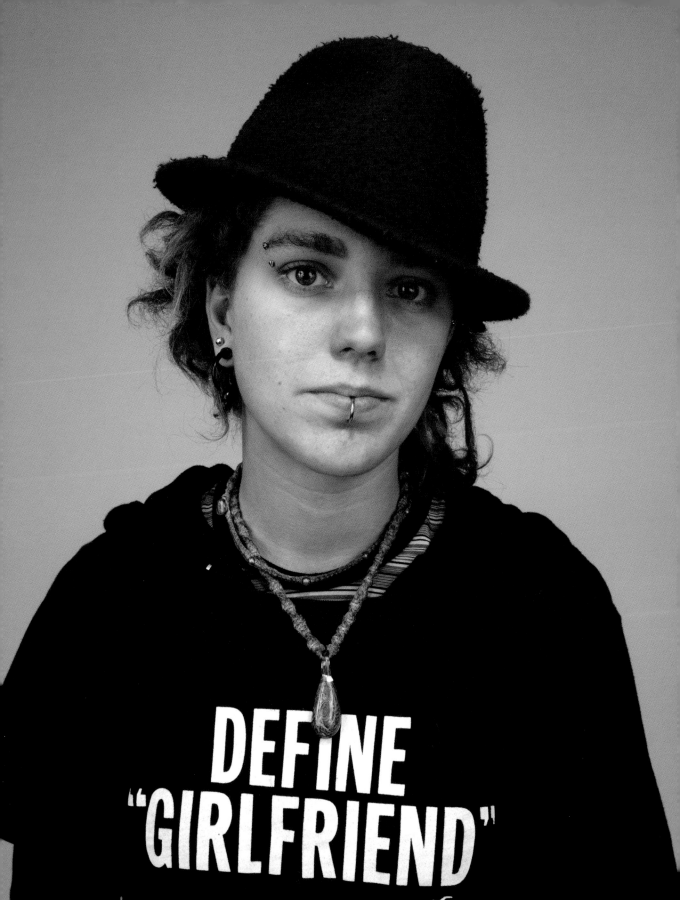

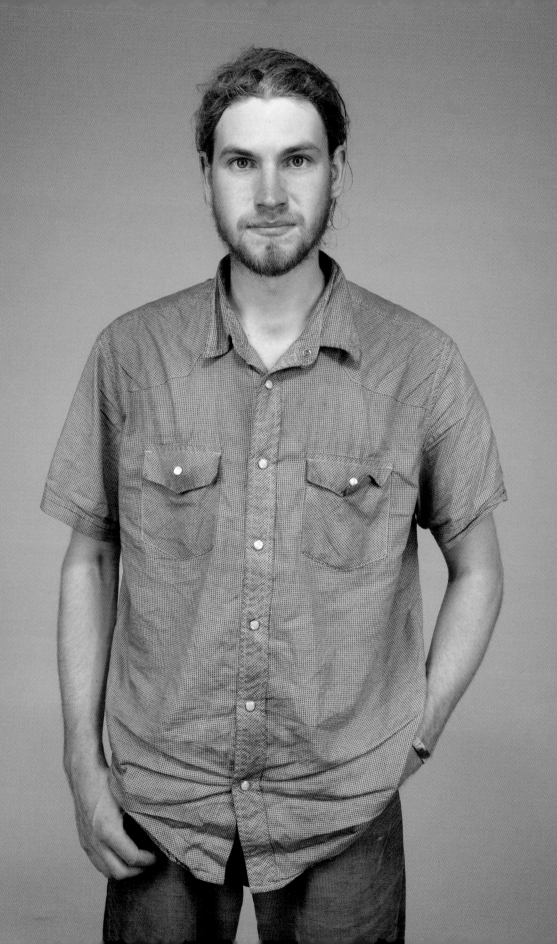

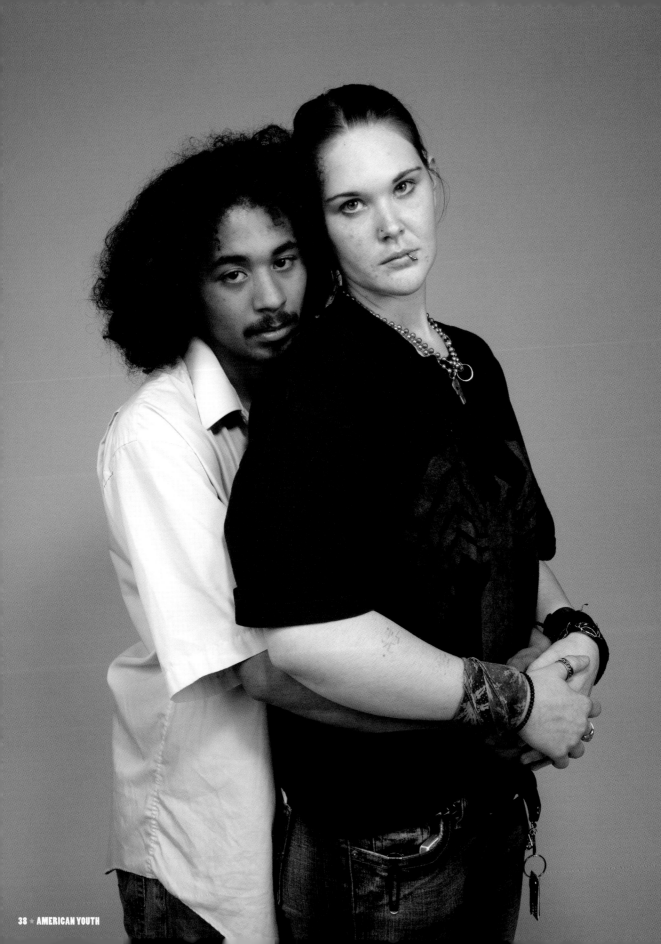

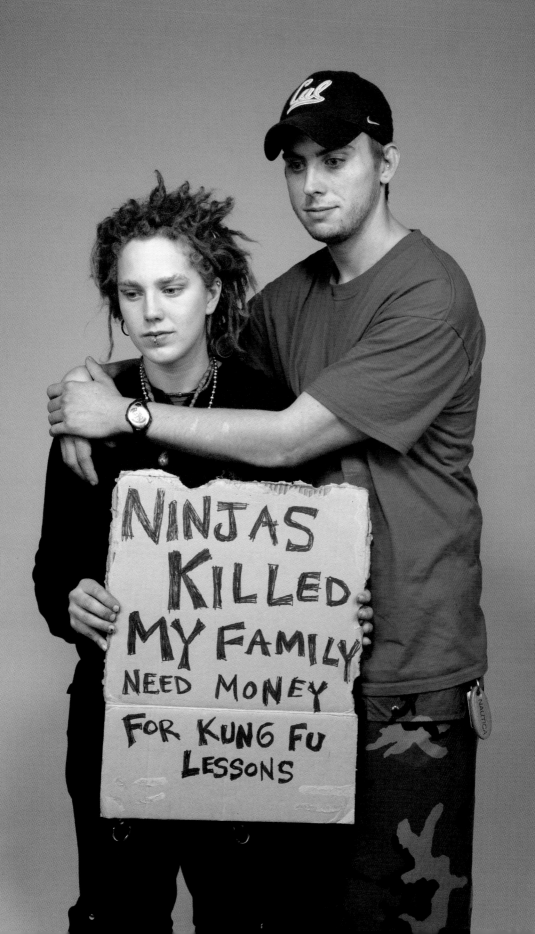

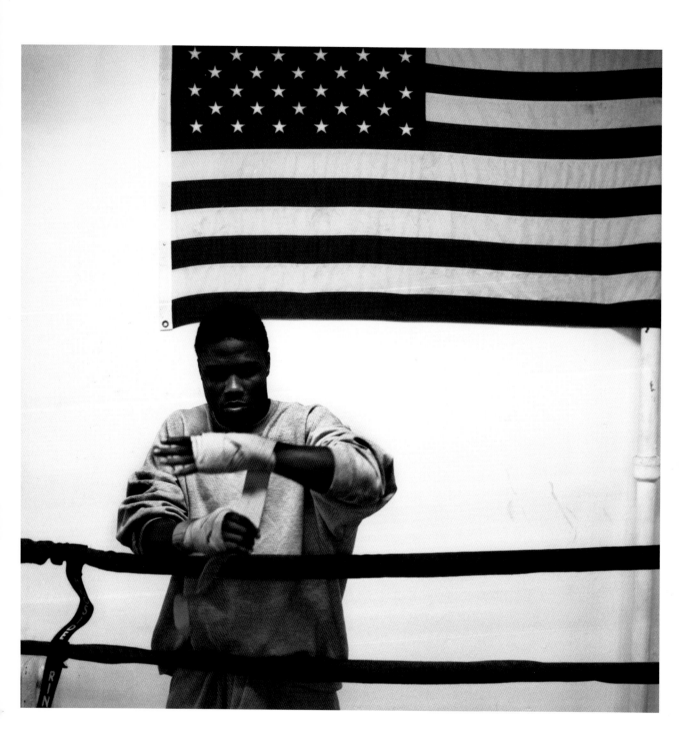

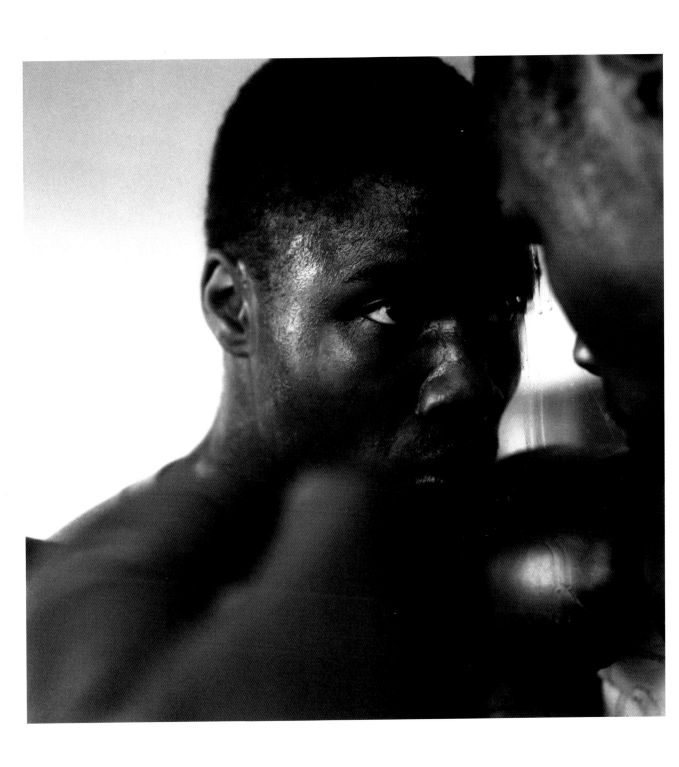

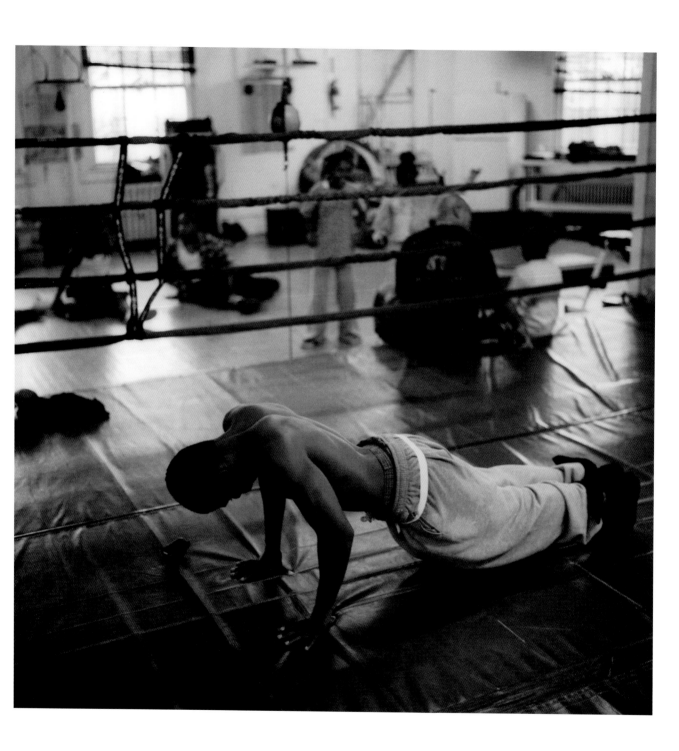

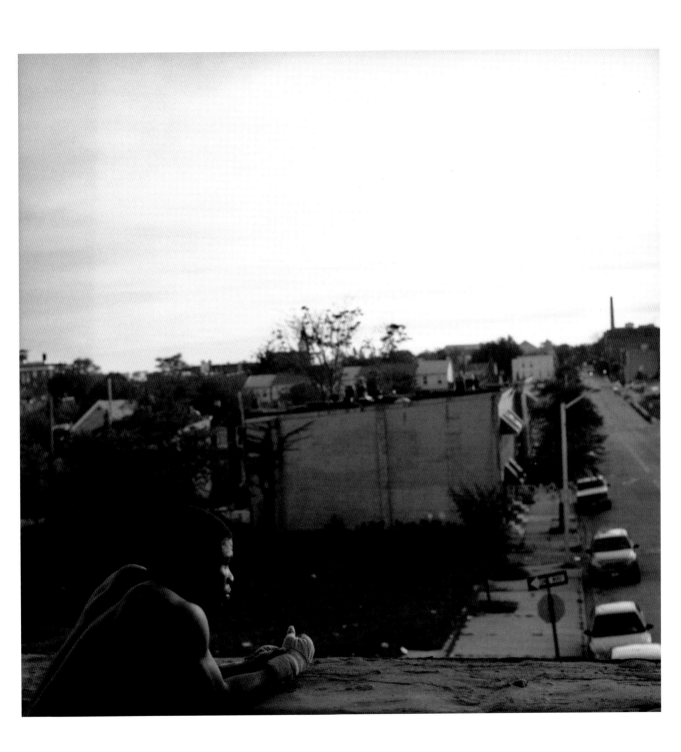

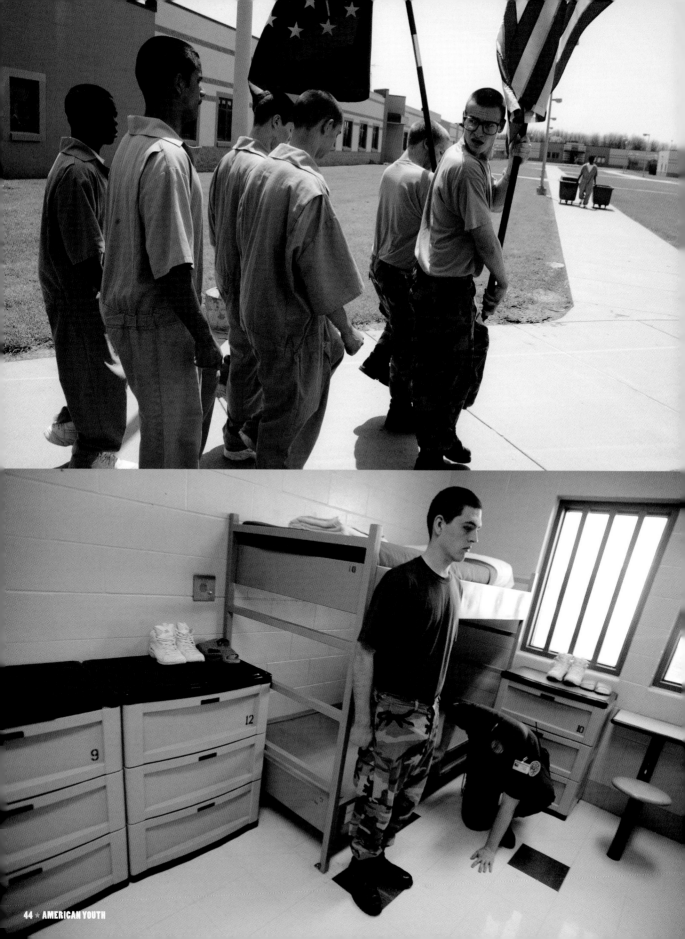

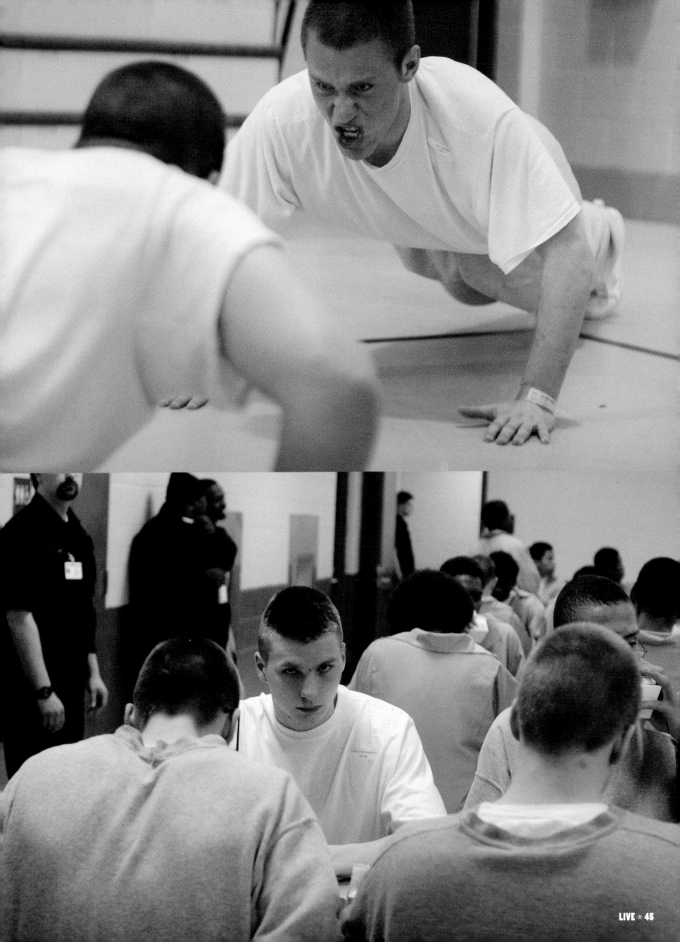

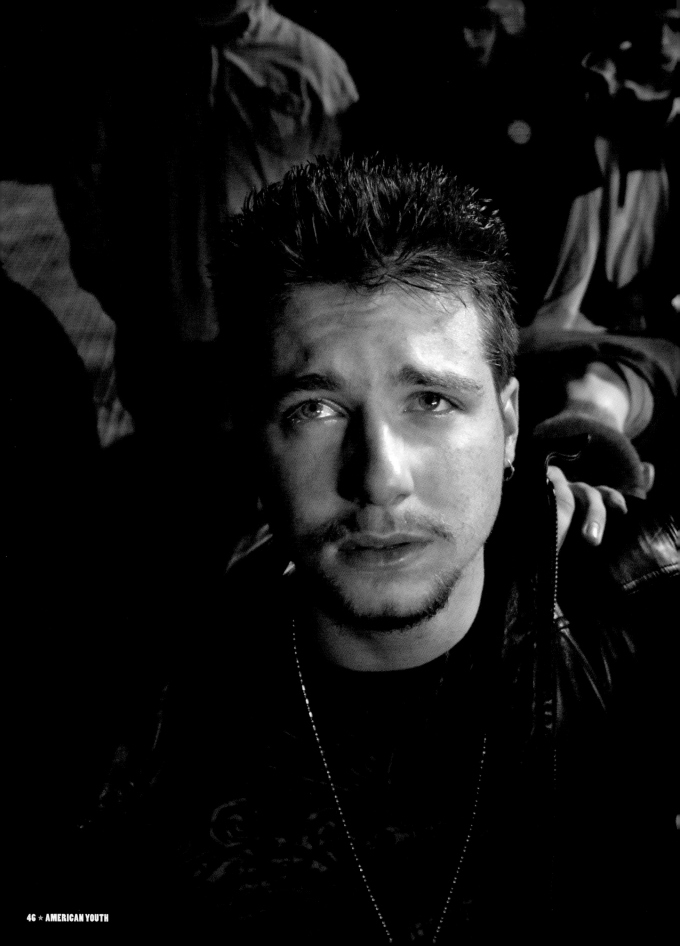

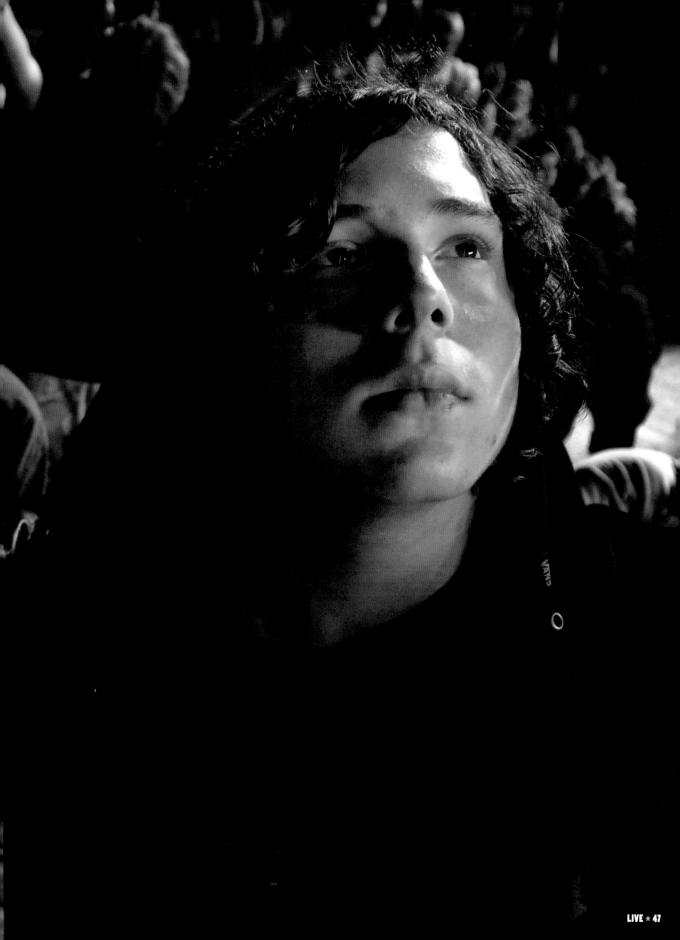

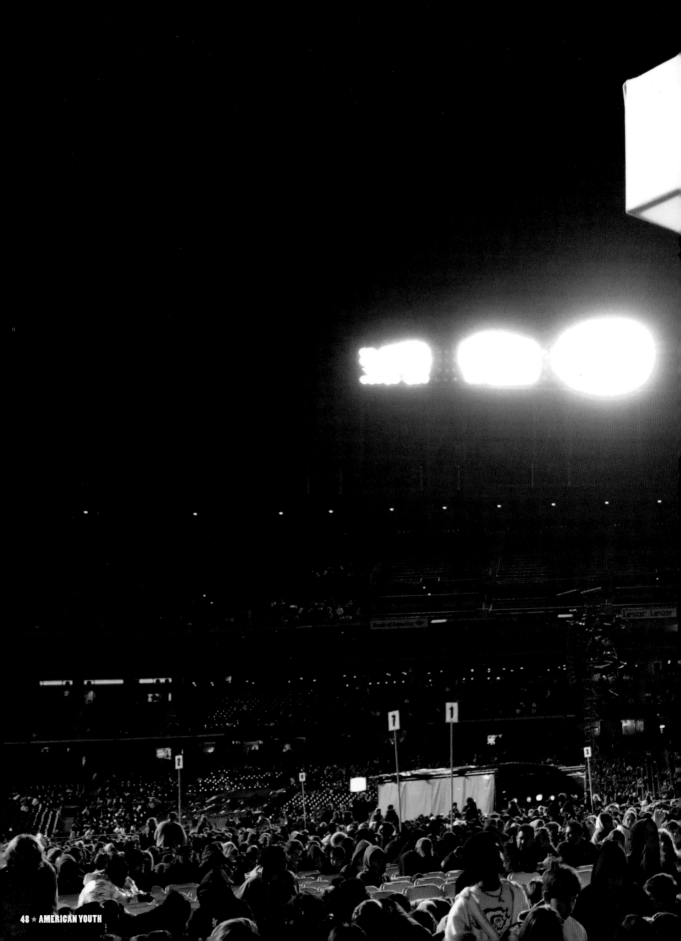

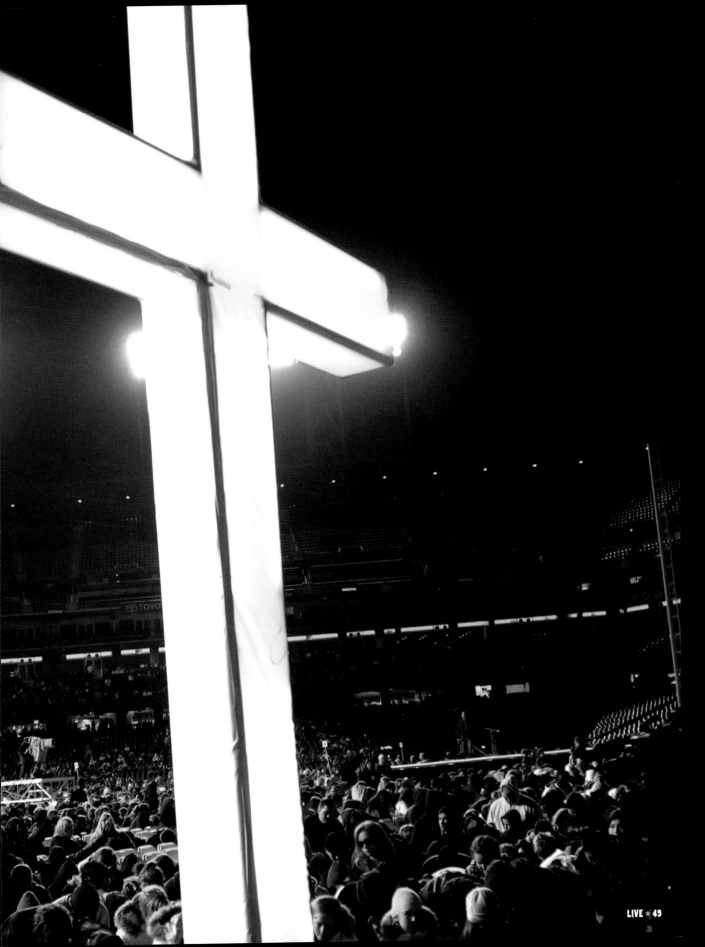

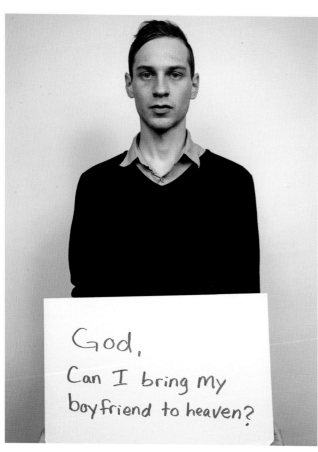

God,
Can I bring my
boyfriend to heaven?

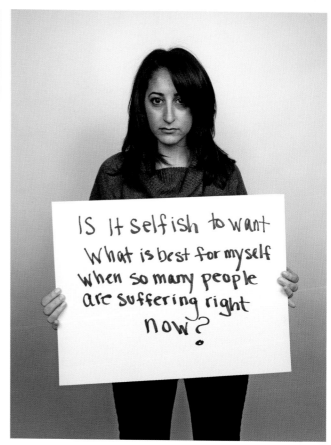

IS It selfish to want
What is best for myself
When so many people
are suffering right
now?

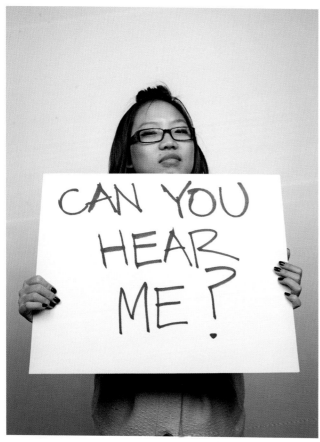

CAN YOU
HEAR
ME!

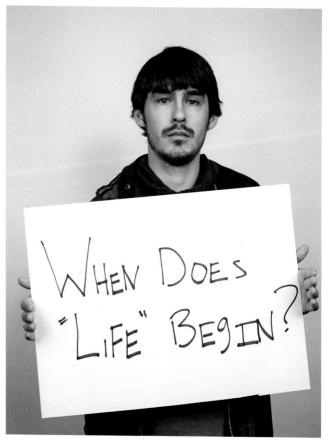

WHEN DOES
"LIFE" BEGIN?

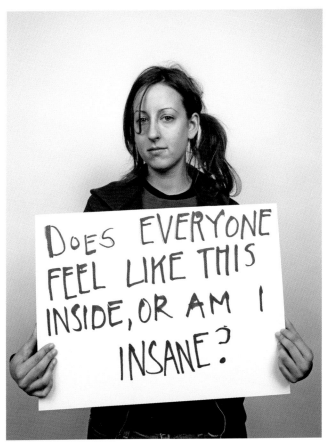

DOES EVERYONE FEEL LIKE THIS INSIDE, OR AM I INSANE?

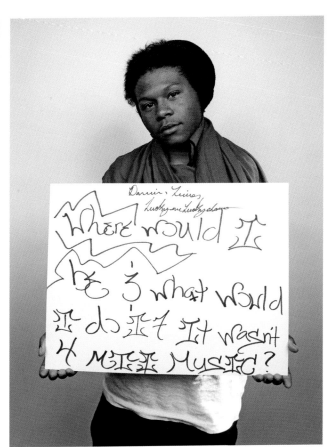

Darwin, Zuinos,
Lucky-one Lucky-clamp
Where would I be 3 what world I do if It wasn't 4 MUSIC MUSIC?

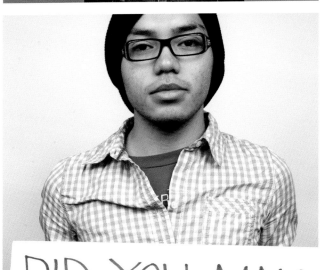

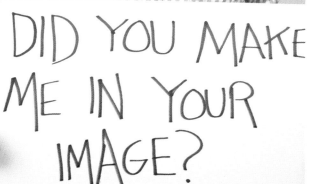

DID YOU MAKE ME IN YOUR IMAGE?

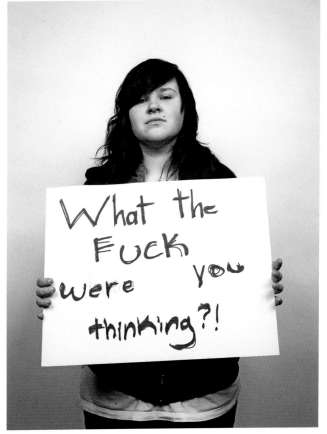

What the FUCK were you thinking?!

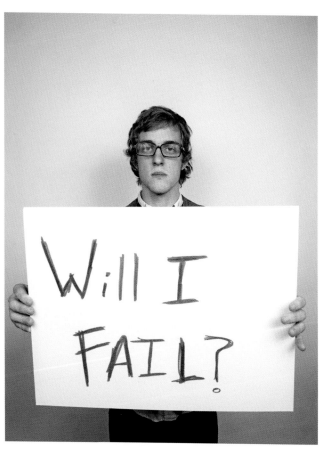

WILL I FAIL?

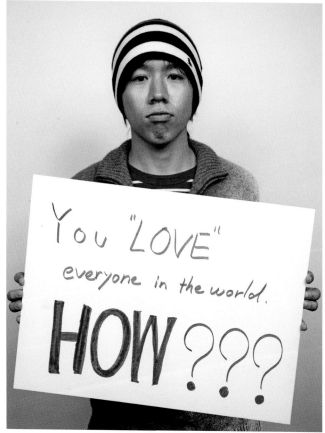

You "LOVE" everyone in the world. HOW???

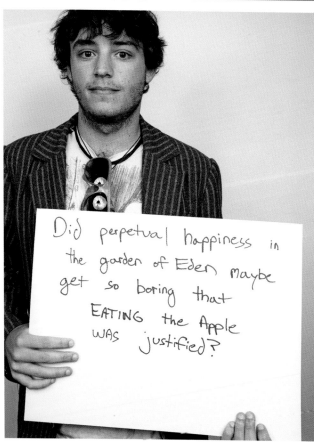

Did perpetual happiness in the garden of Eden maybe get so boring that EATING the Apple WAS justified?

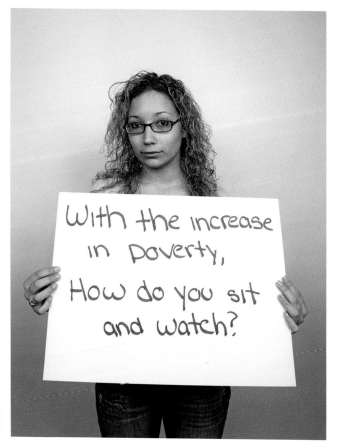

With the increase in poverty, How do you sit and watch?

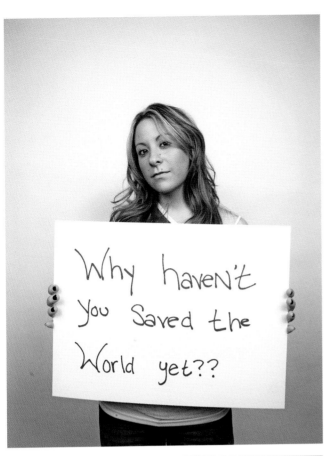

Why haven't you Saved the World yet??

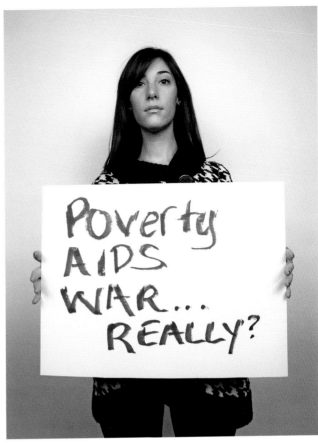

Poverty AIDS WAR... REALLY?

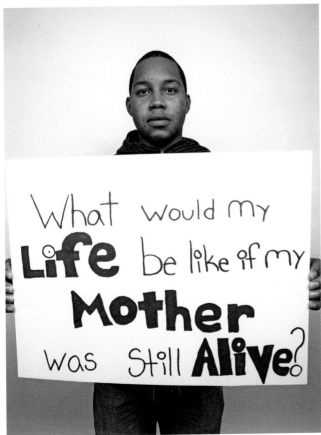

What would my LIFE be like if my MOTHER was Still Alive?

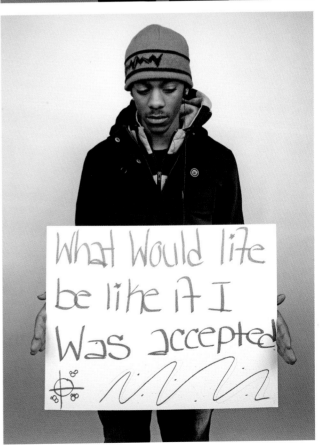

What Would life be like if I Was accepted

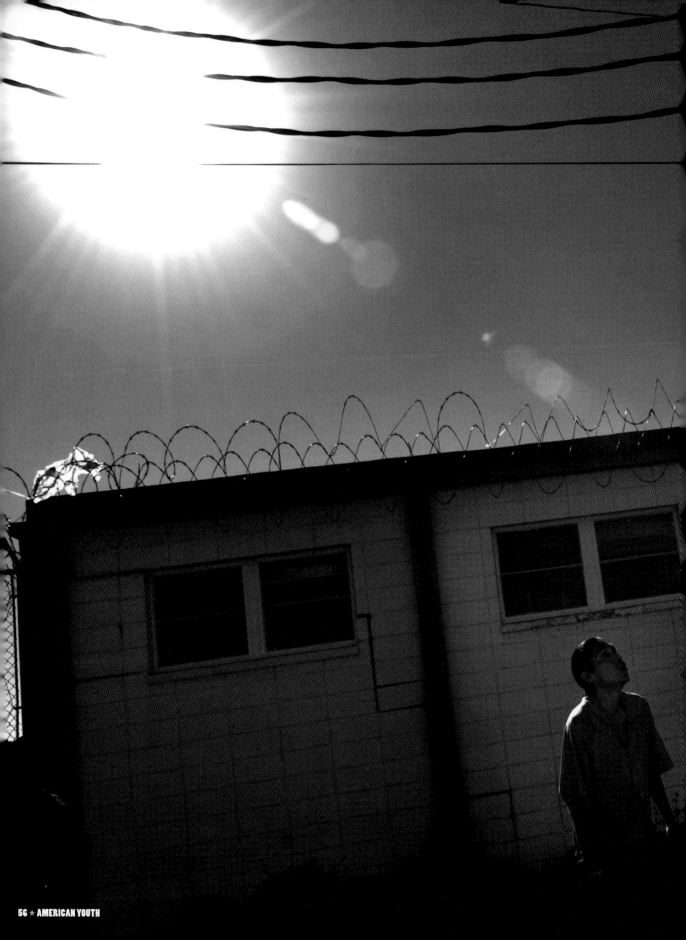

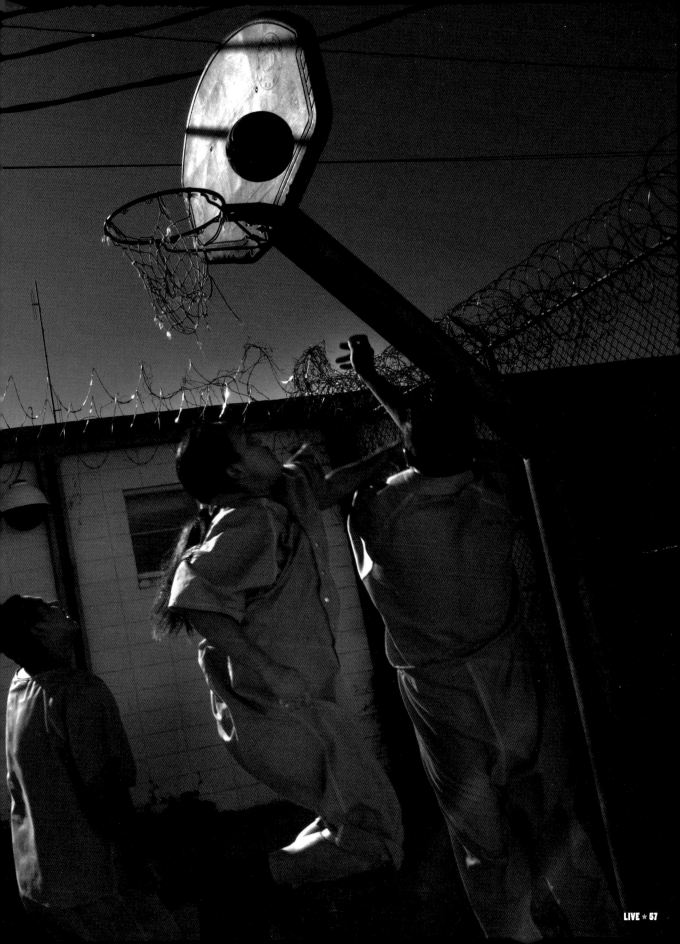

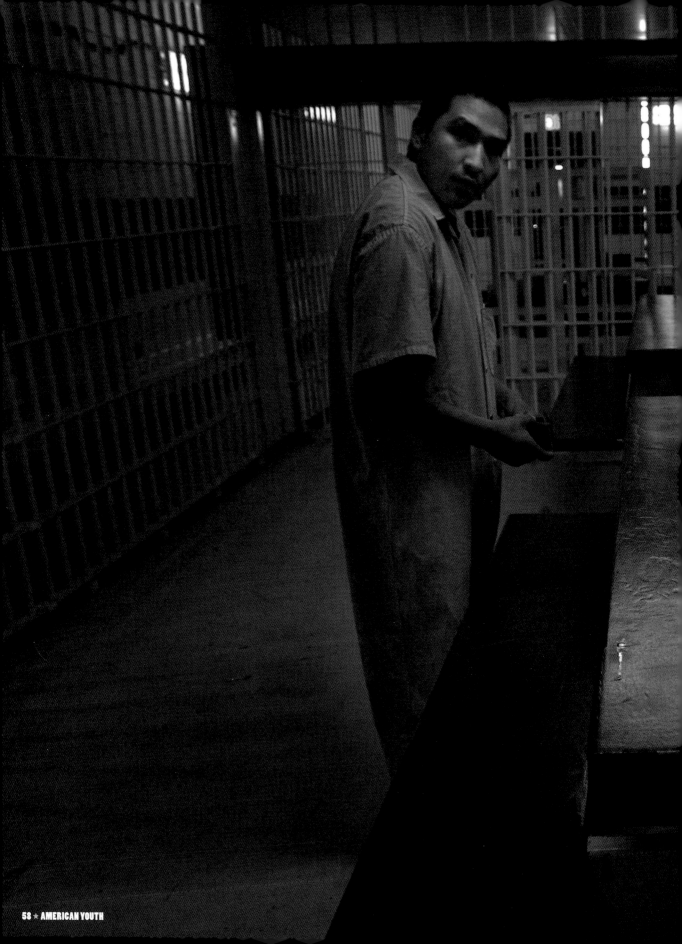

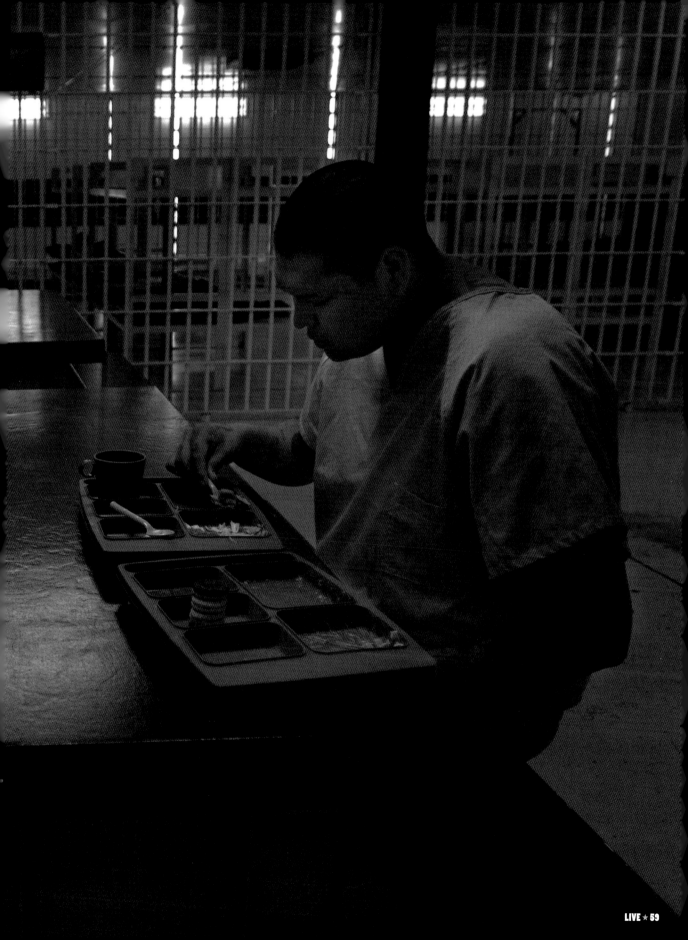

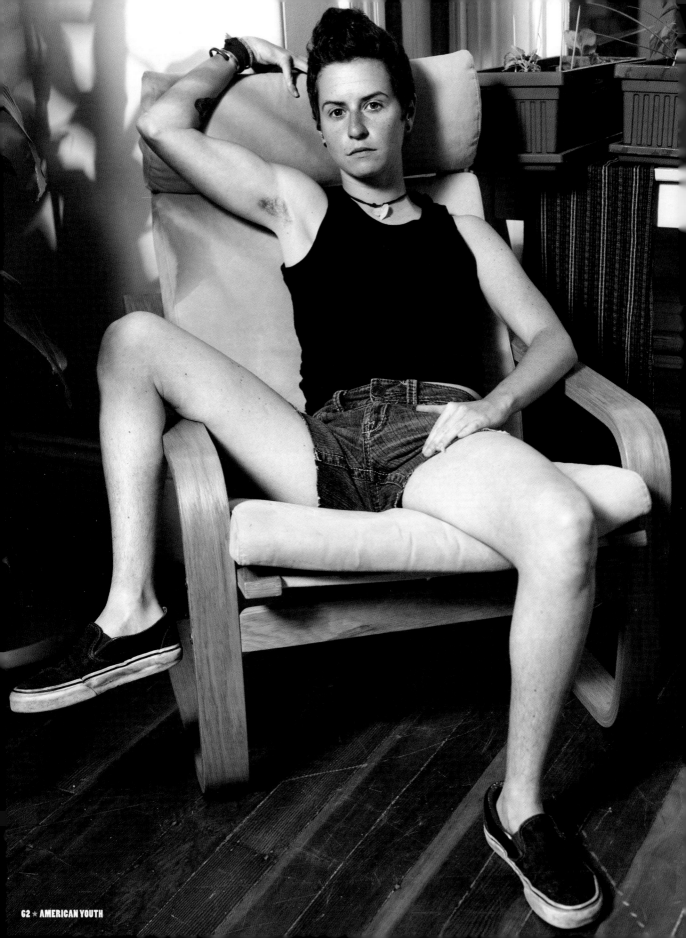

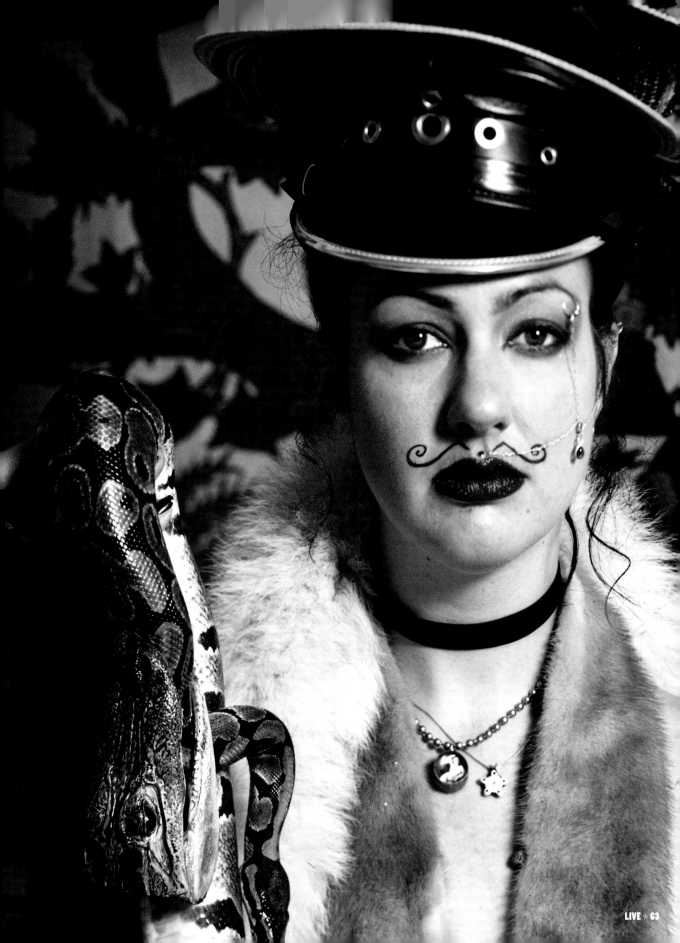

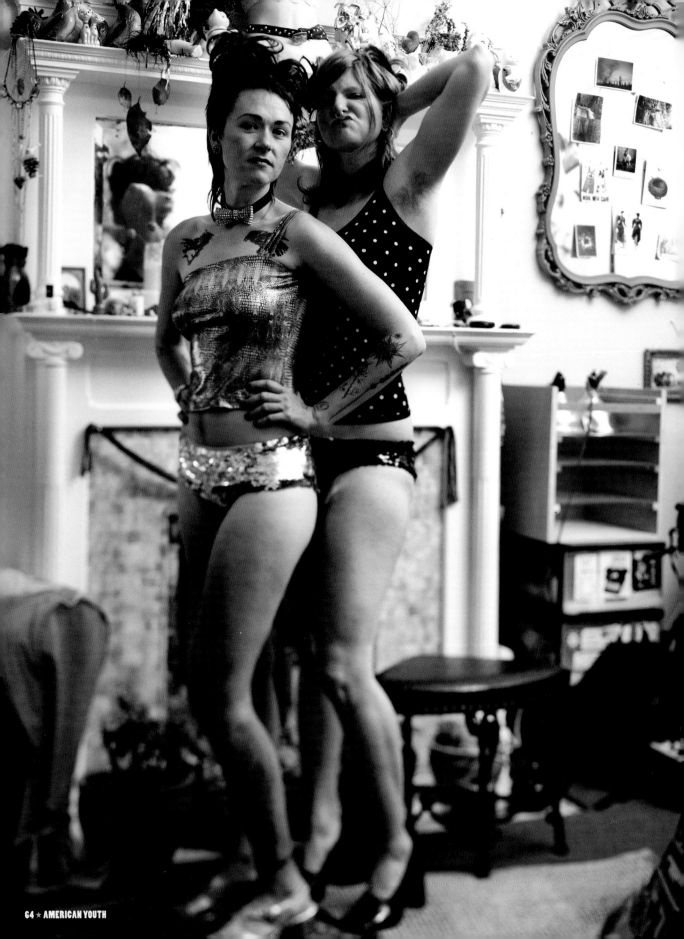

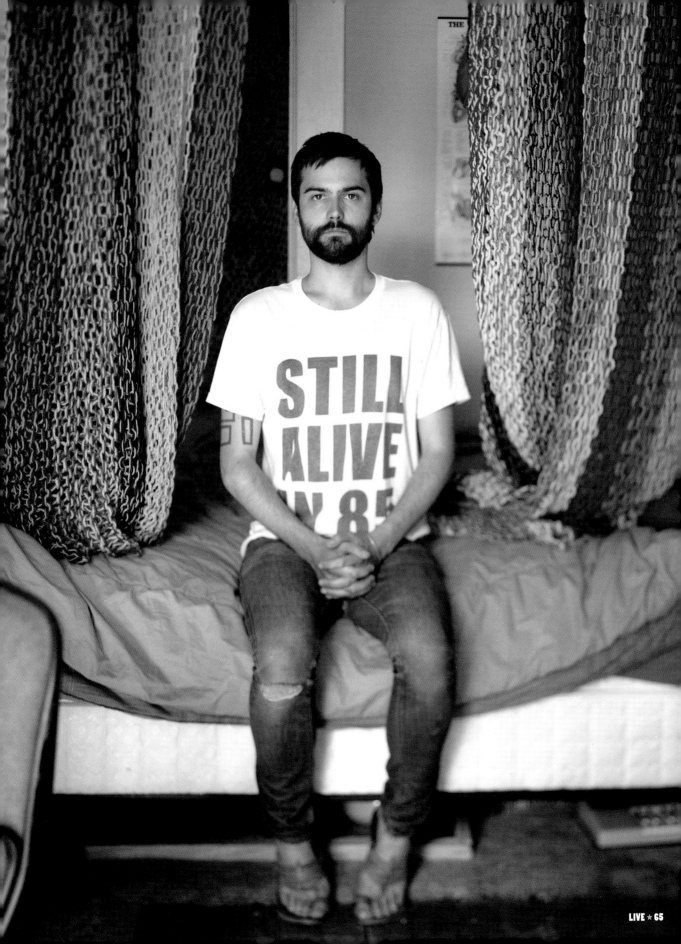

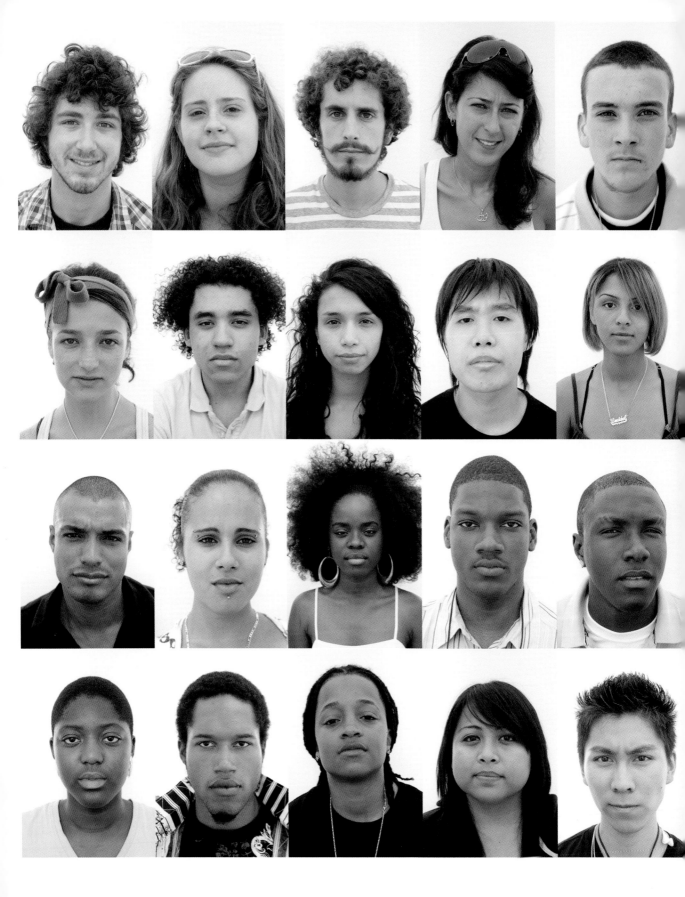

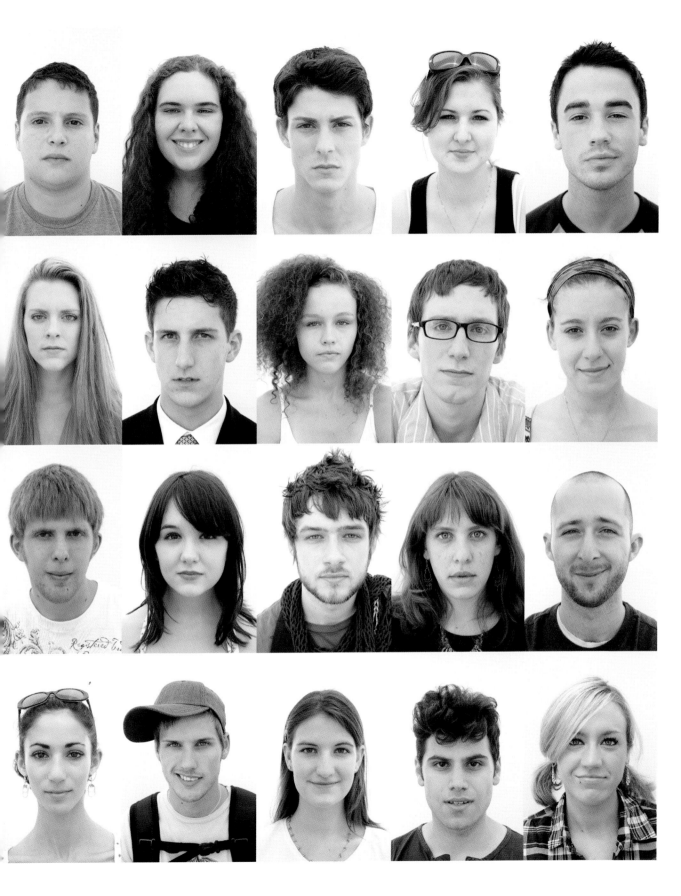

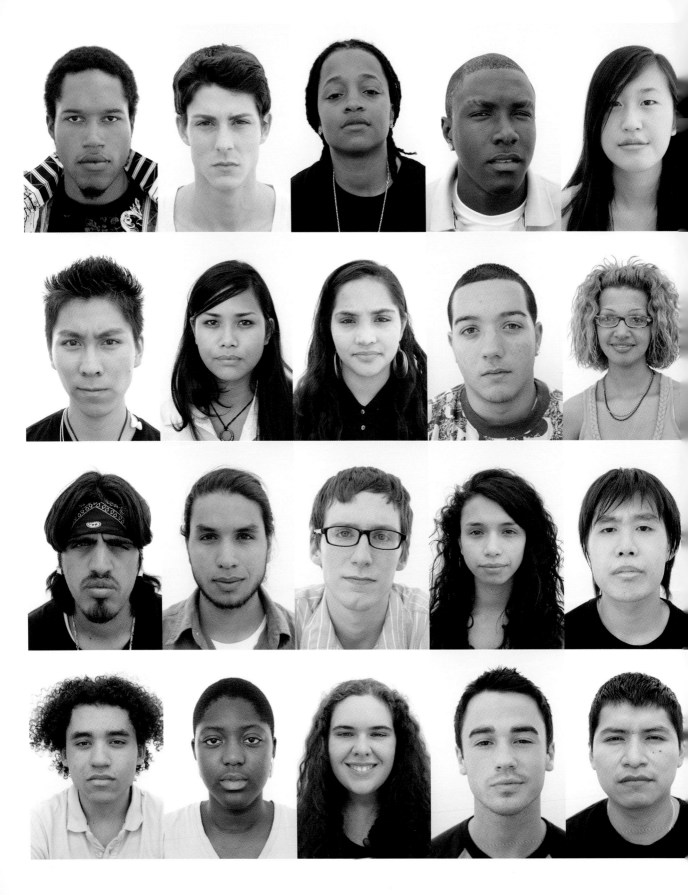

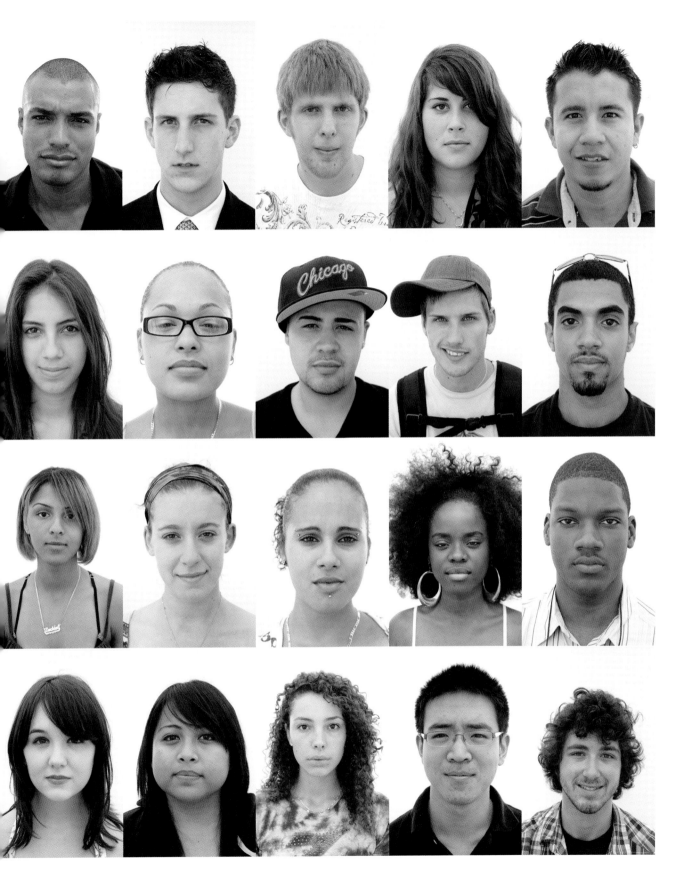

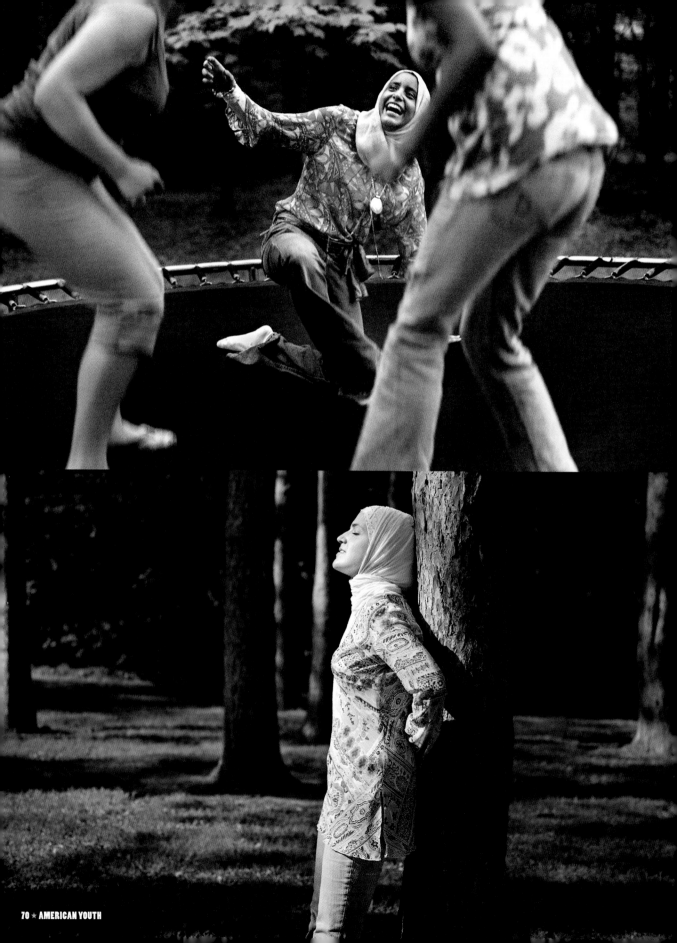

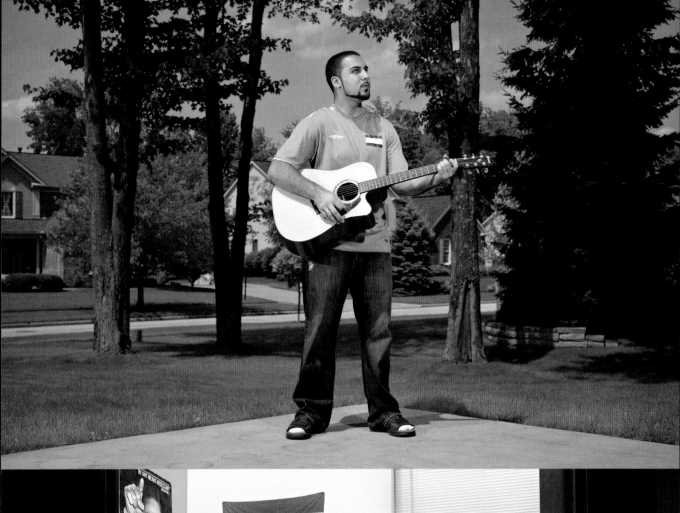

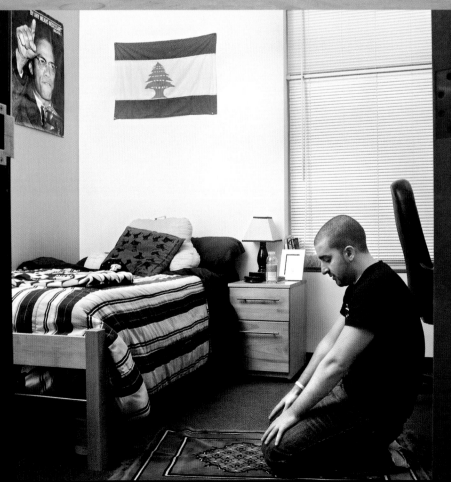

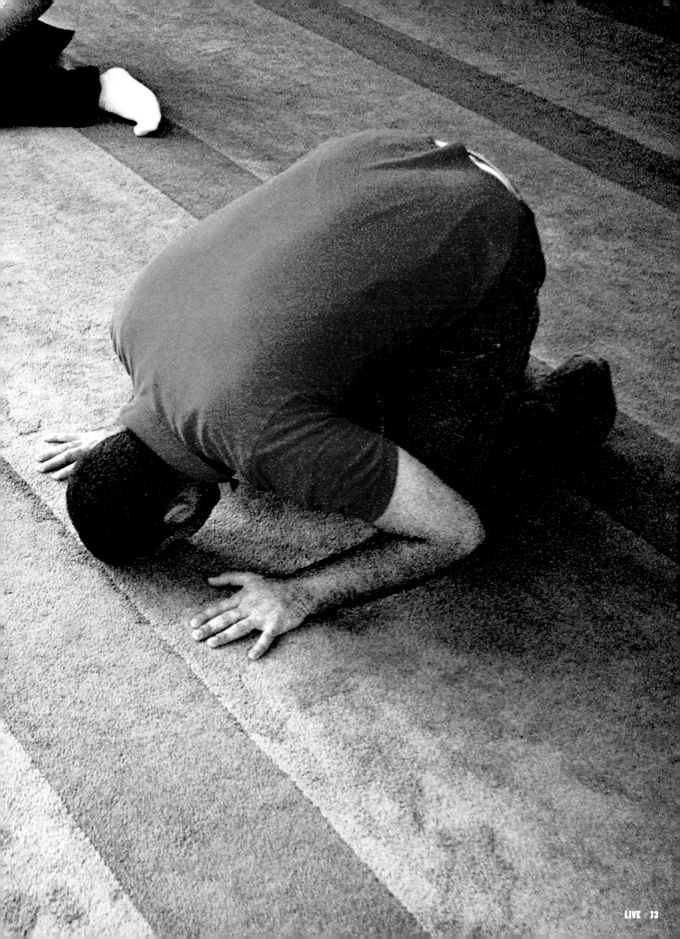

VE

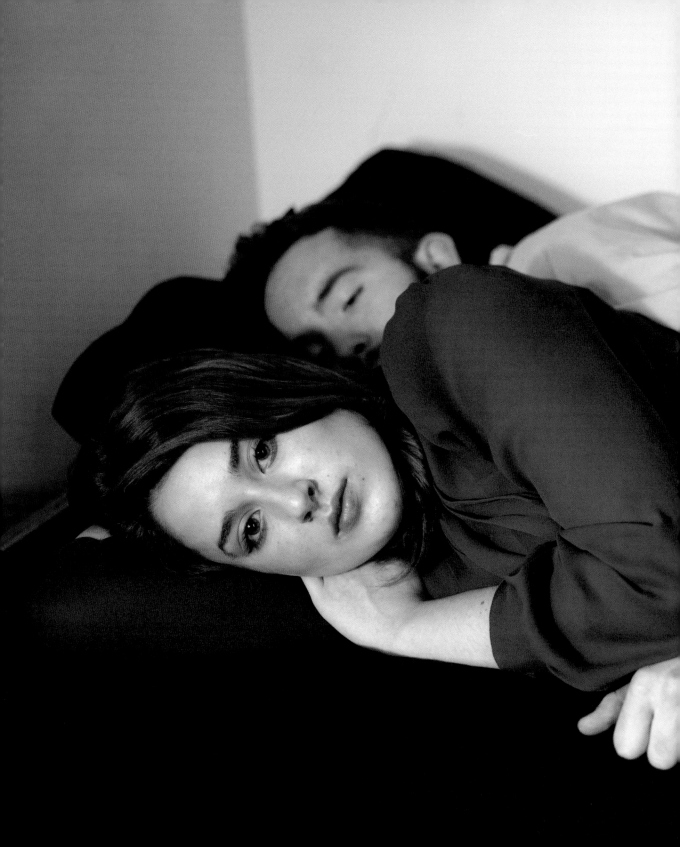

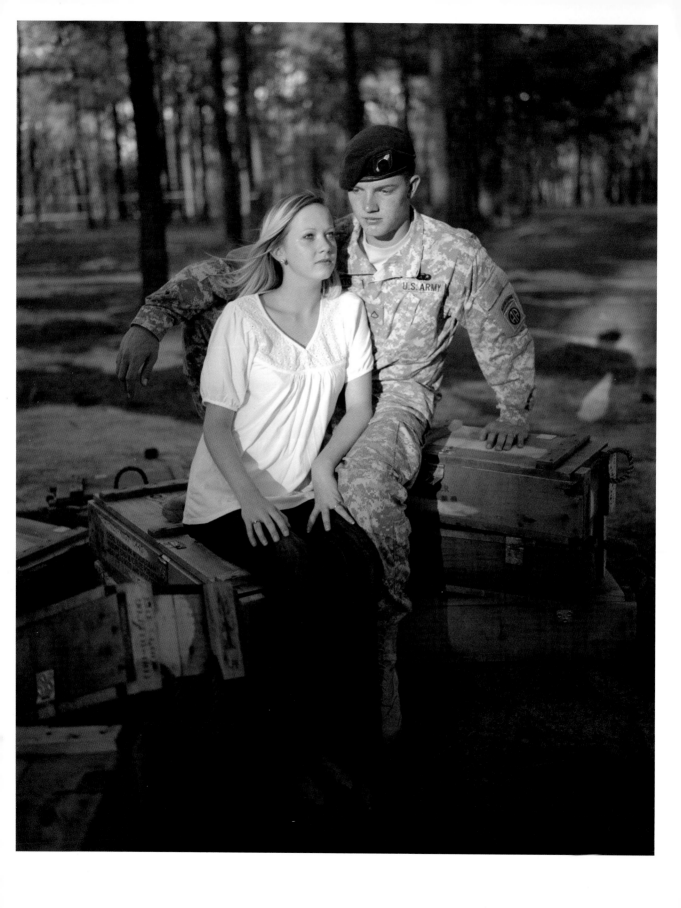

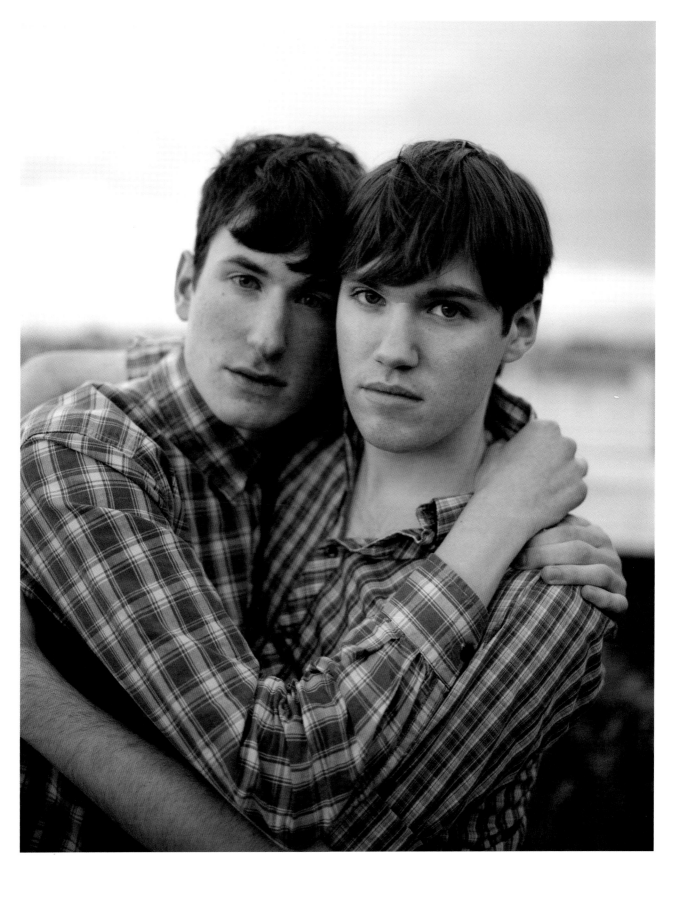

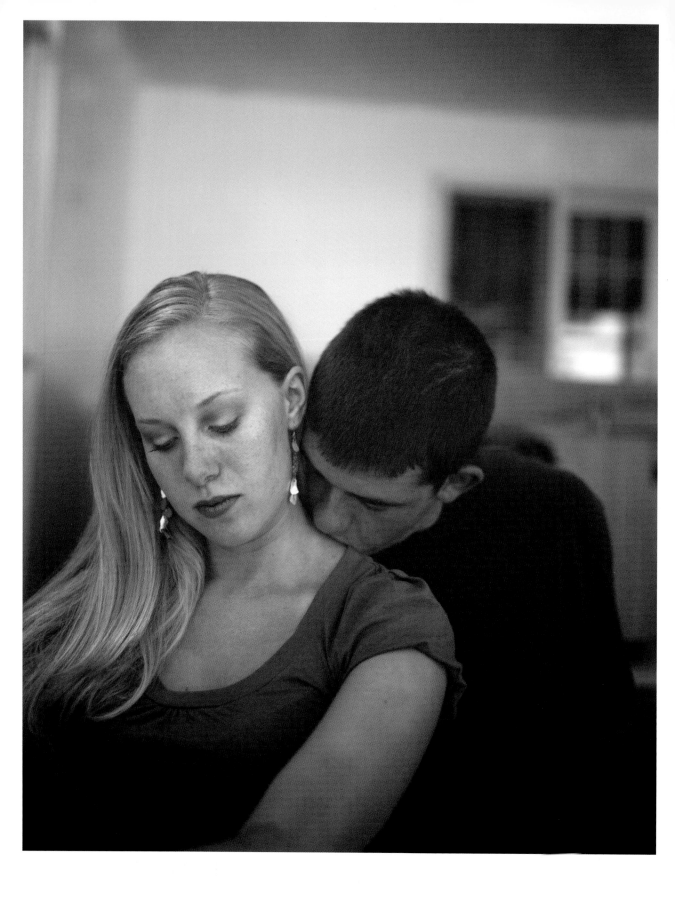

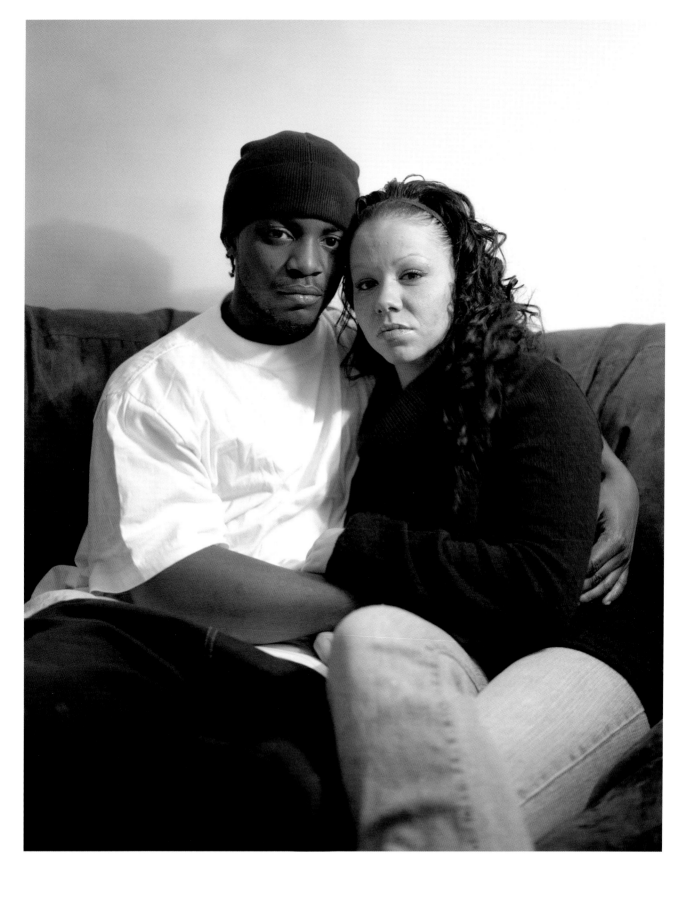

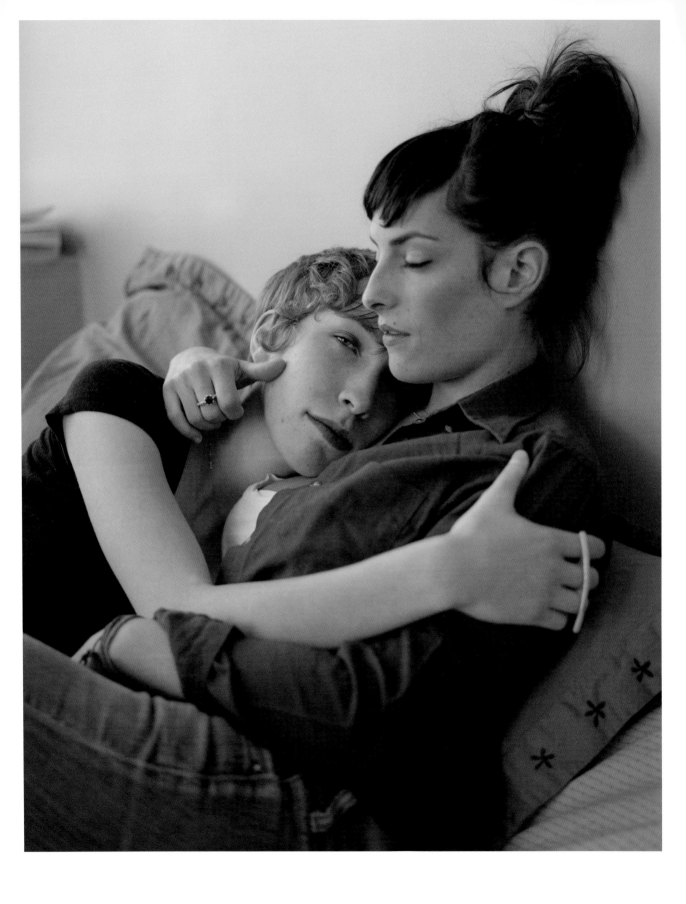

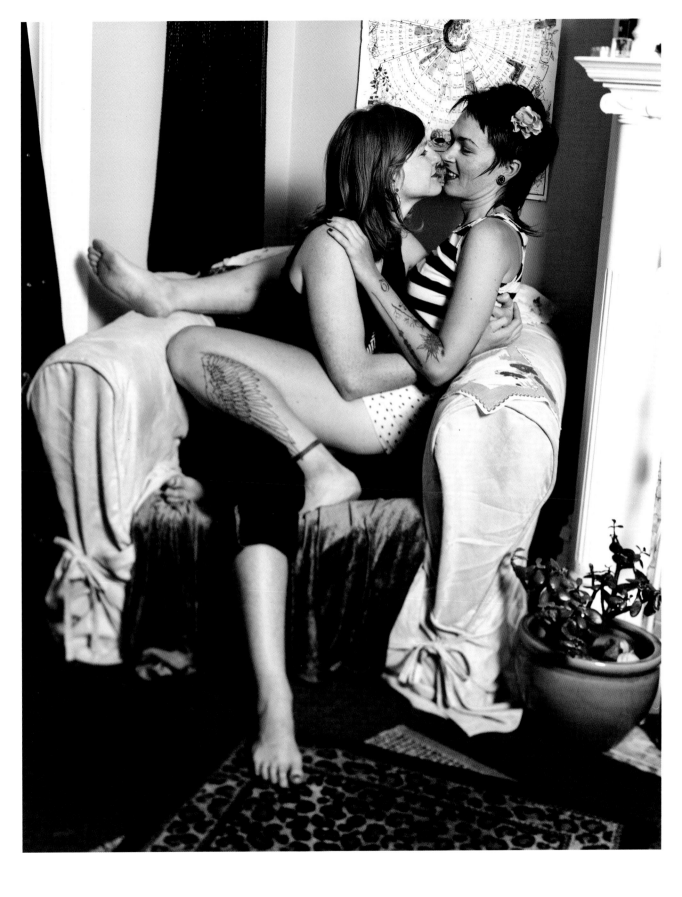

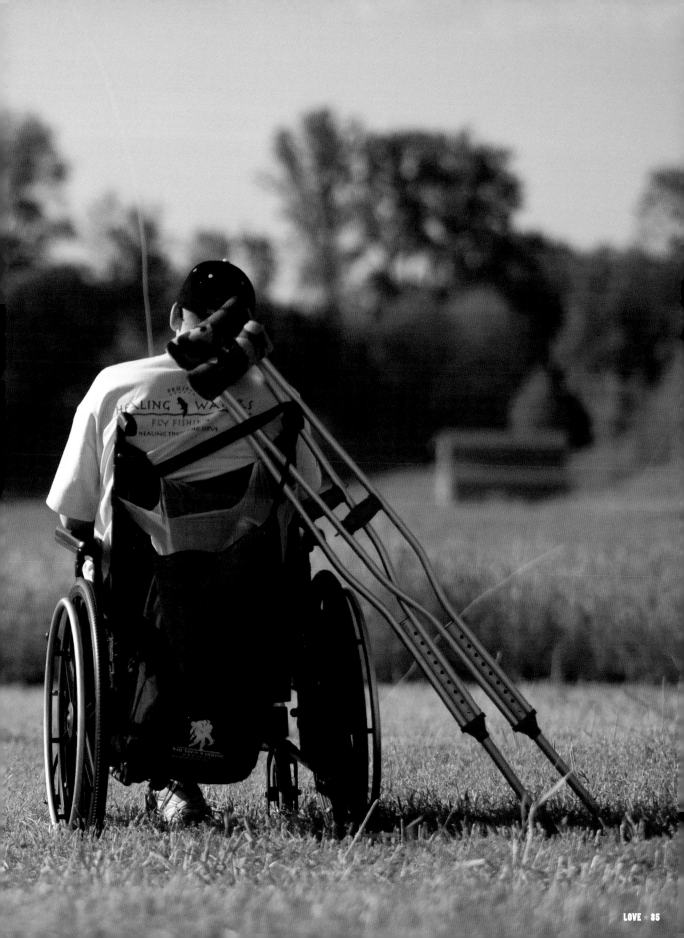

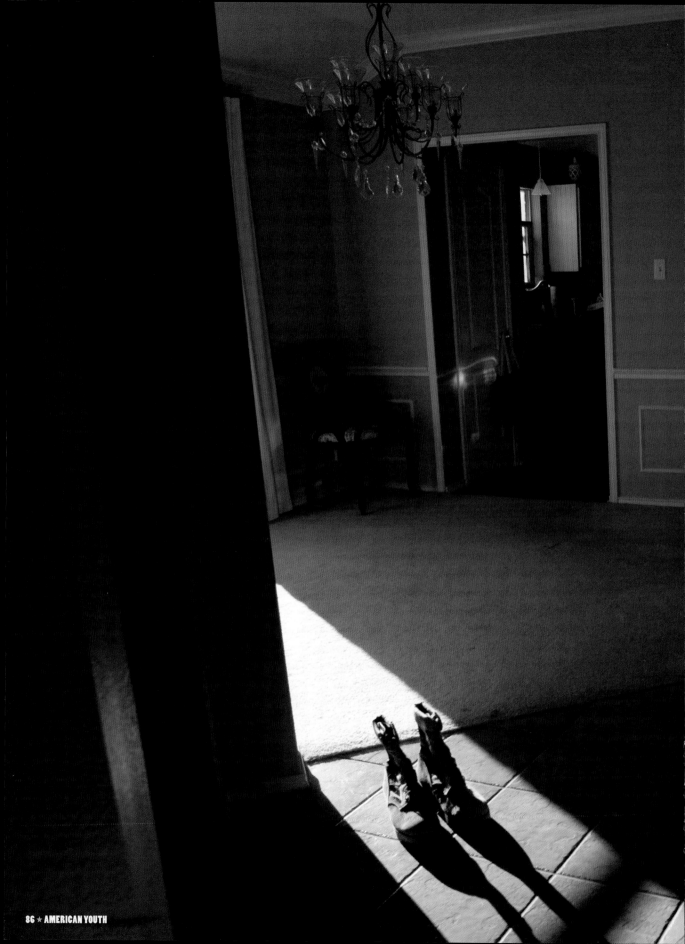

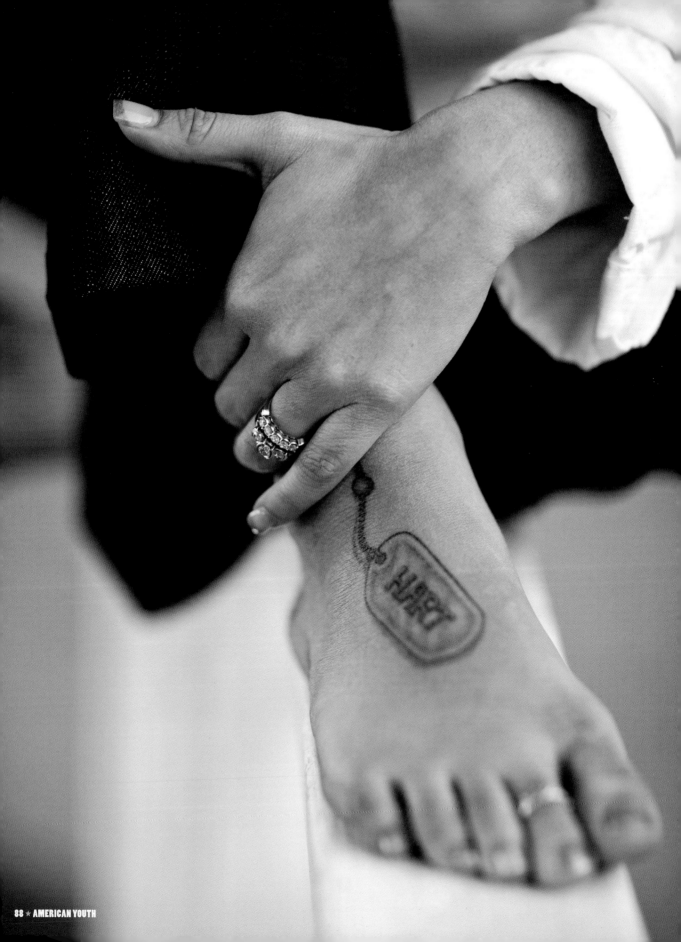

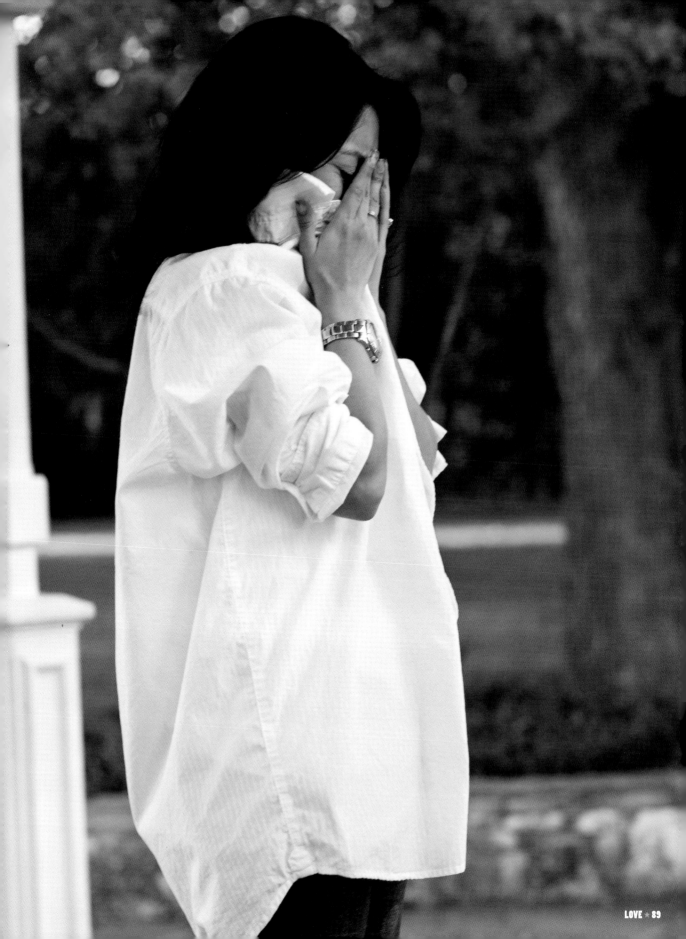

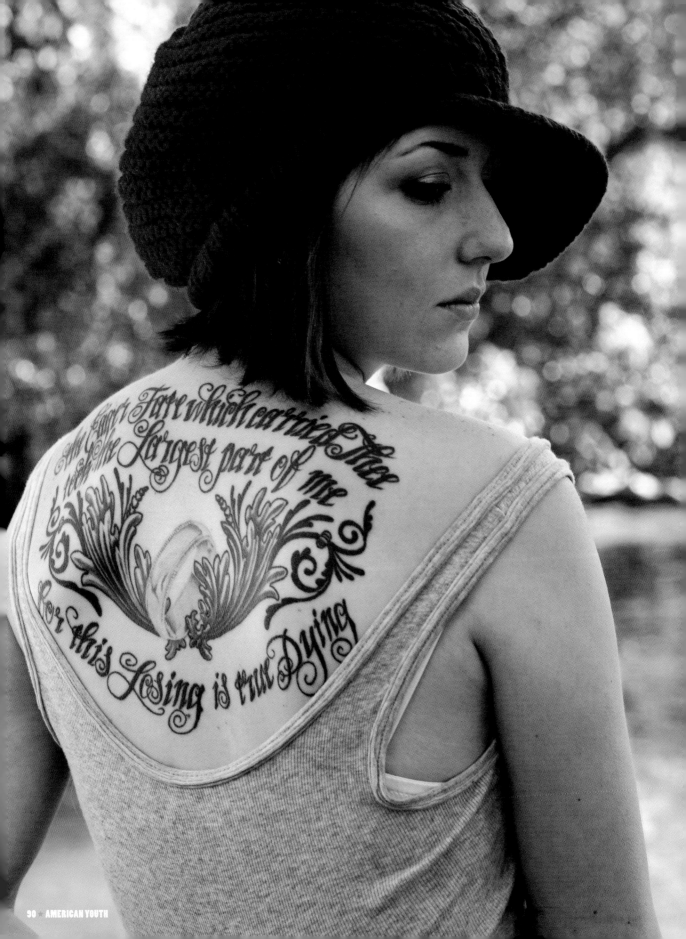

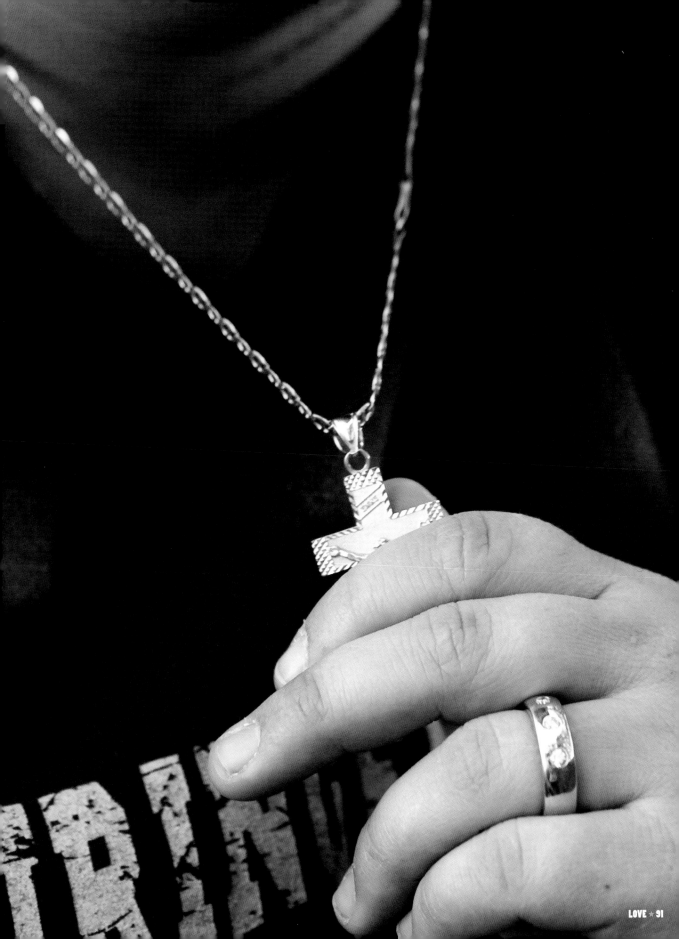

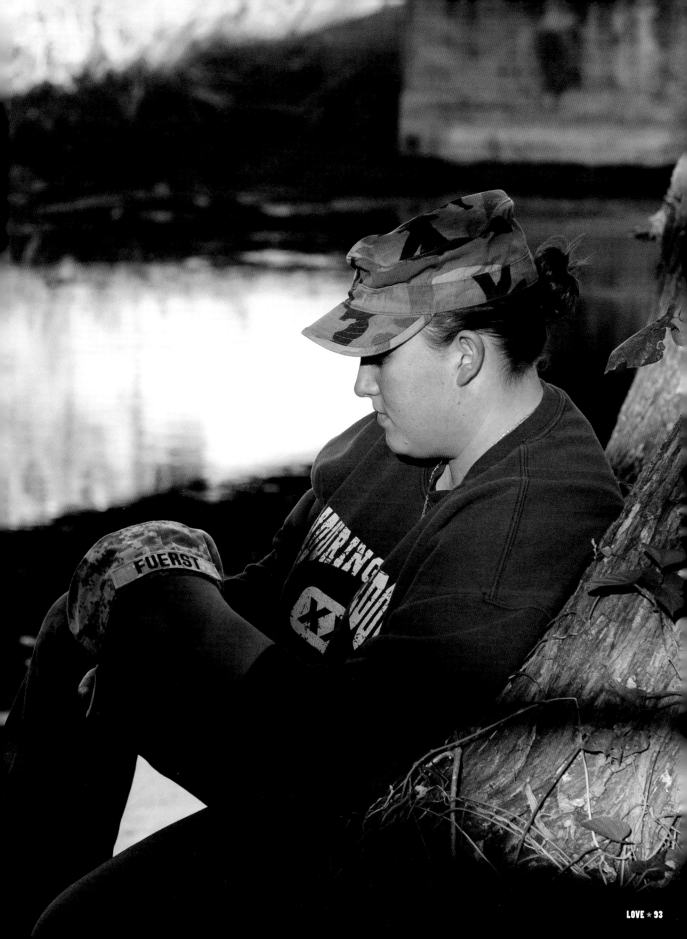

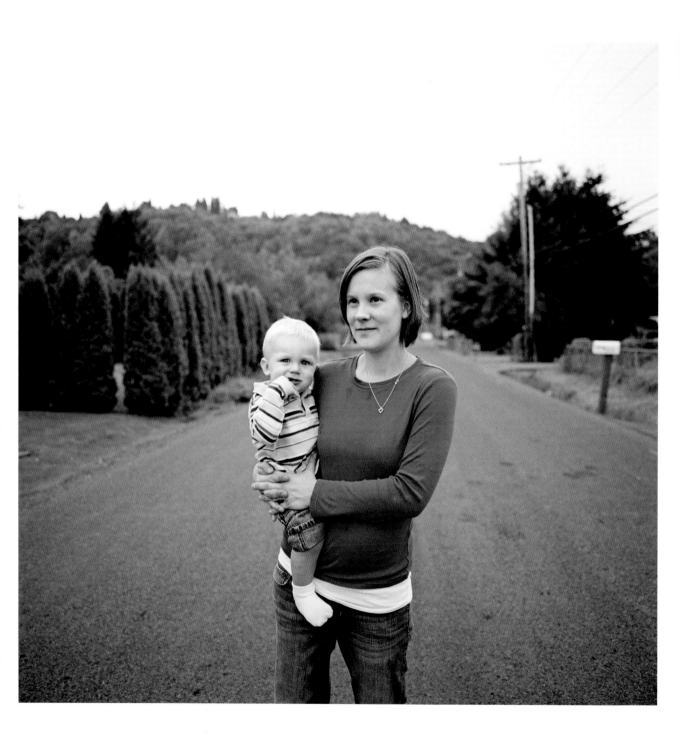

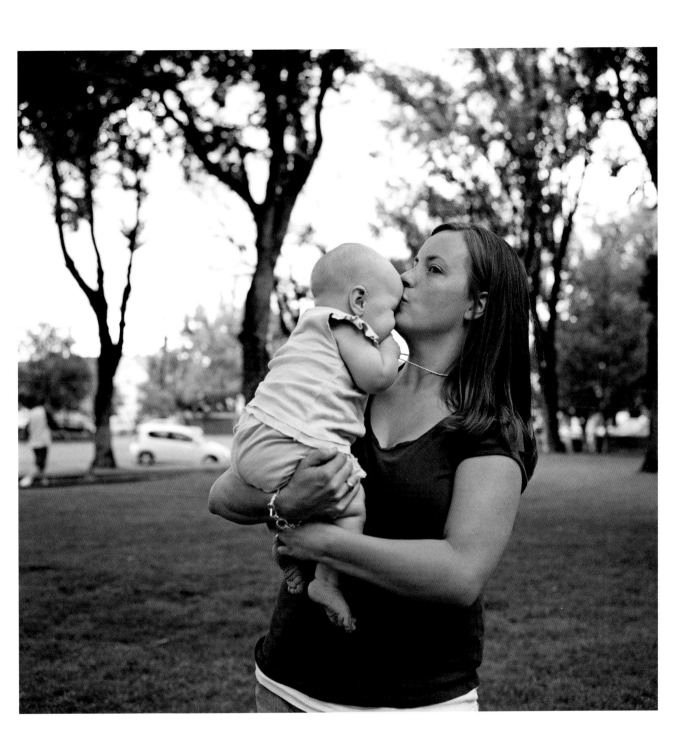

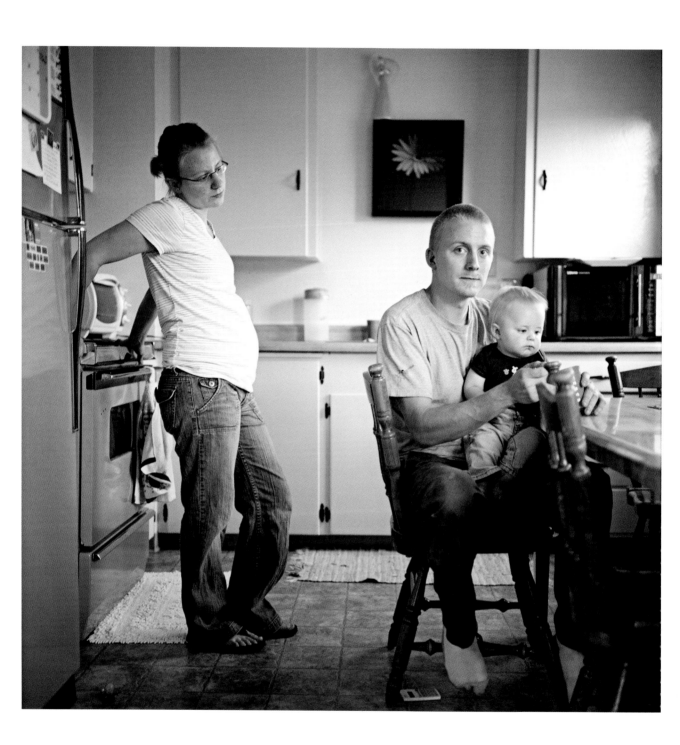

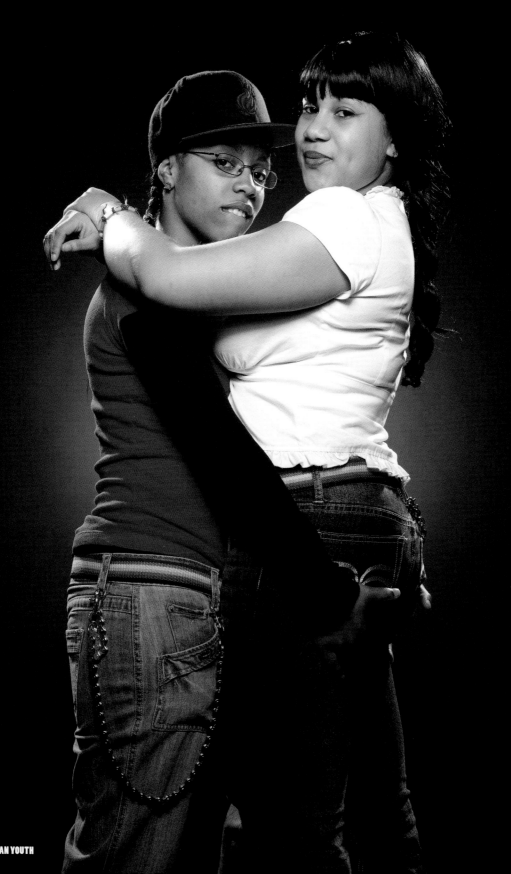

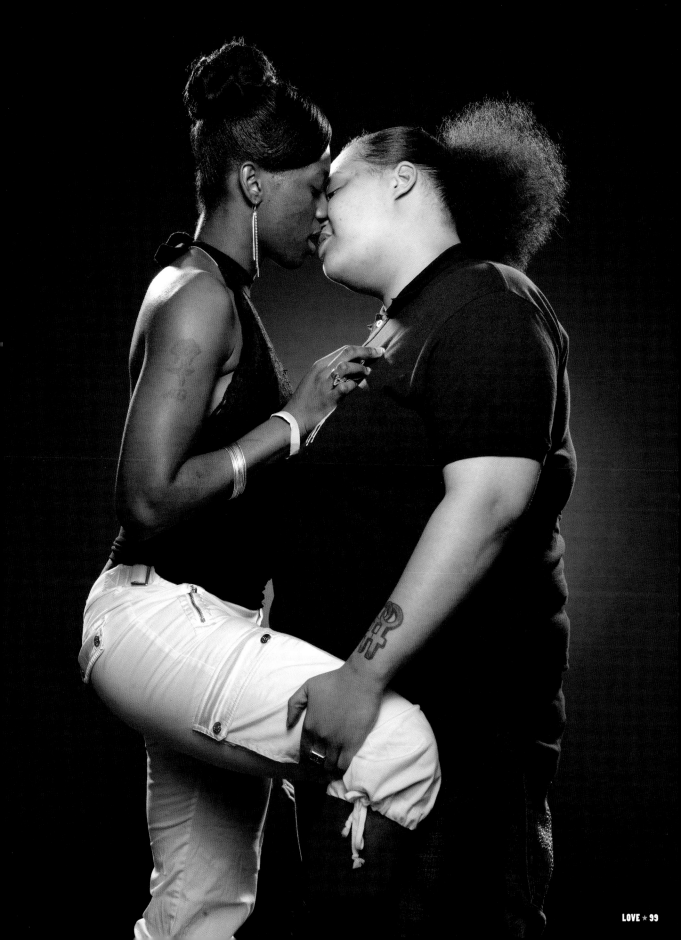

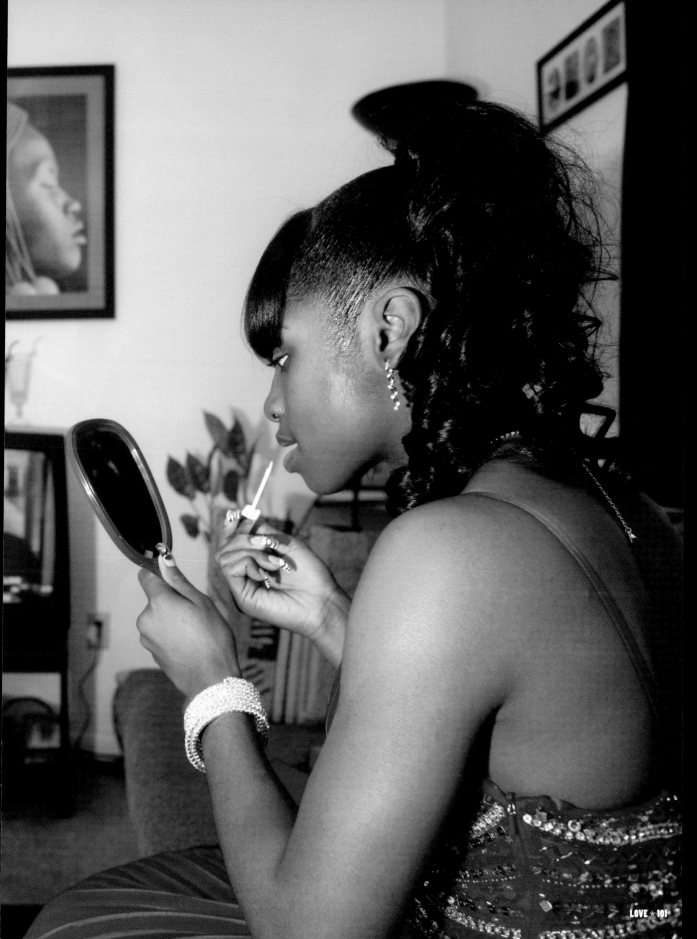

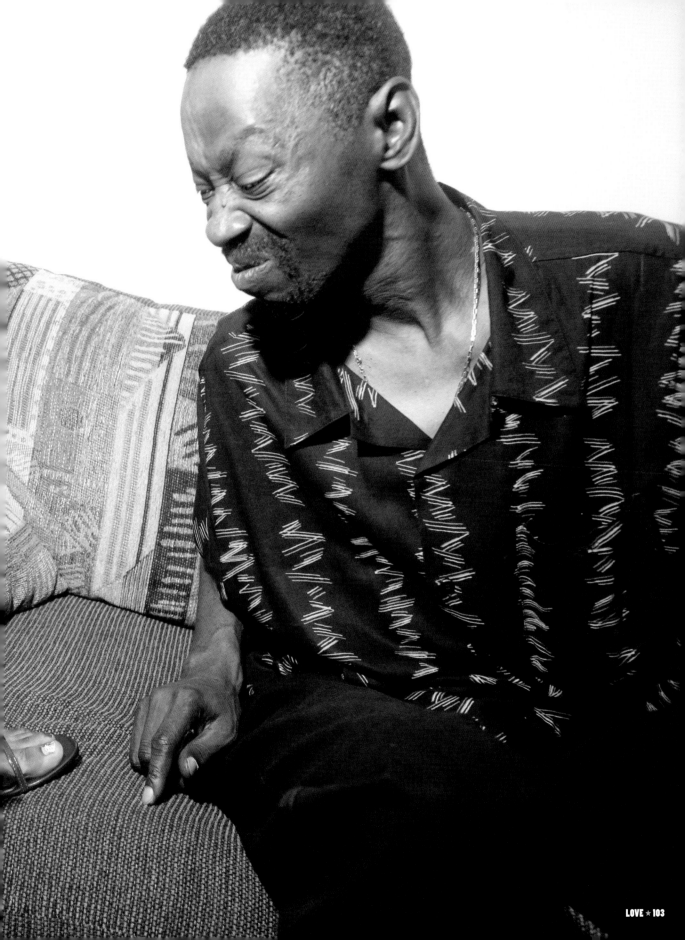

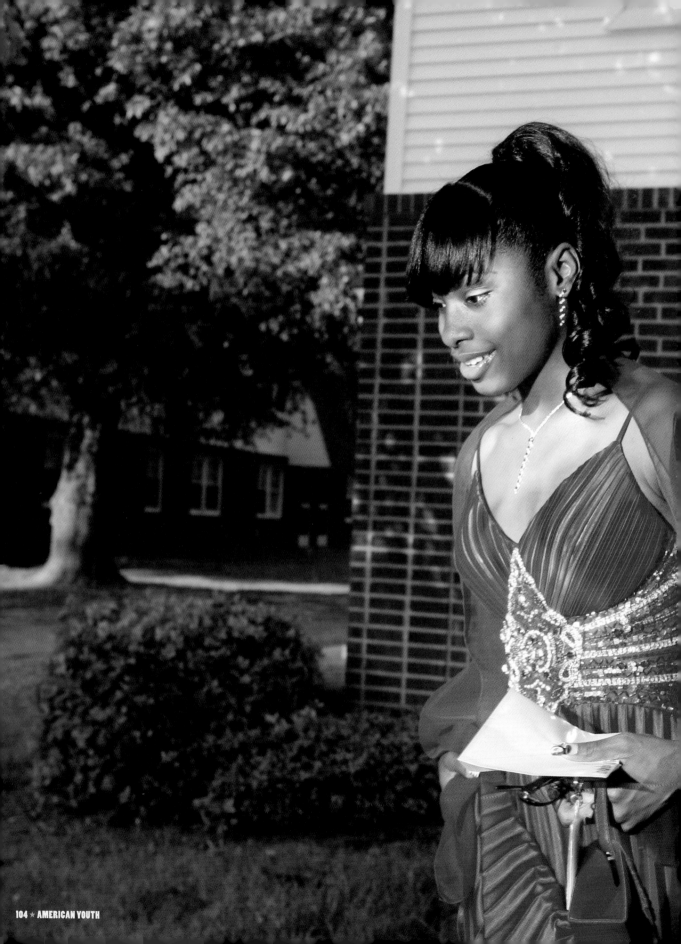

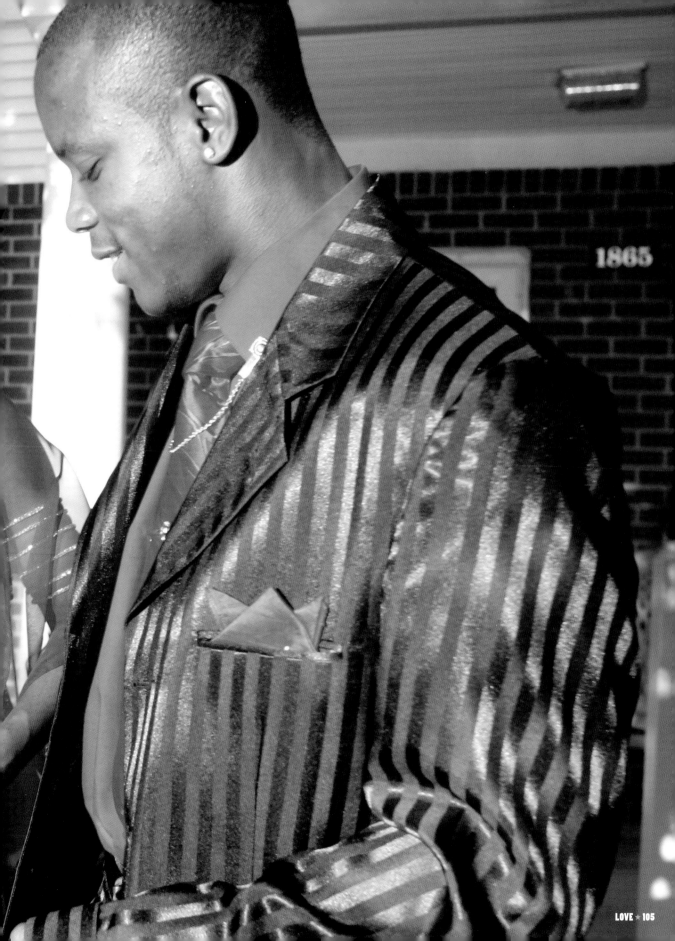

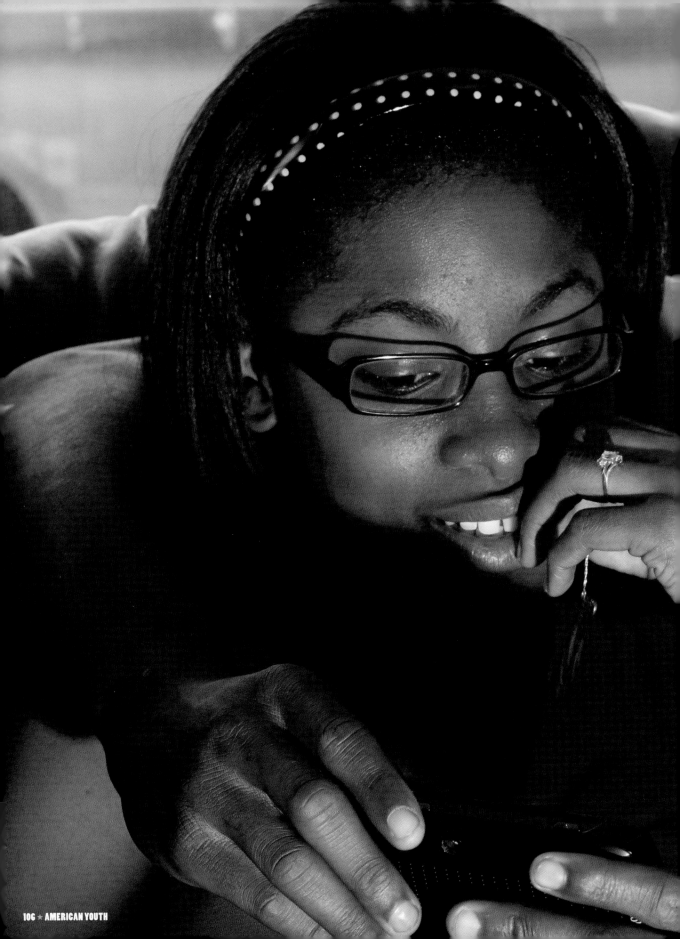

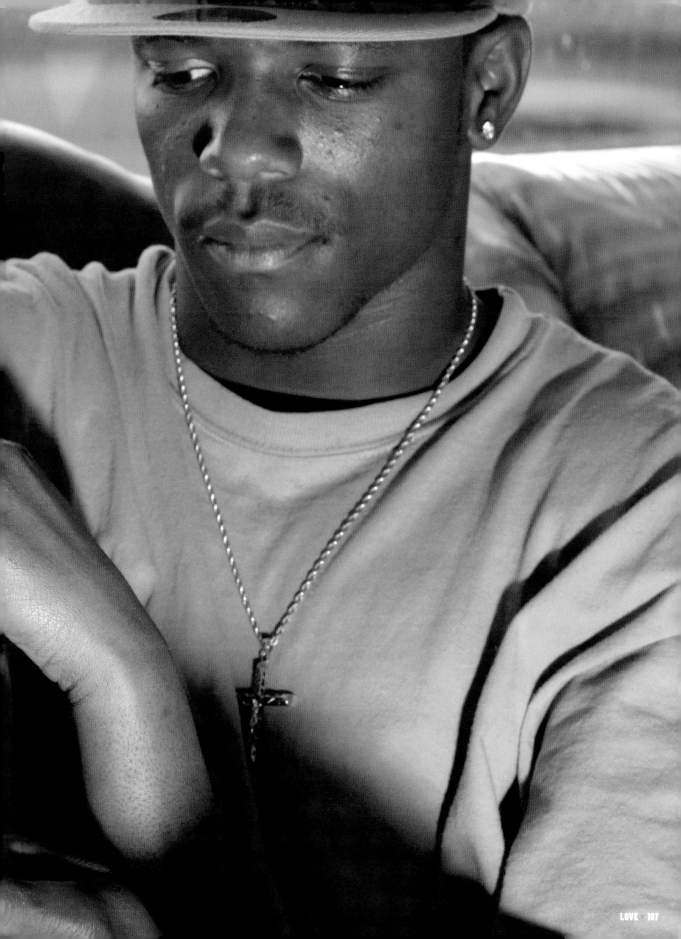

RK

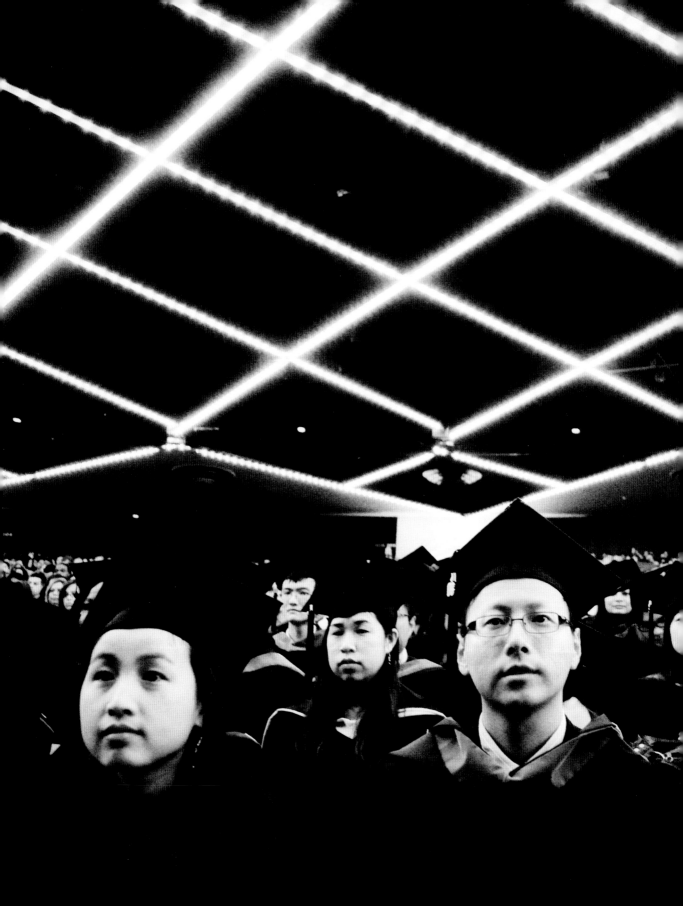

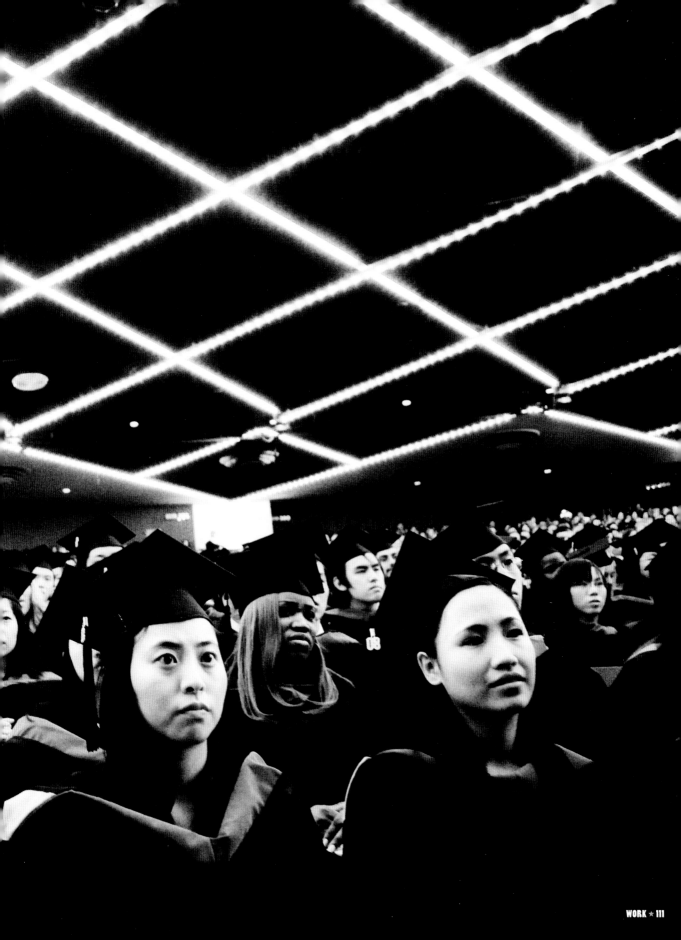

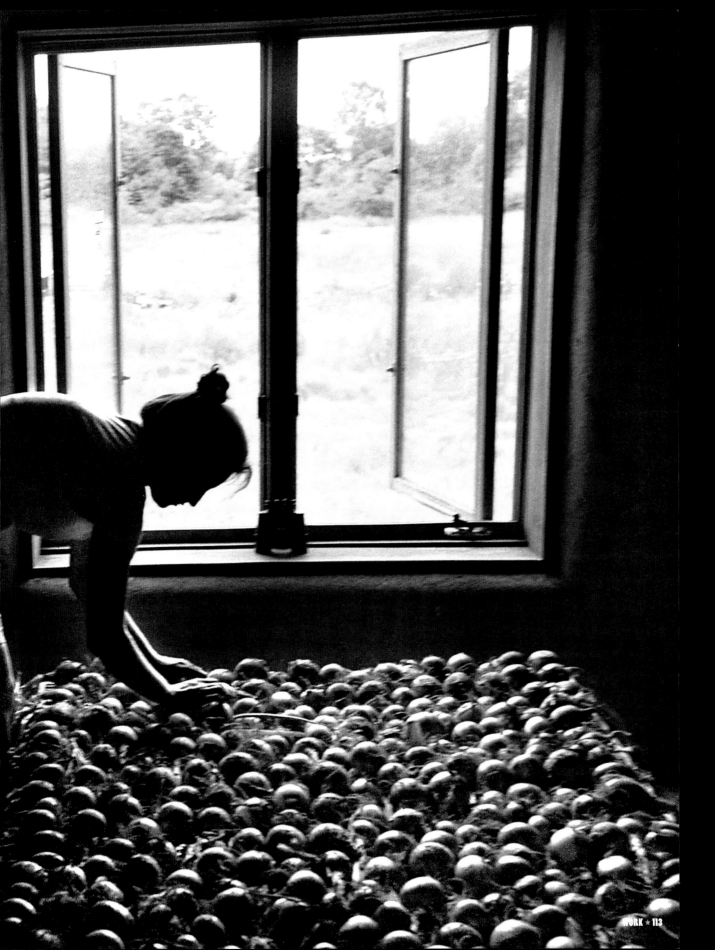

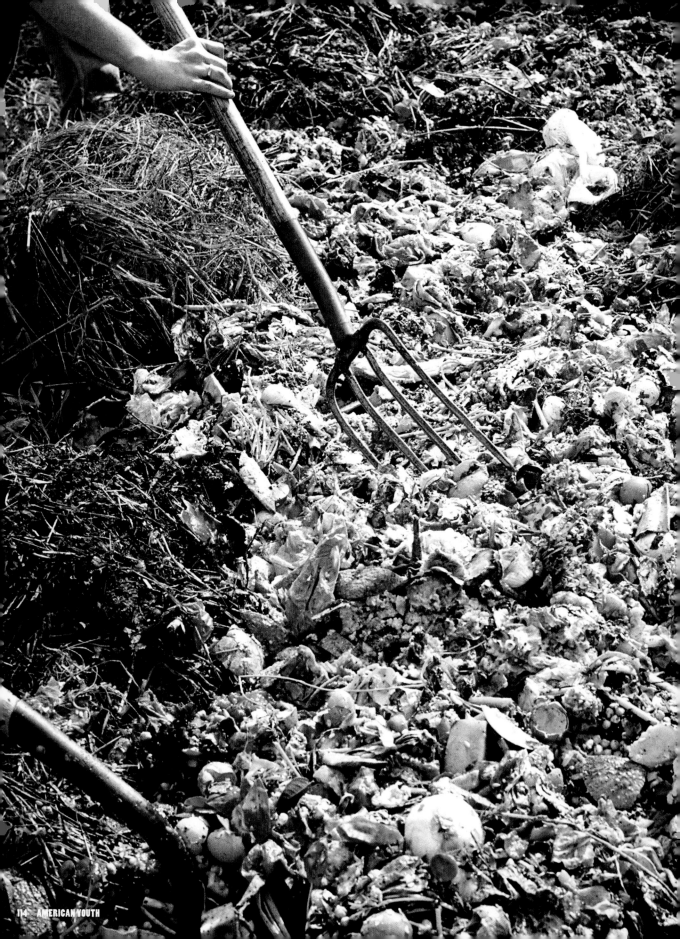

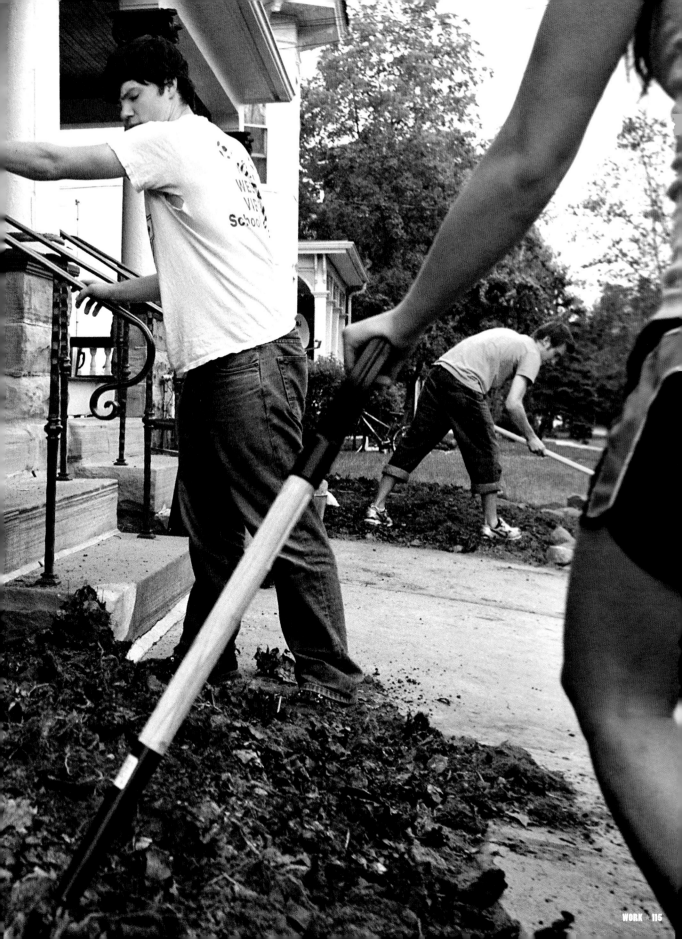

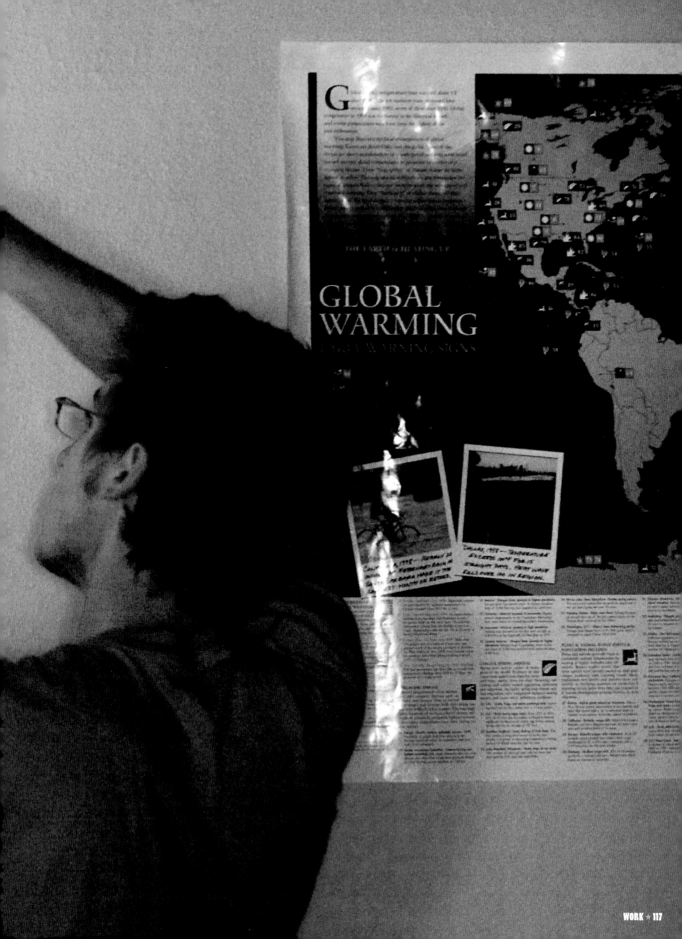

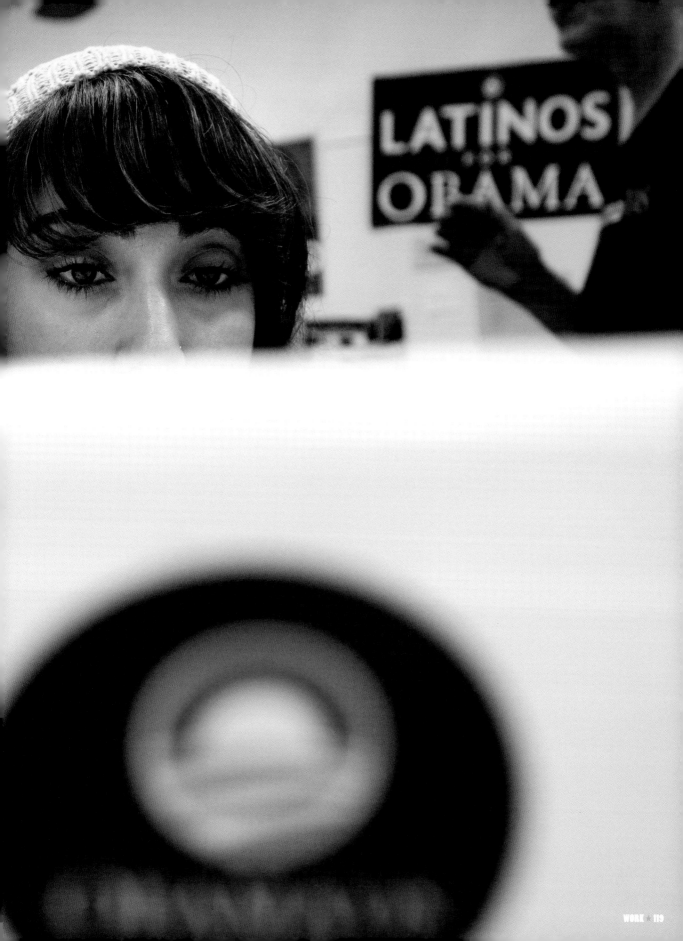

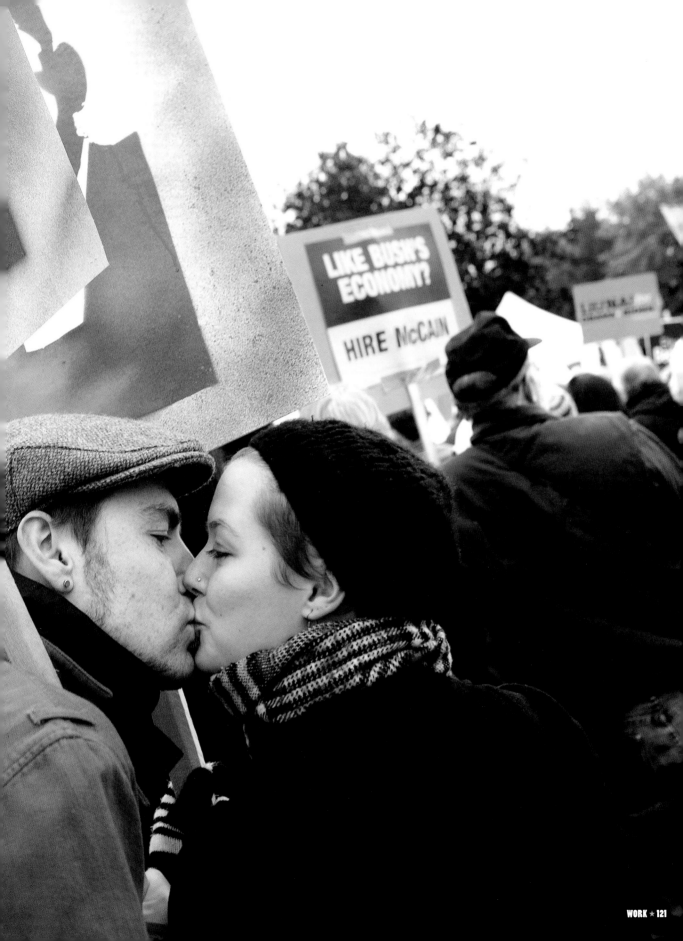

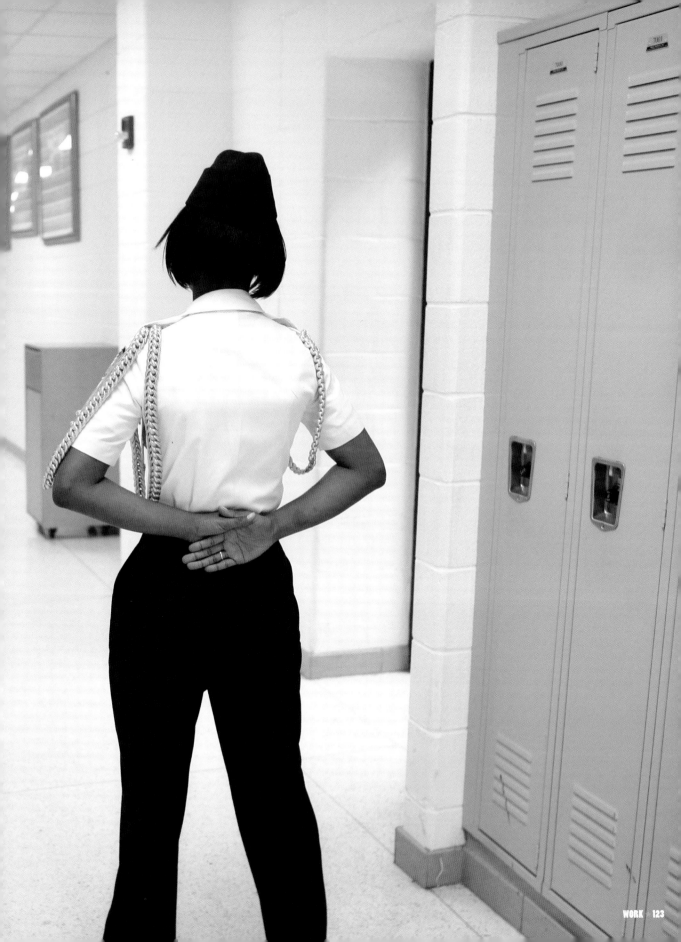

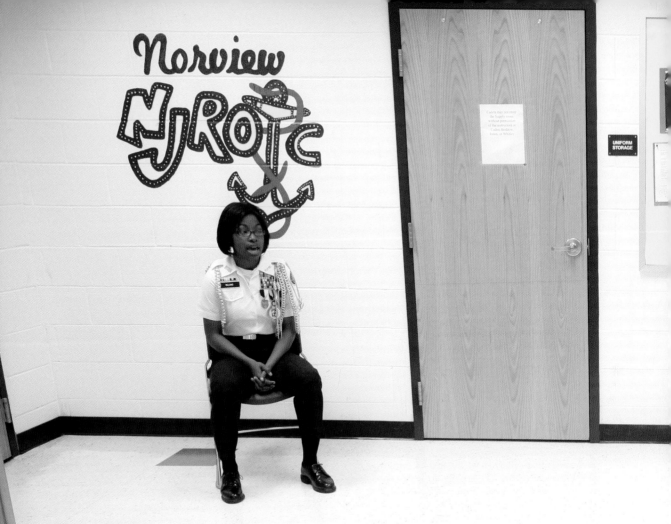

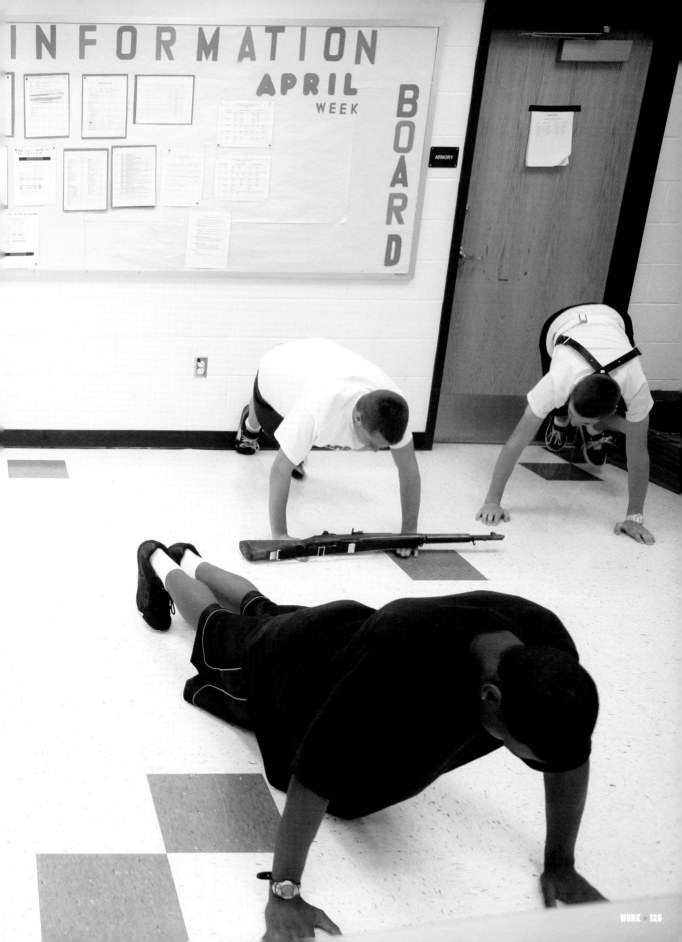

INFORMATION
APRIL
WEEK

BOARD

ARMORY

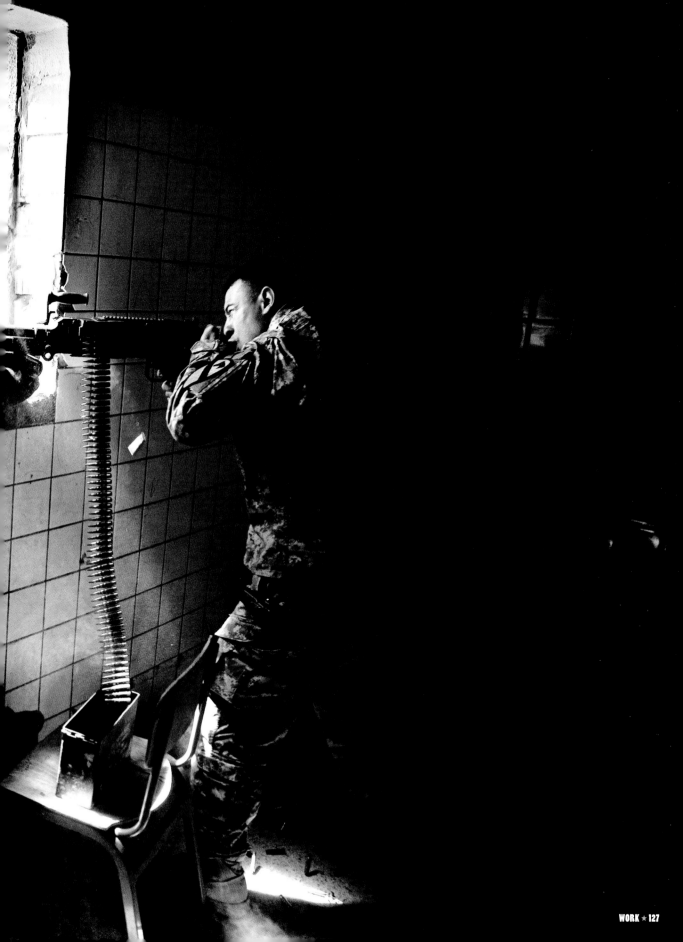

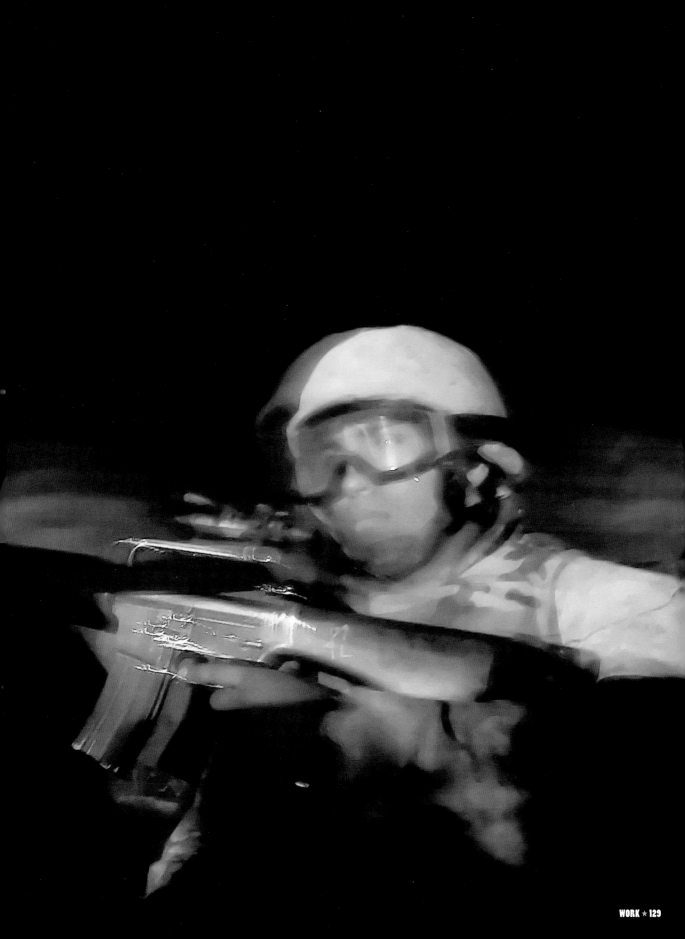

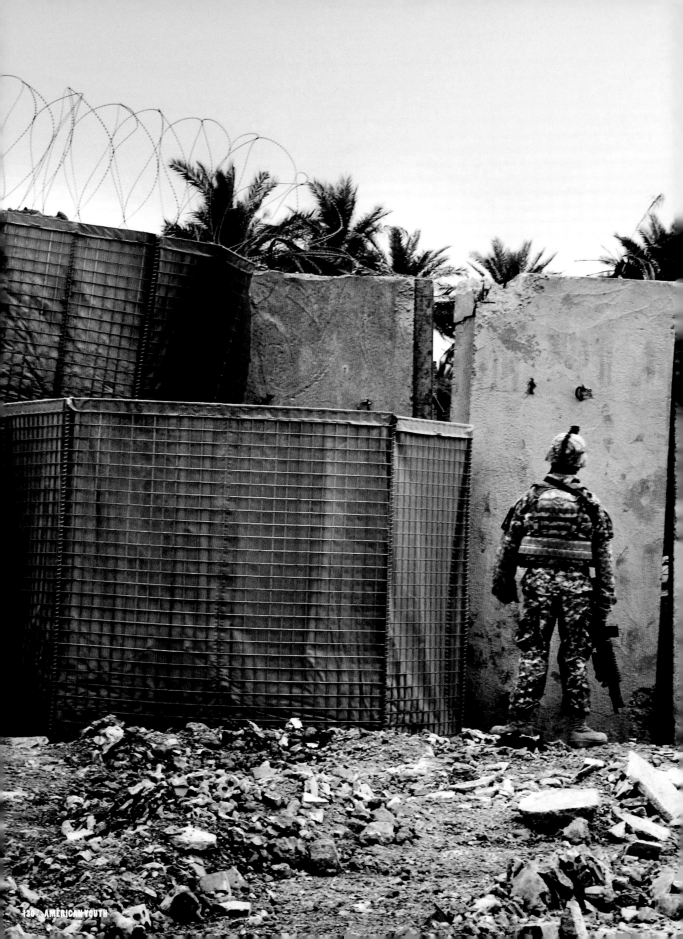

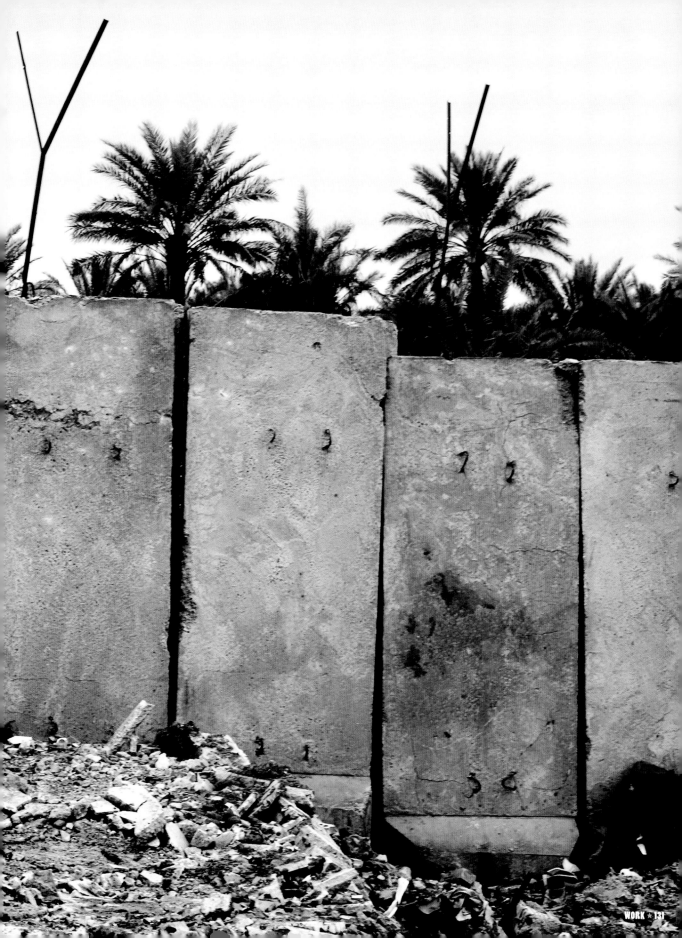

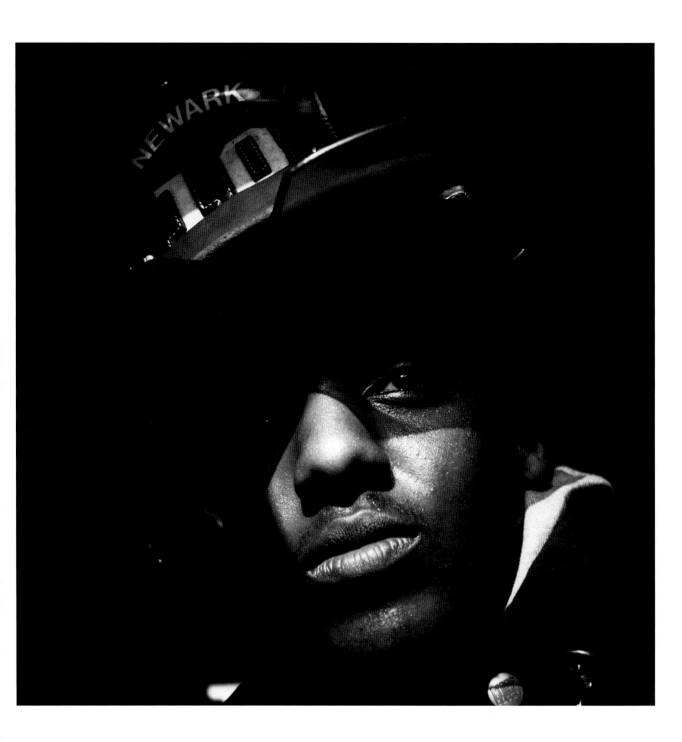

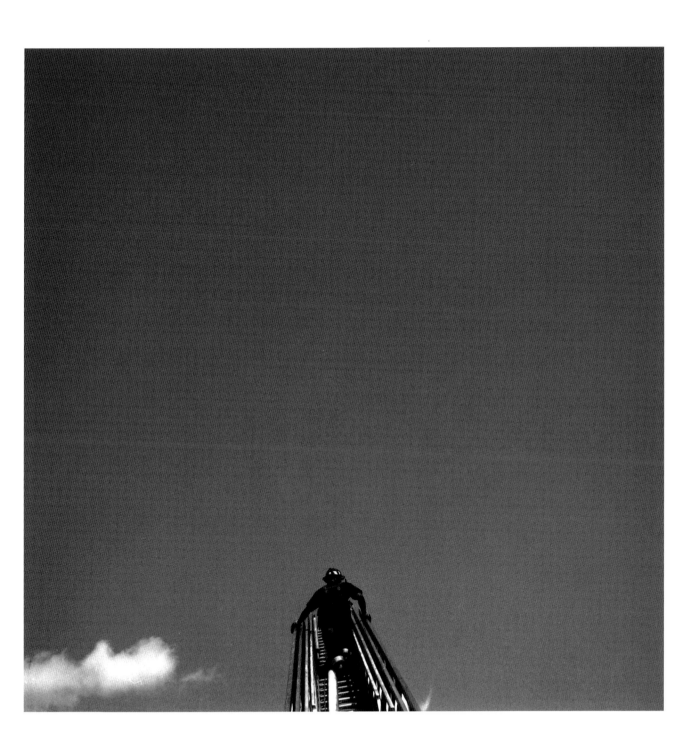

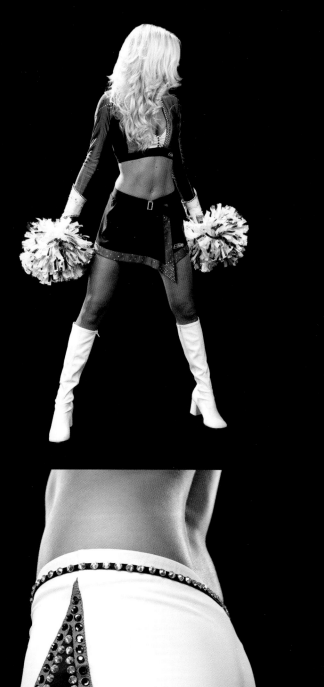

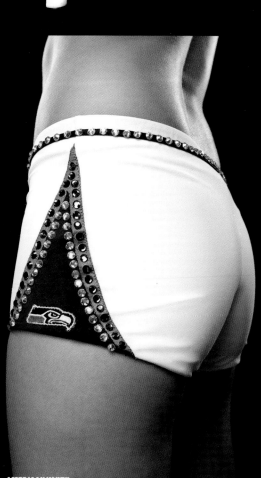
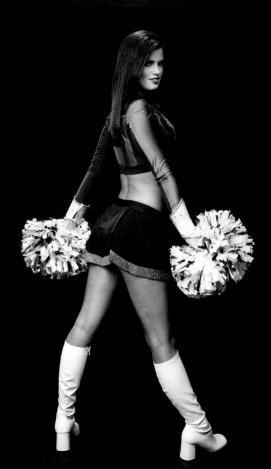

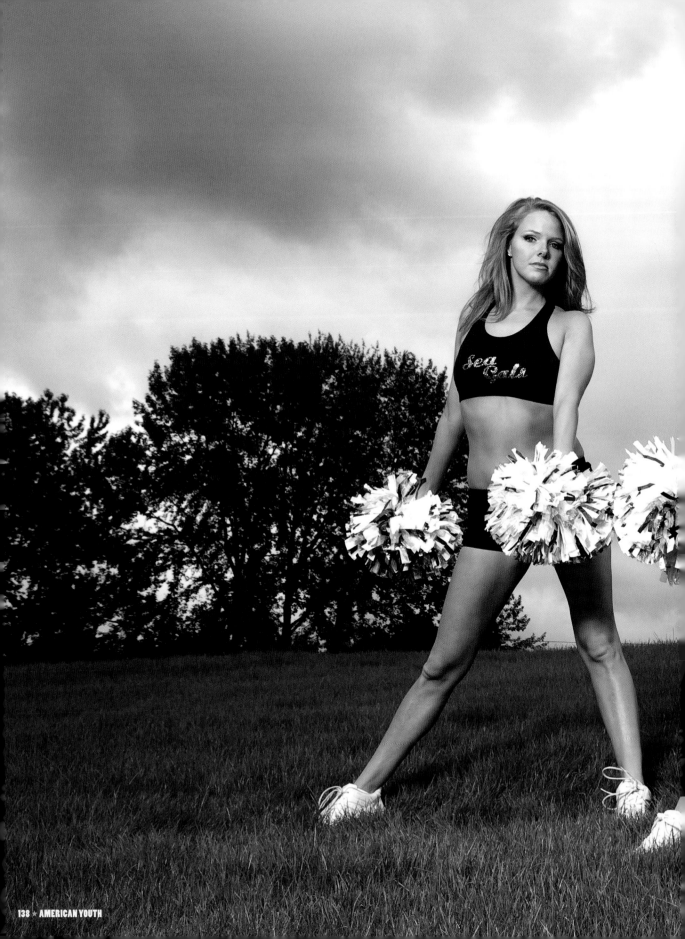

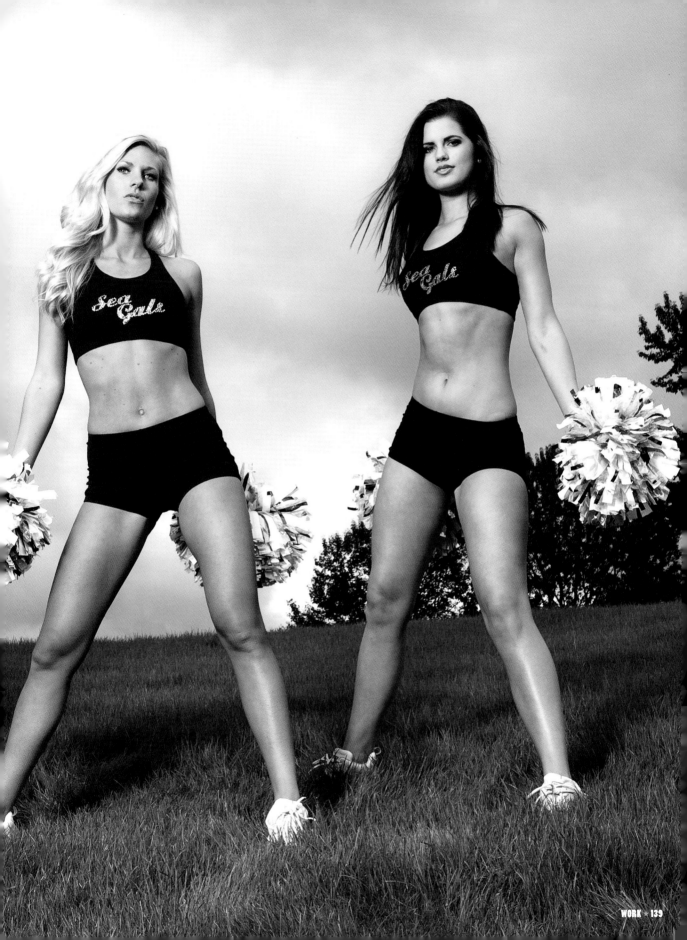

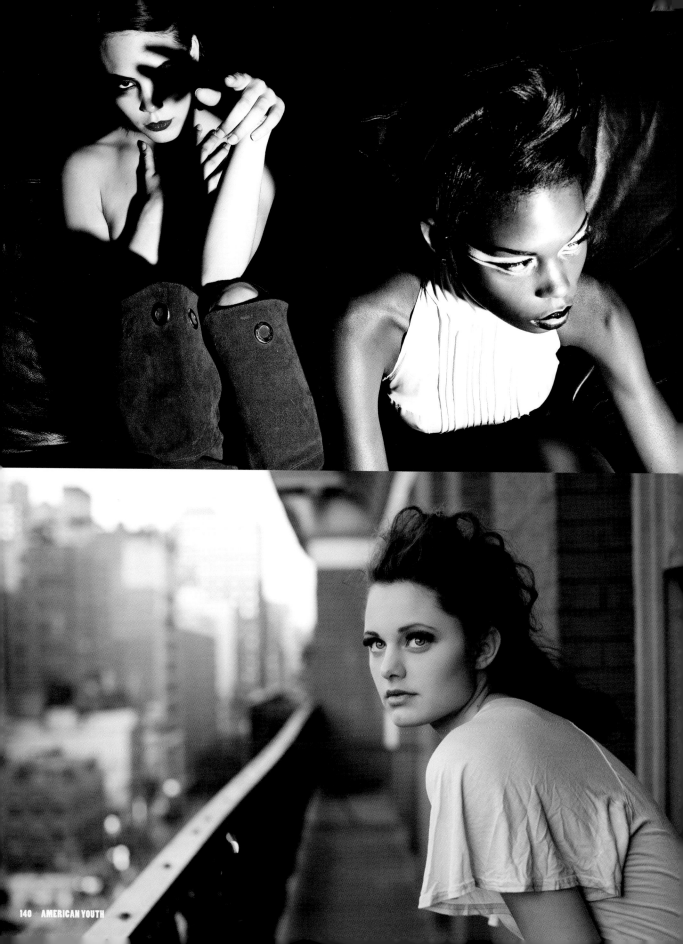

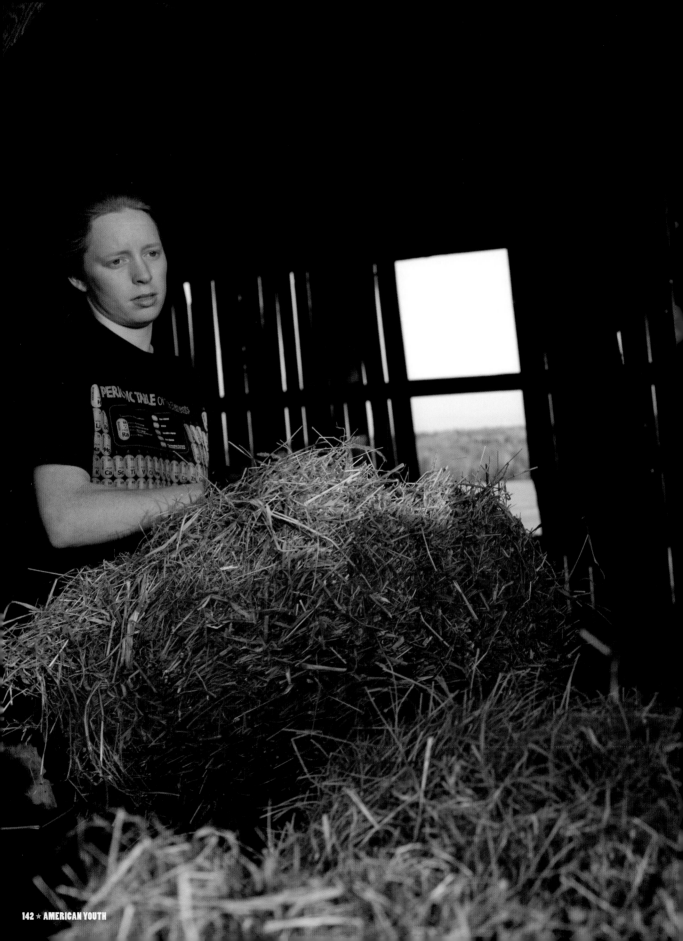

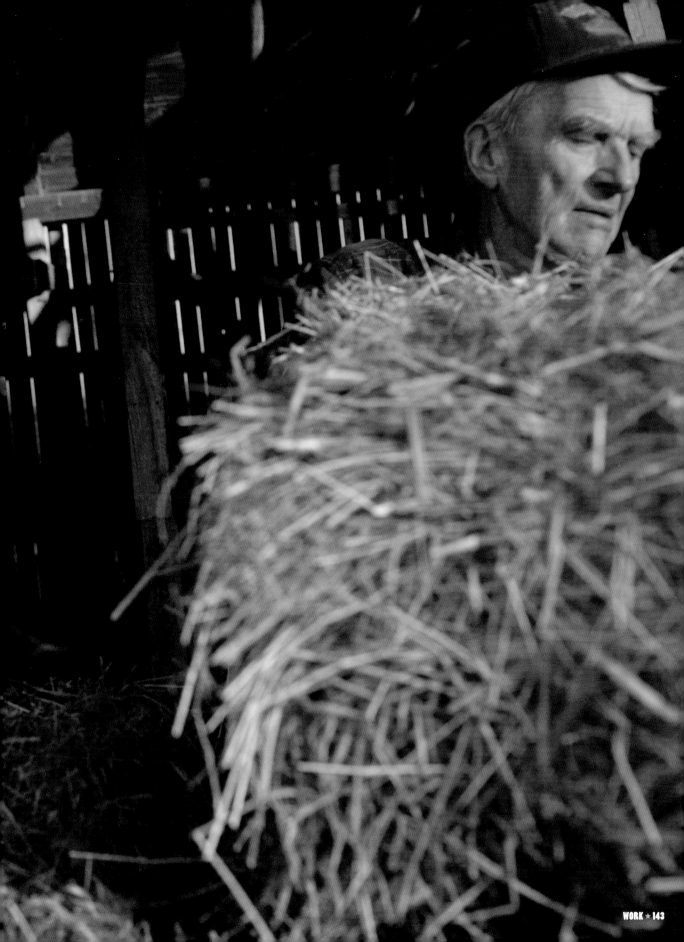

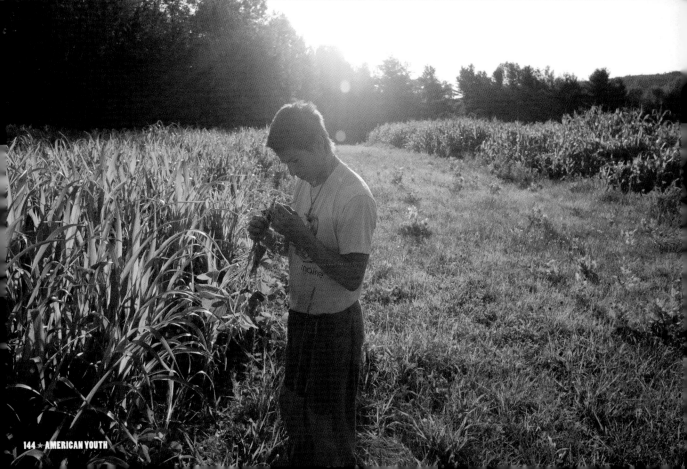

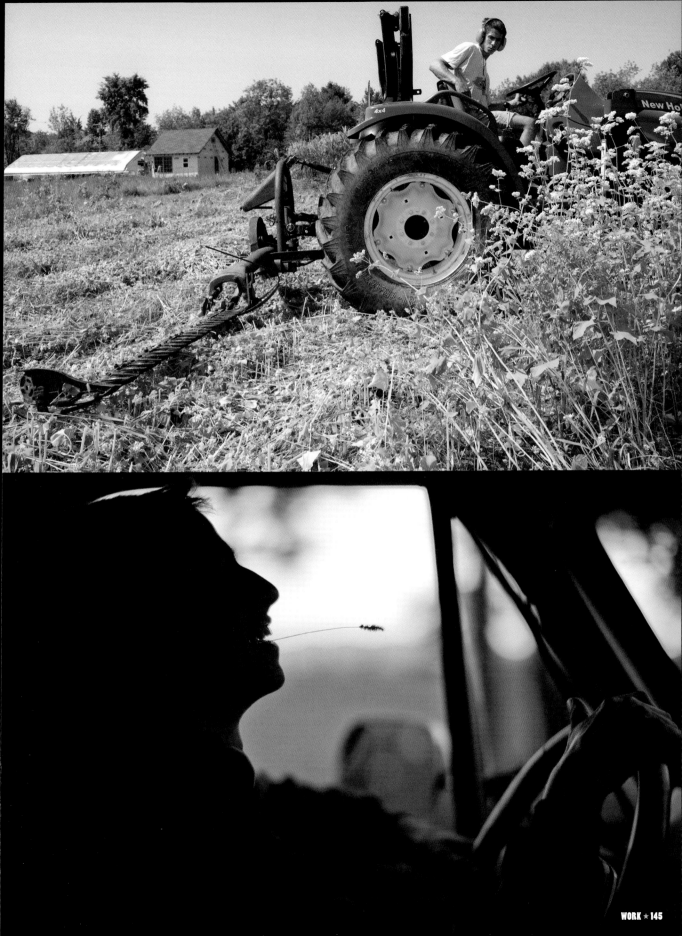

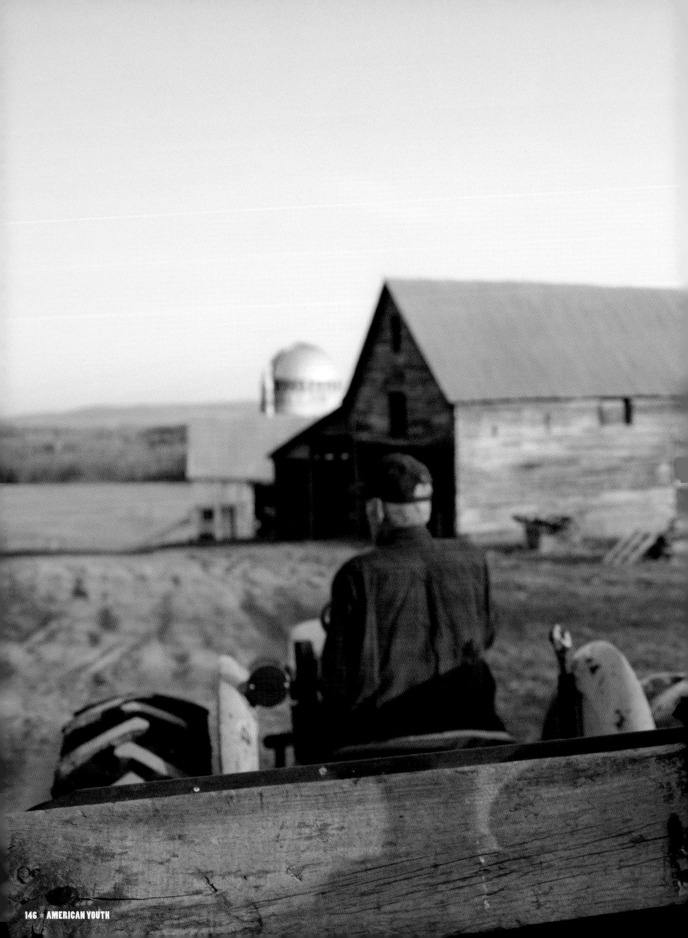

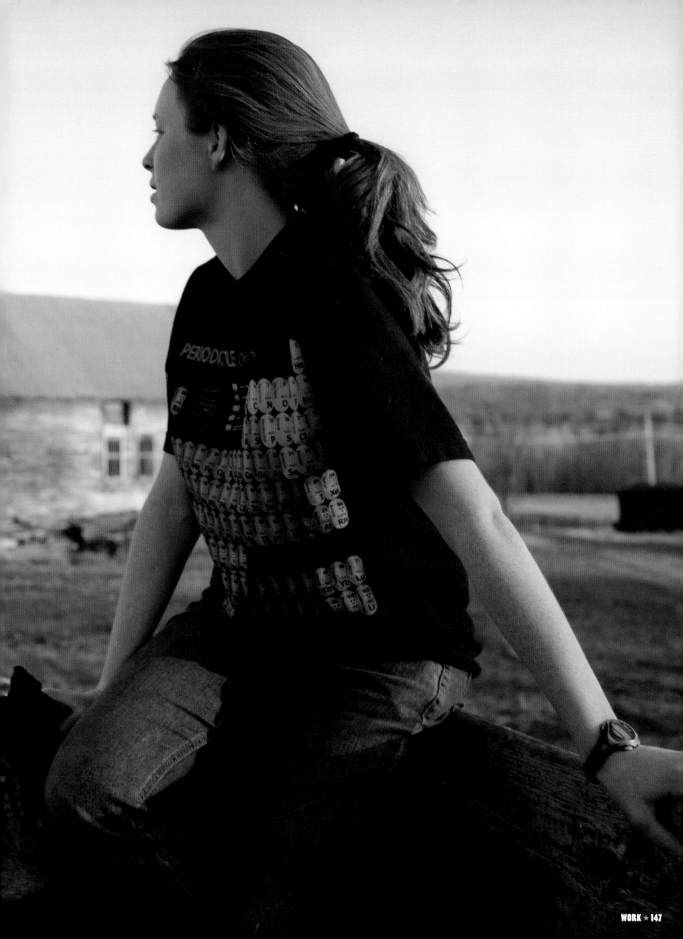

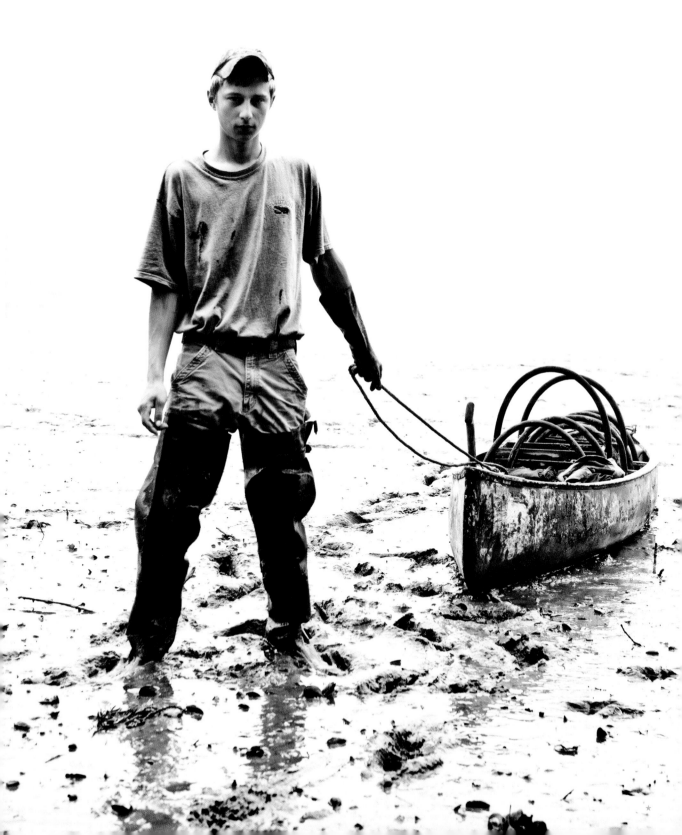

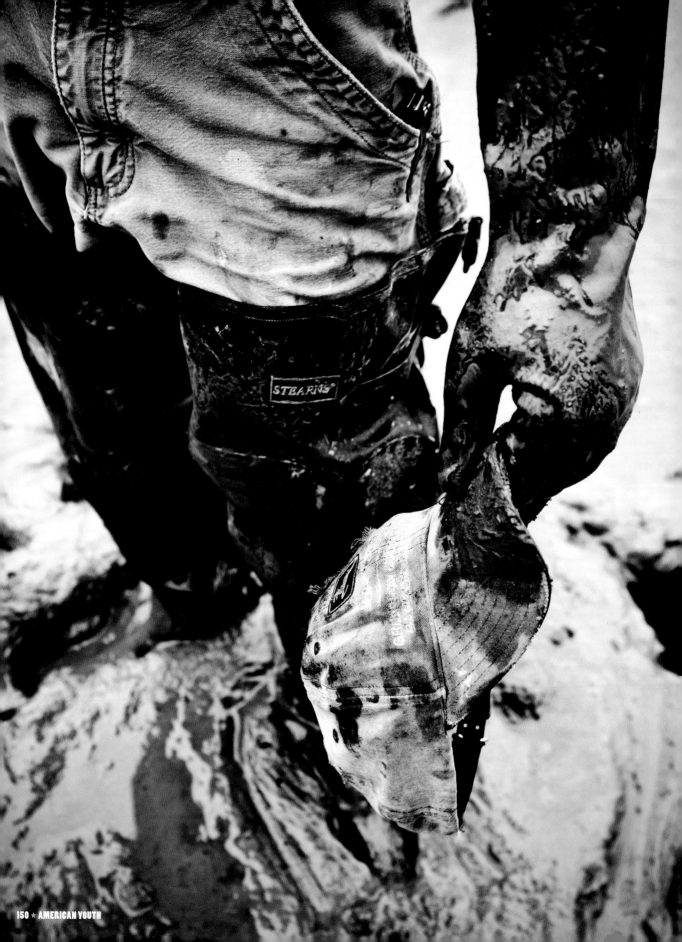

625468

CHAIN REACTION
STONINGTON, ME

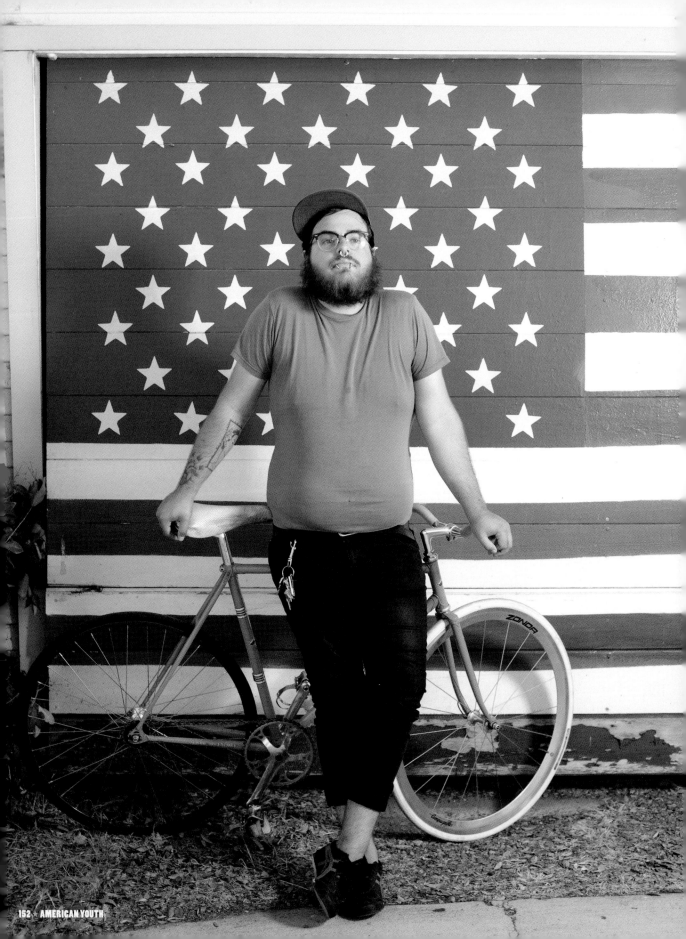

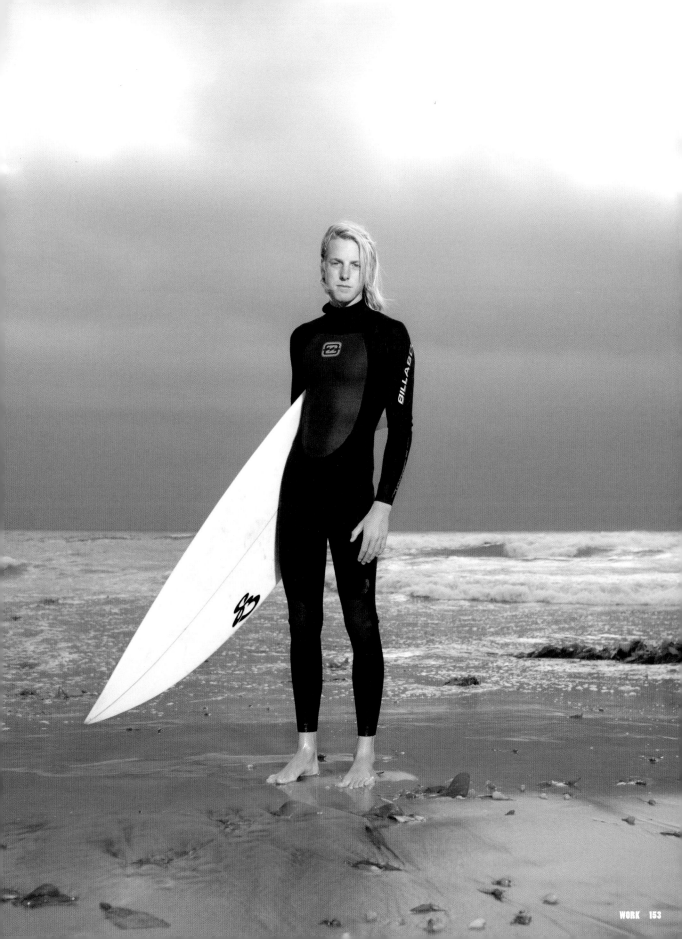

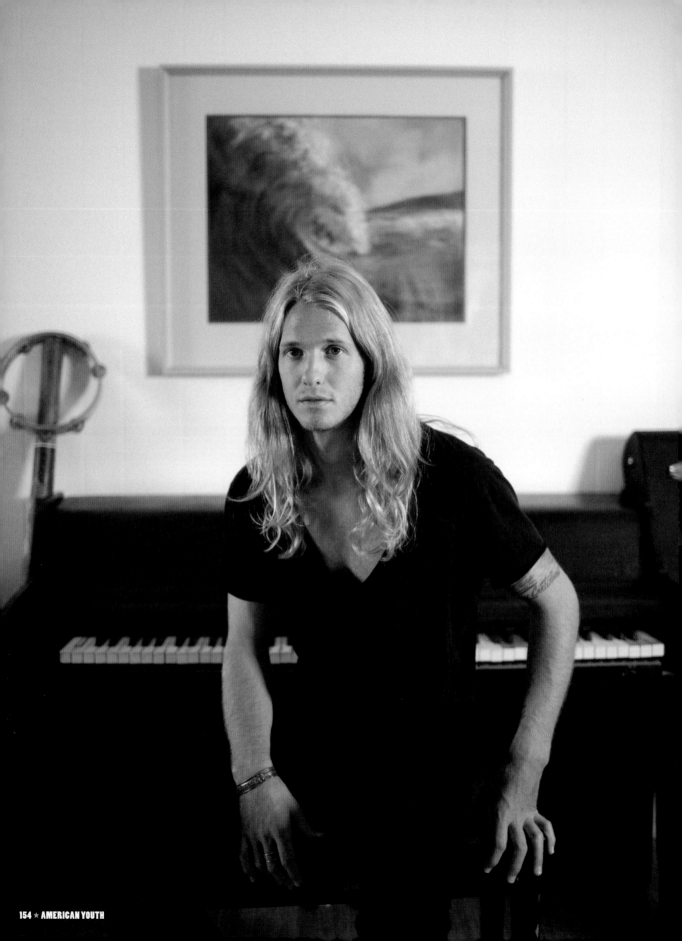

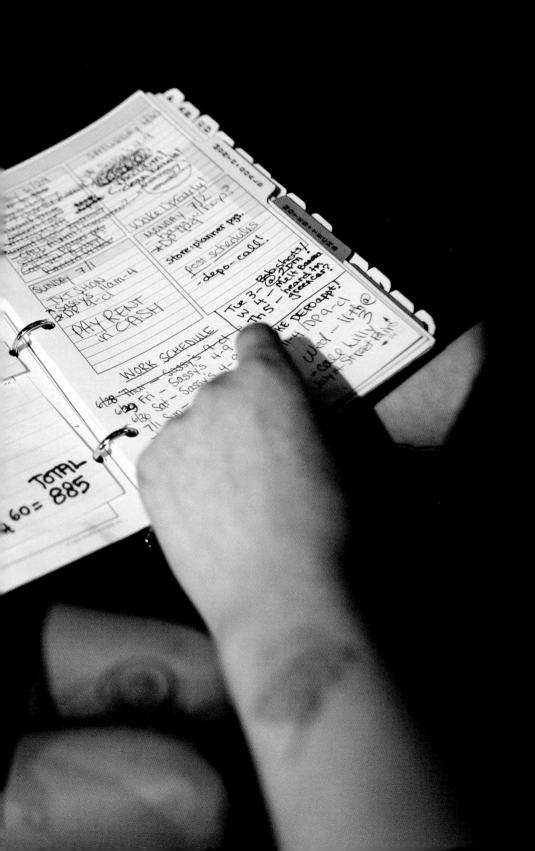

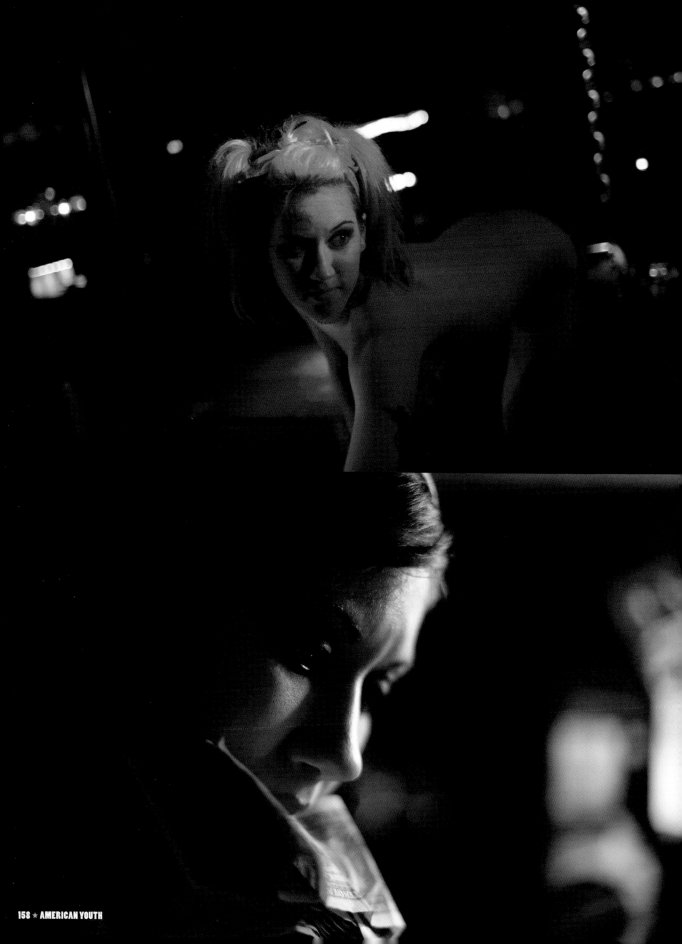

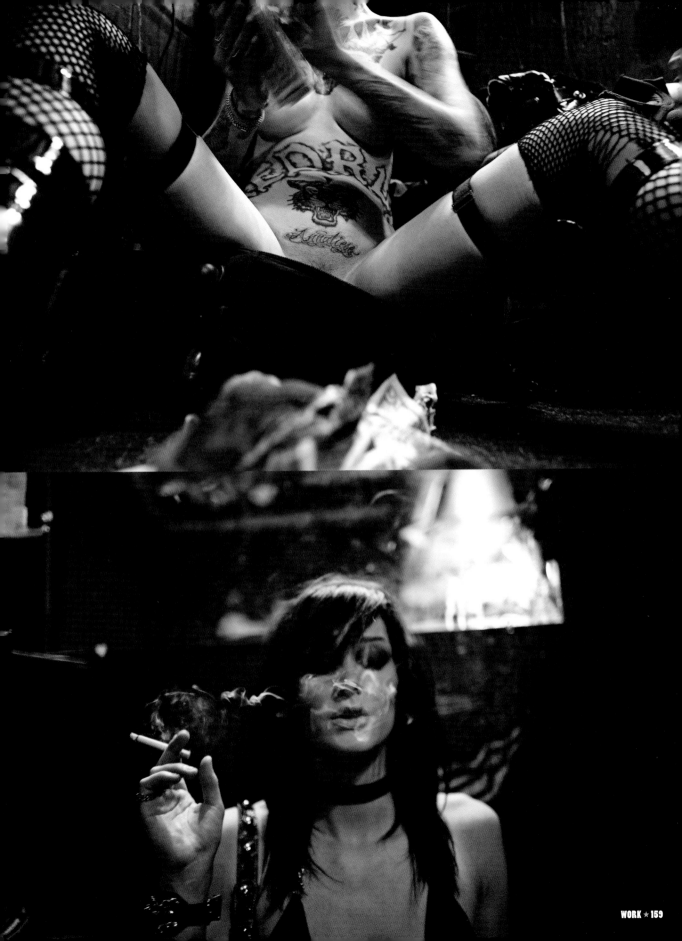

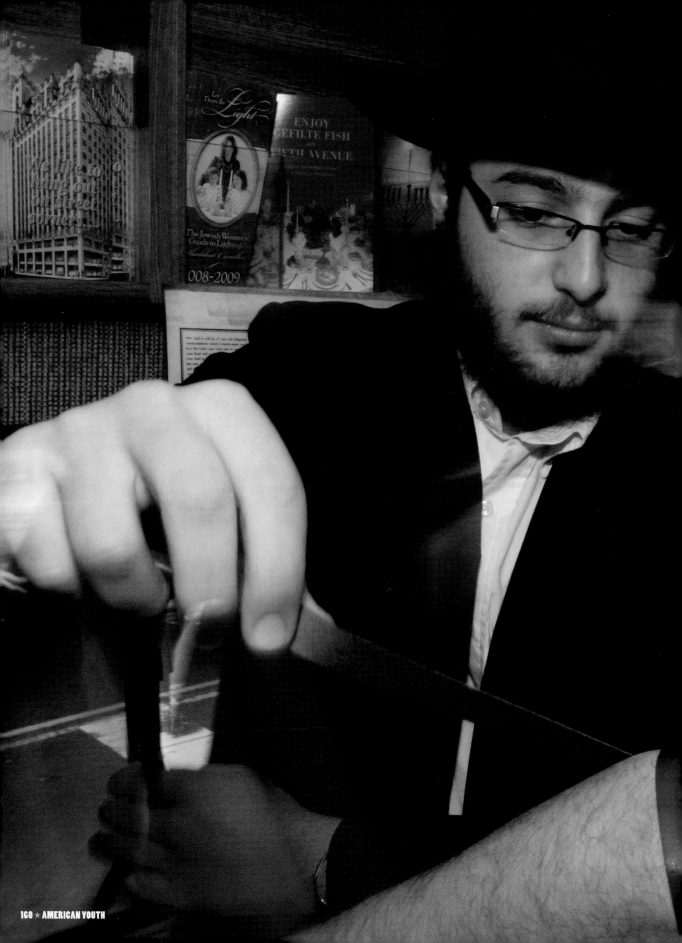

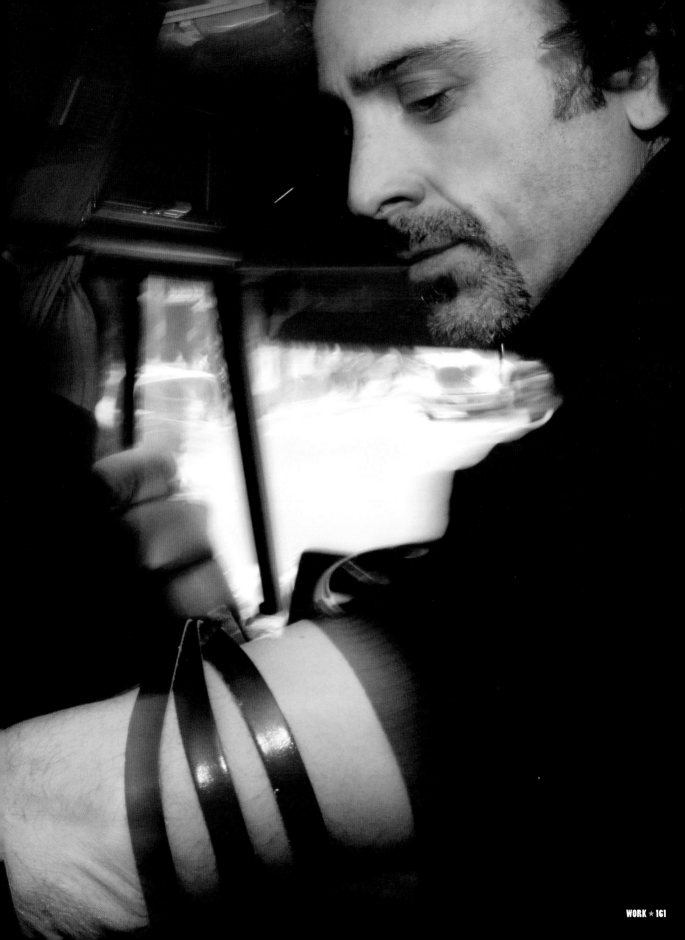

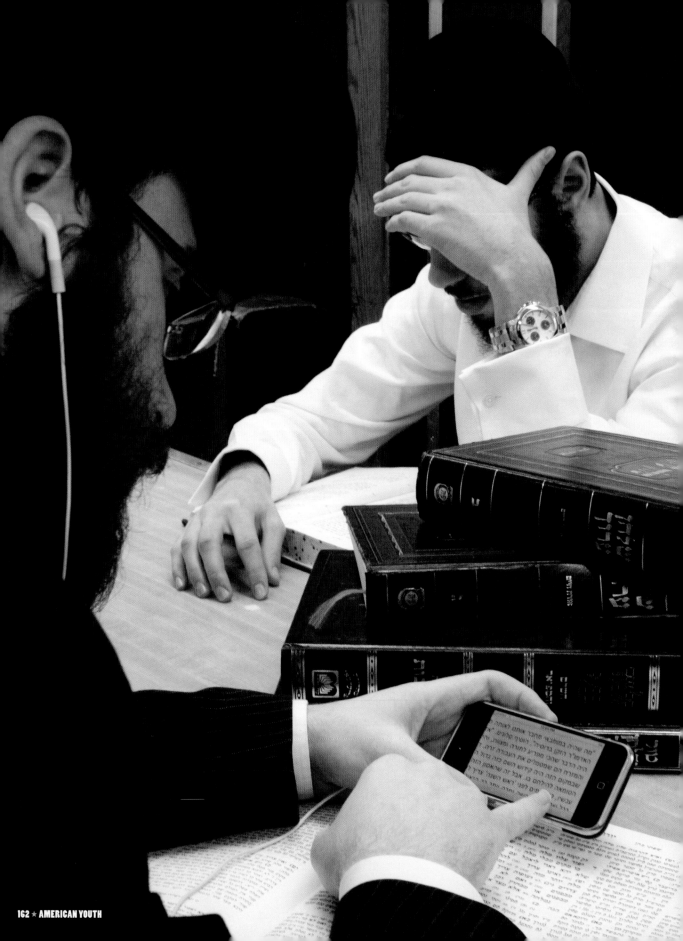

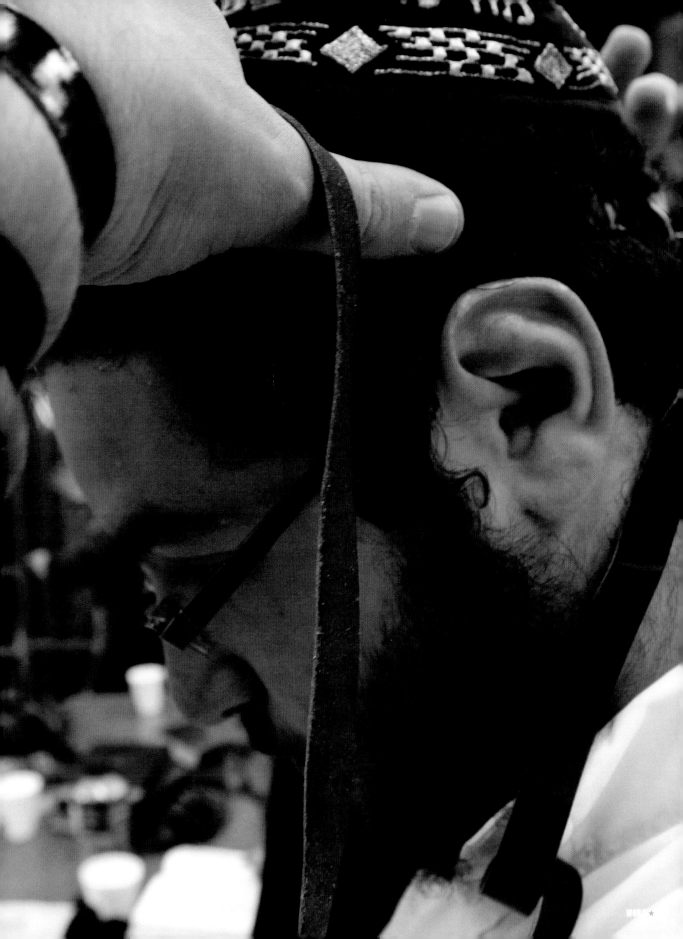

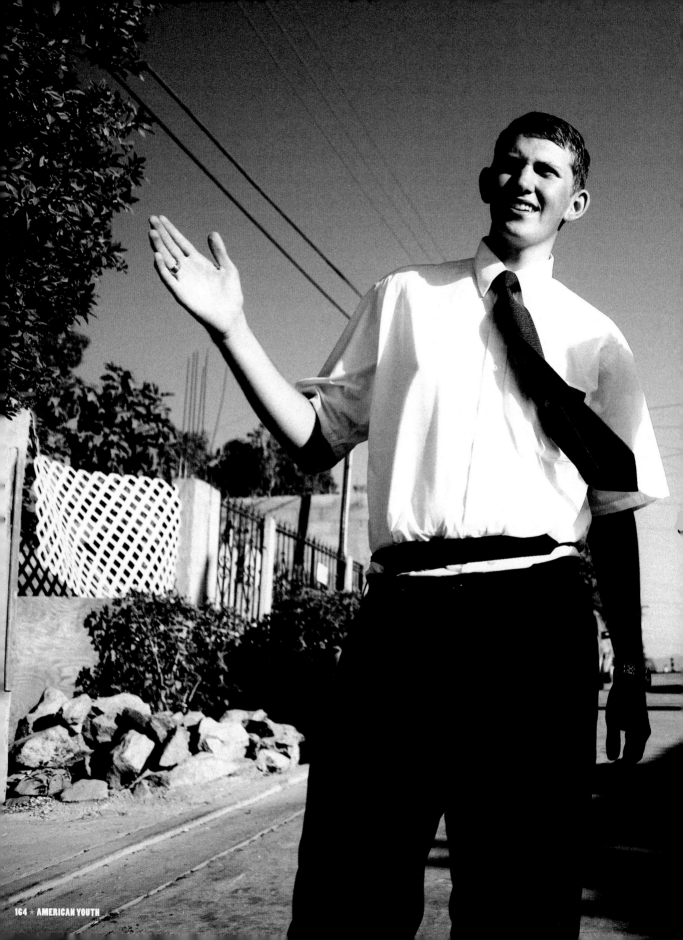

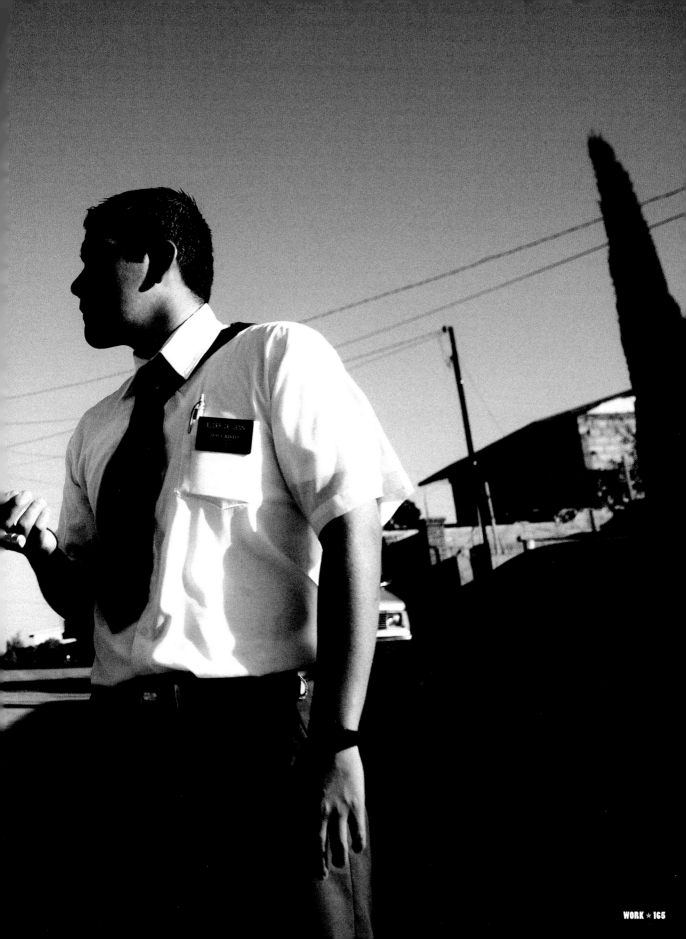

C
FEB
8
2007

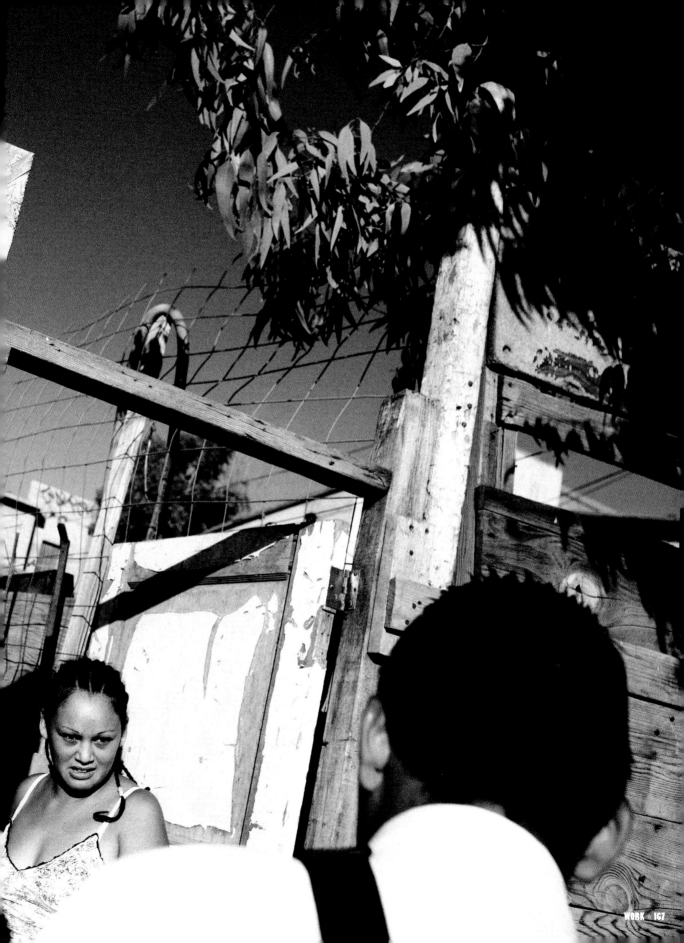

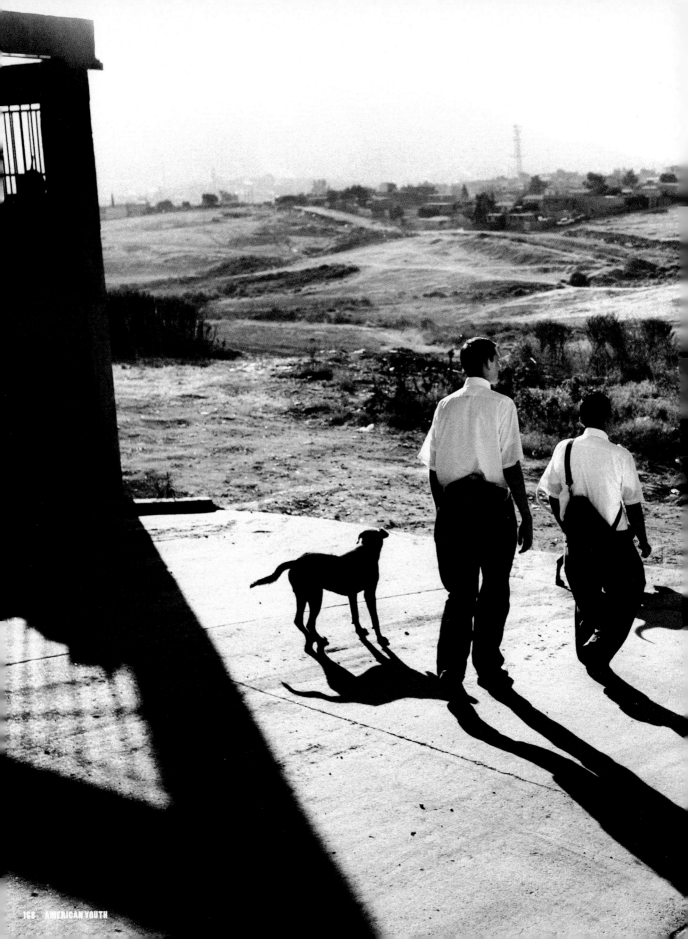

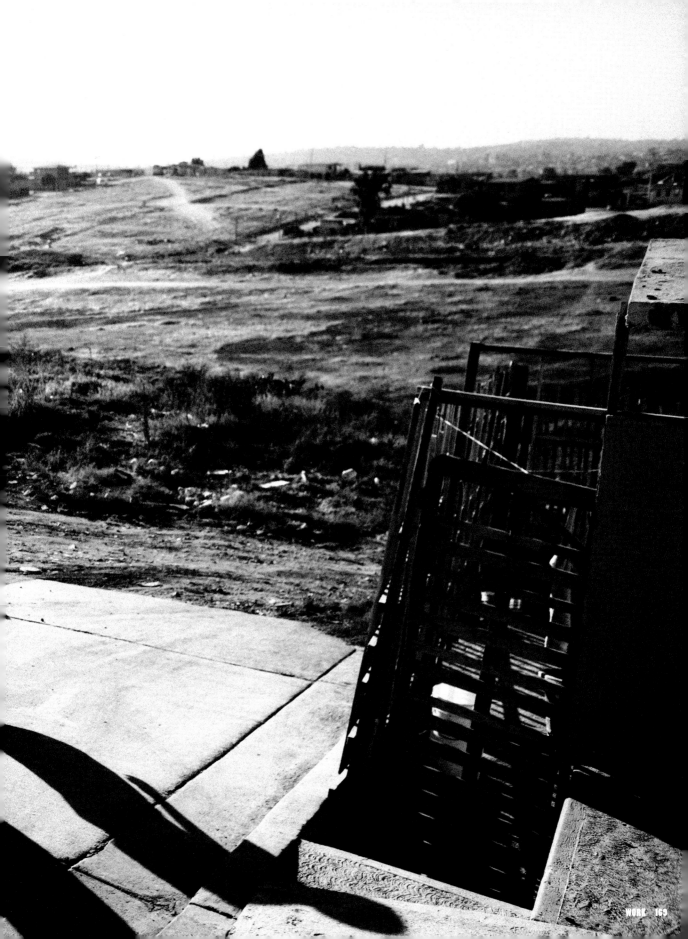

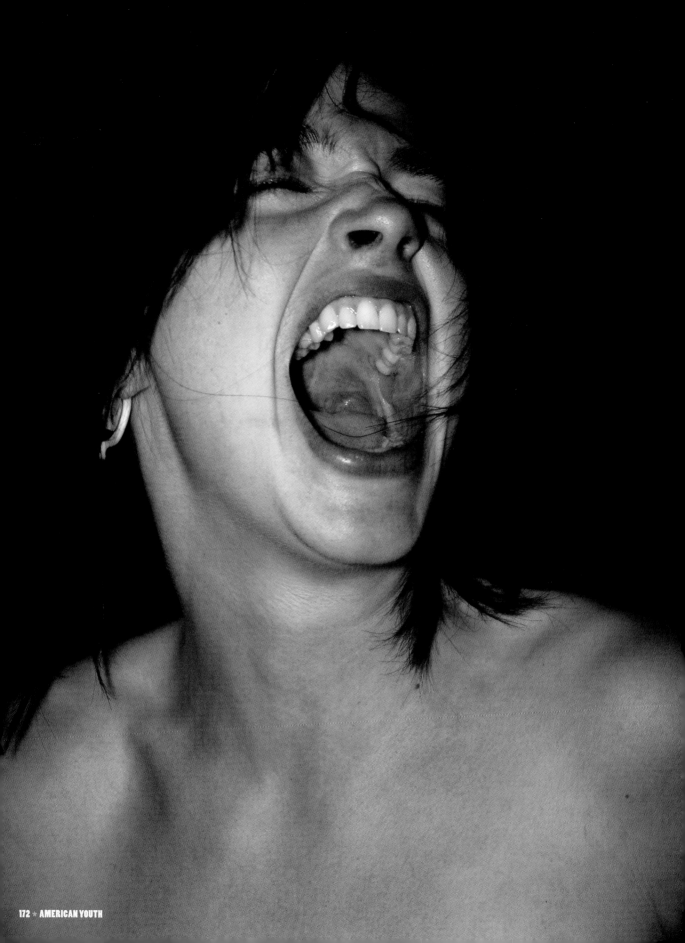

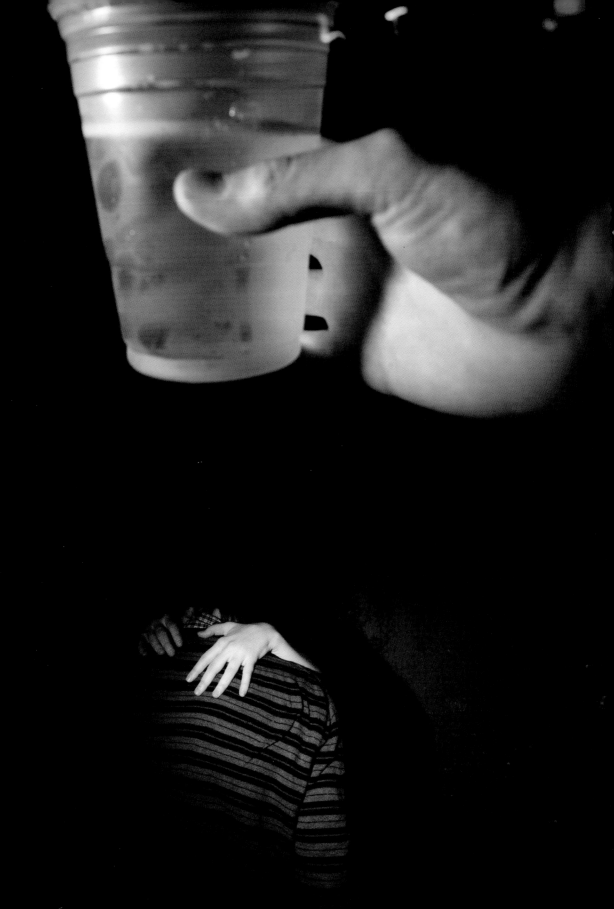

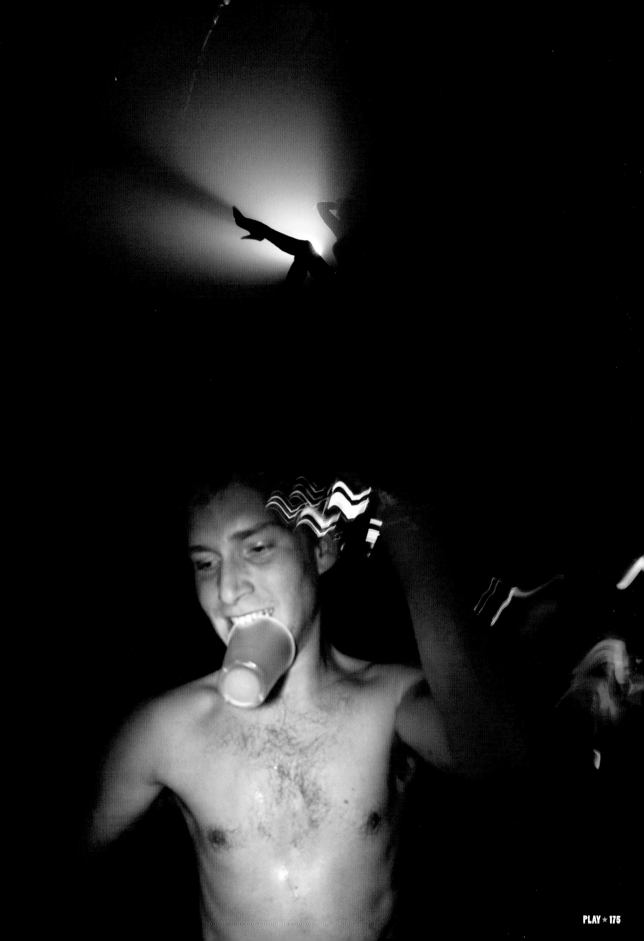

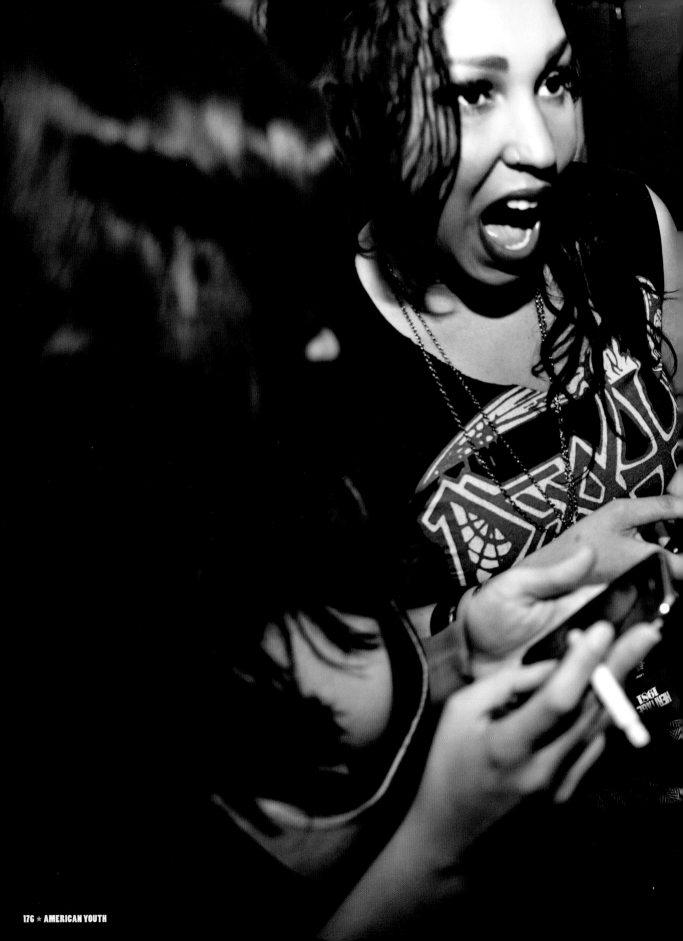

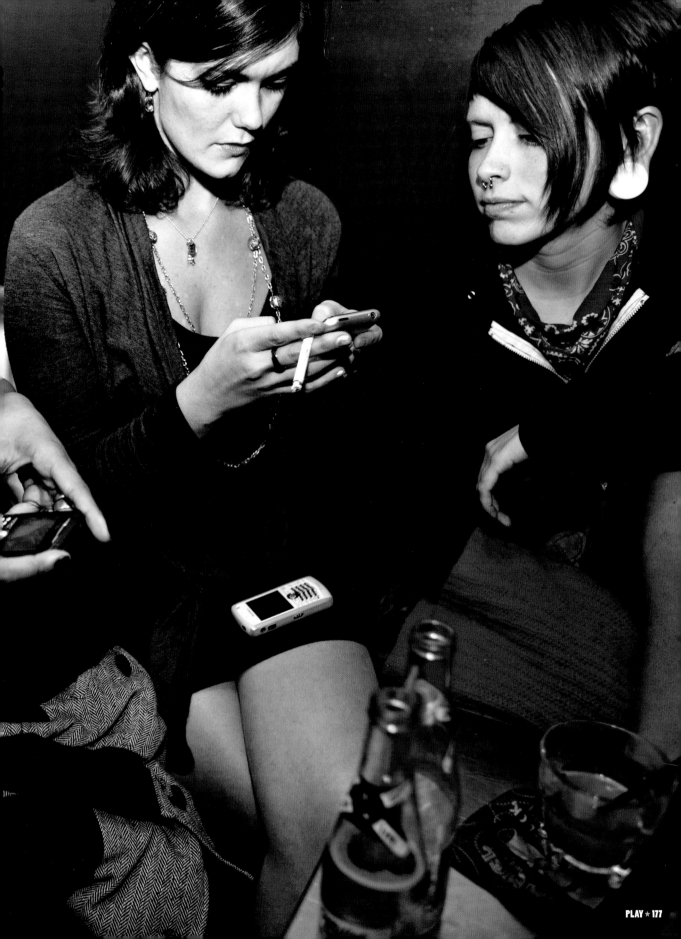

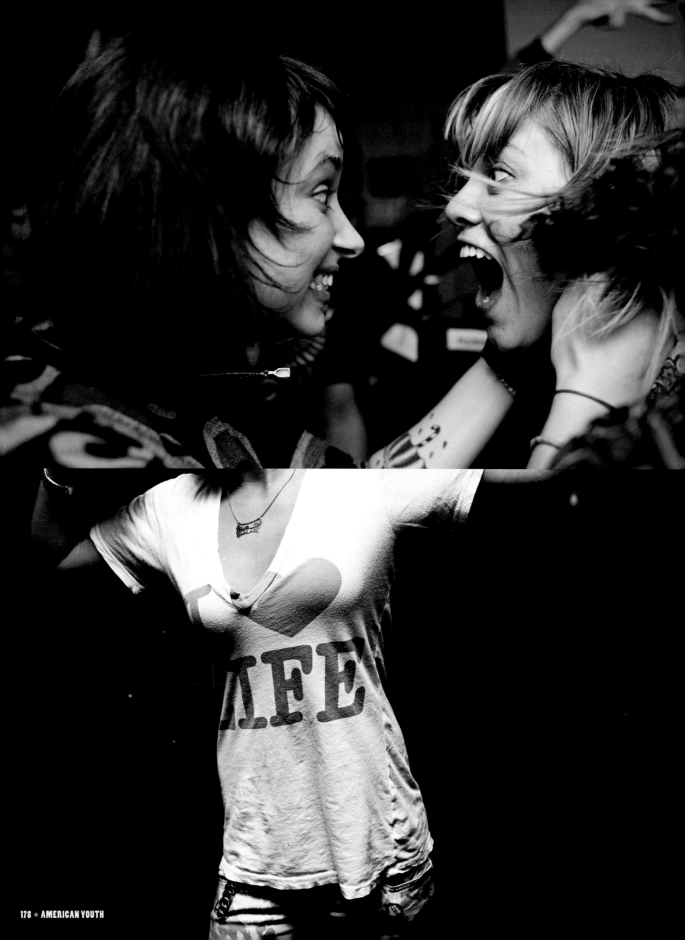

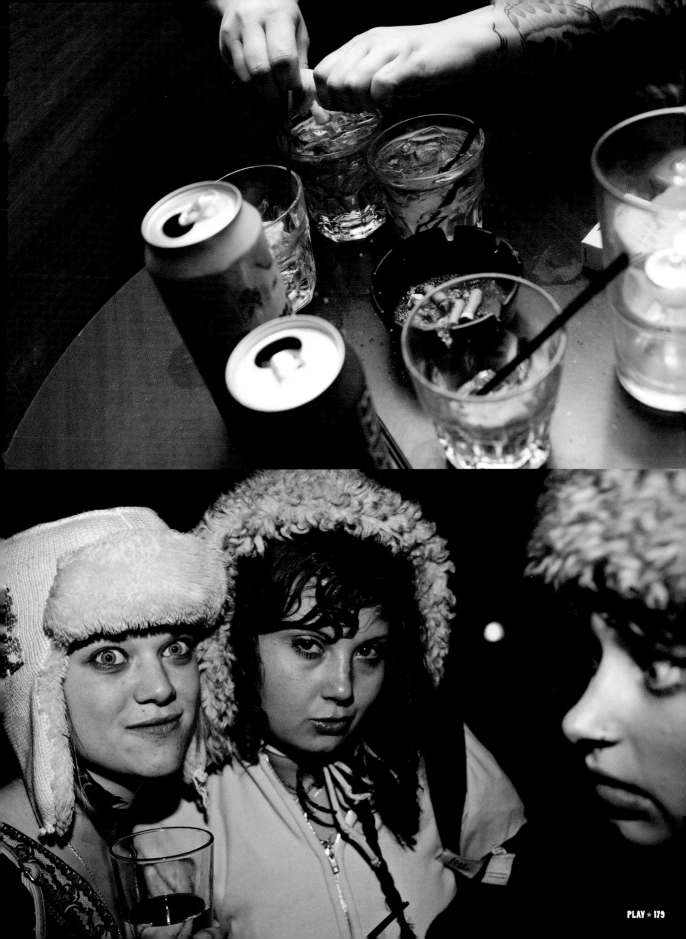

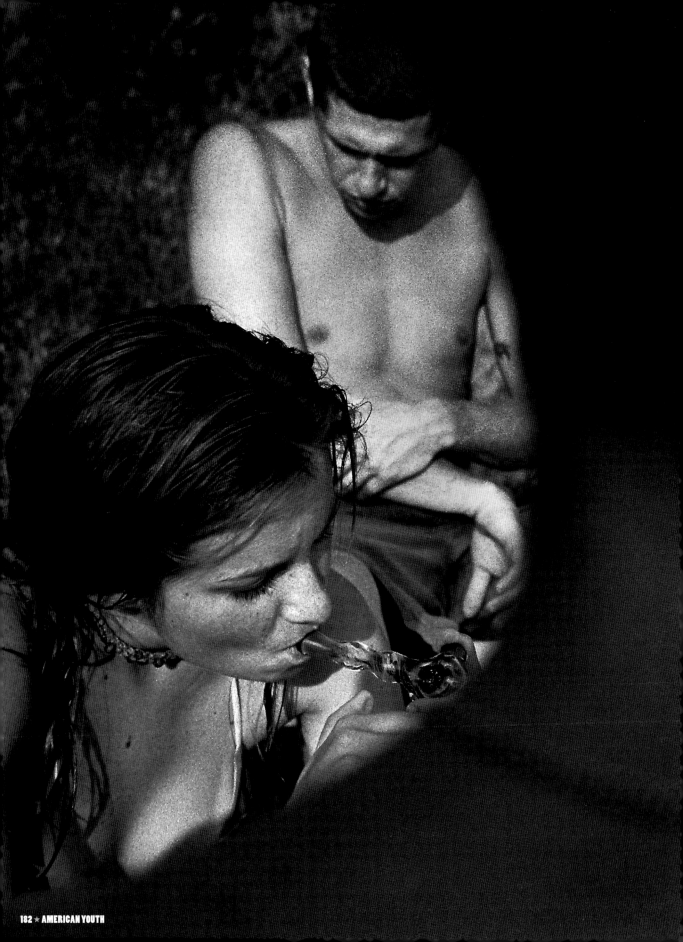

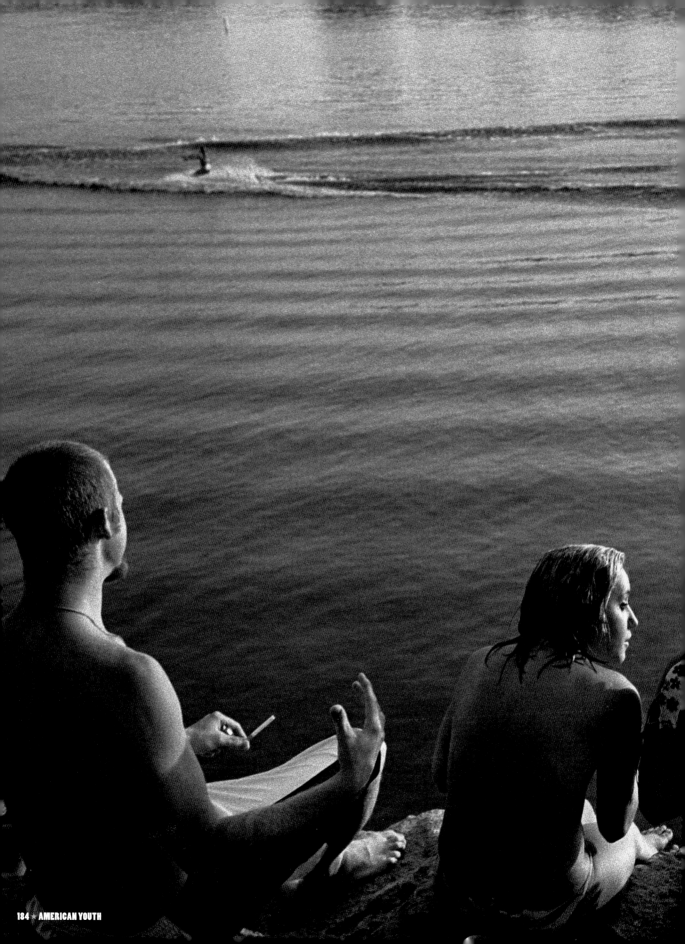

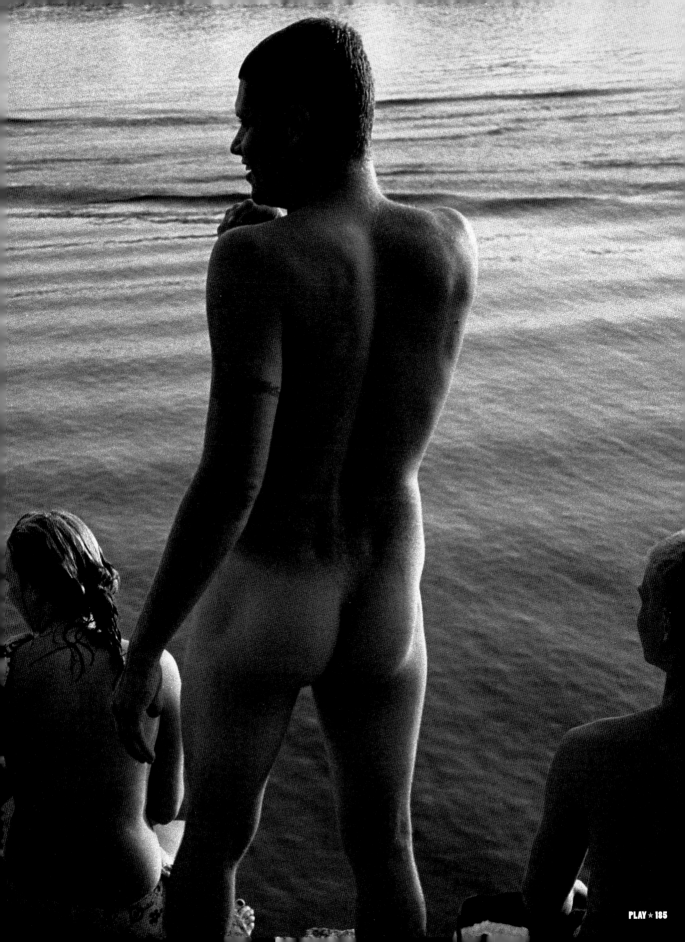

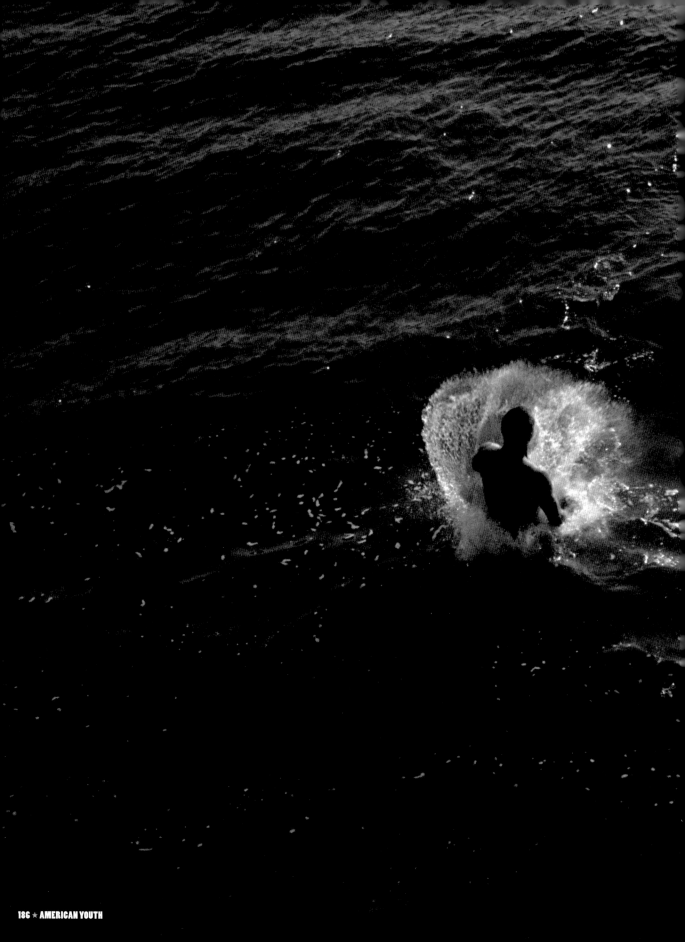

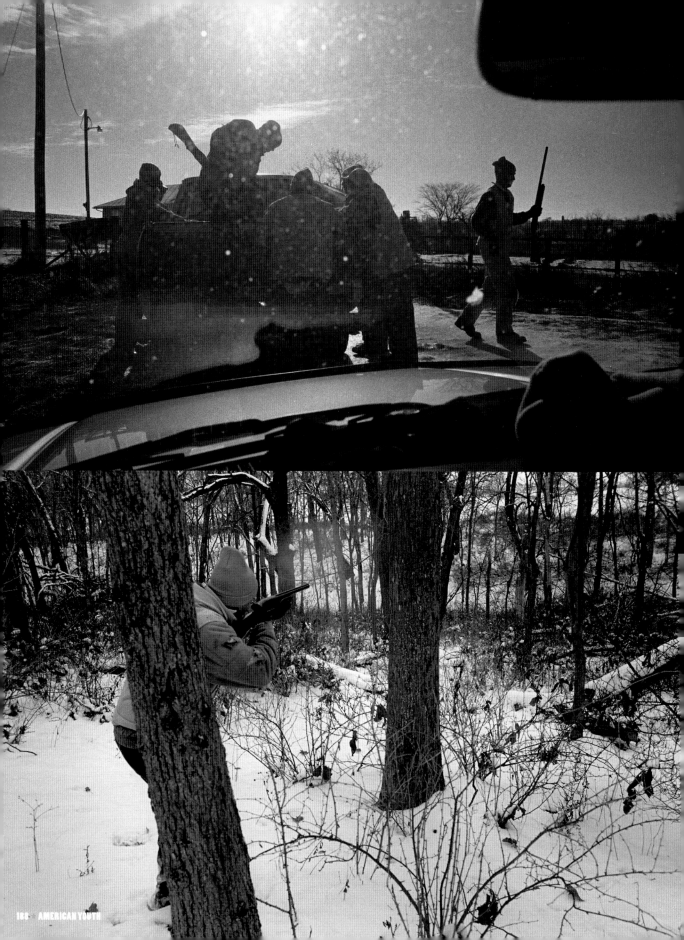

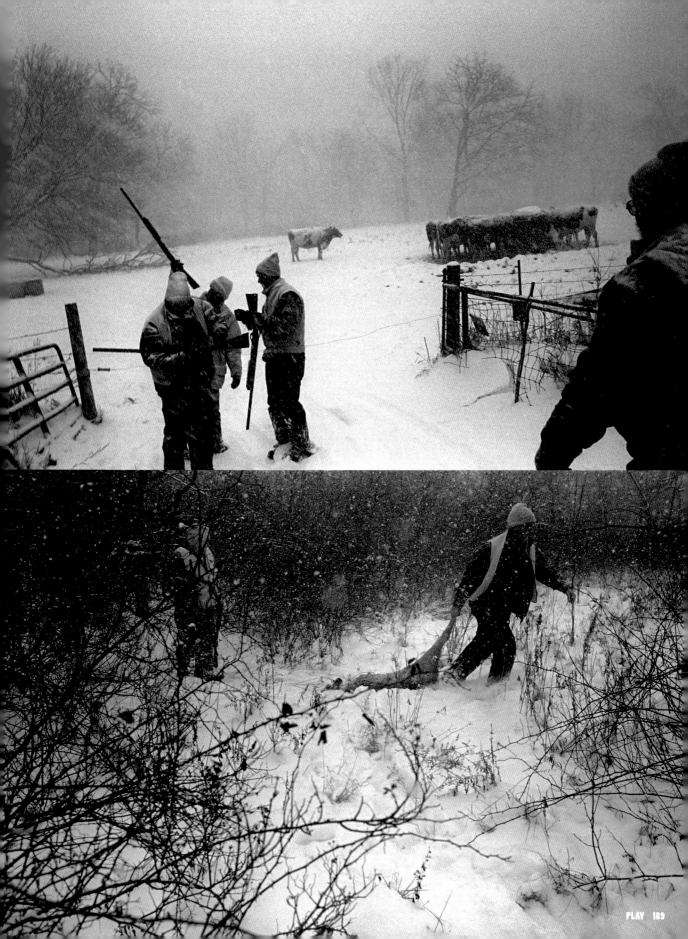

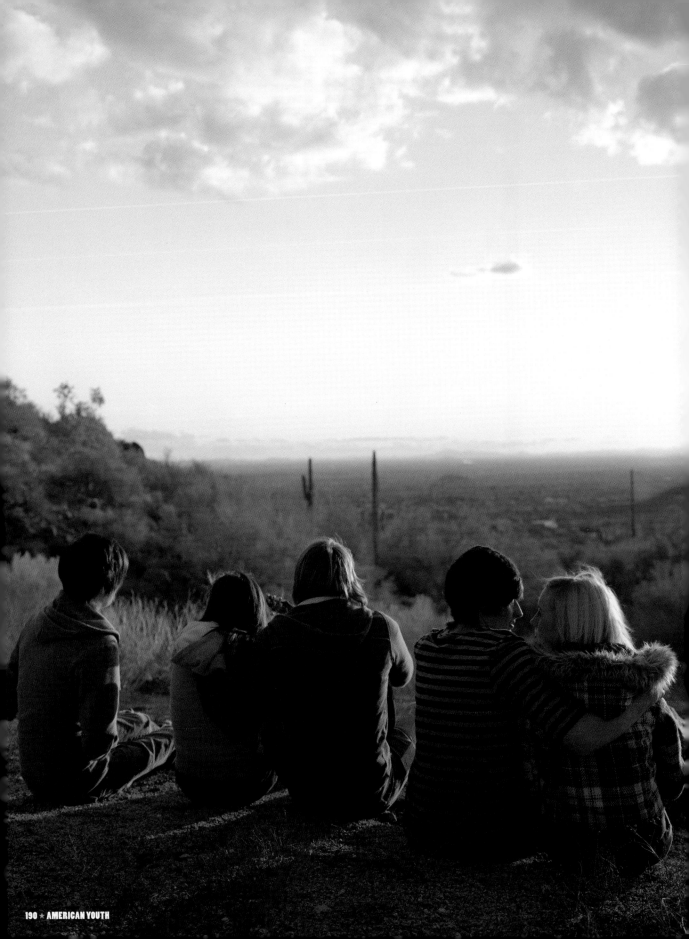

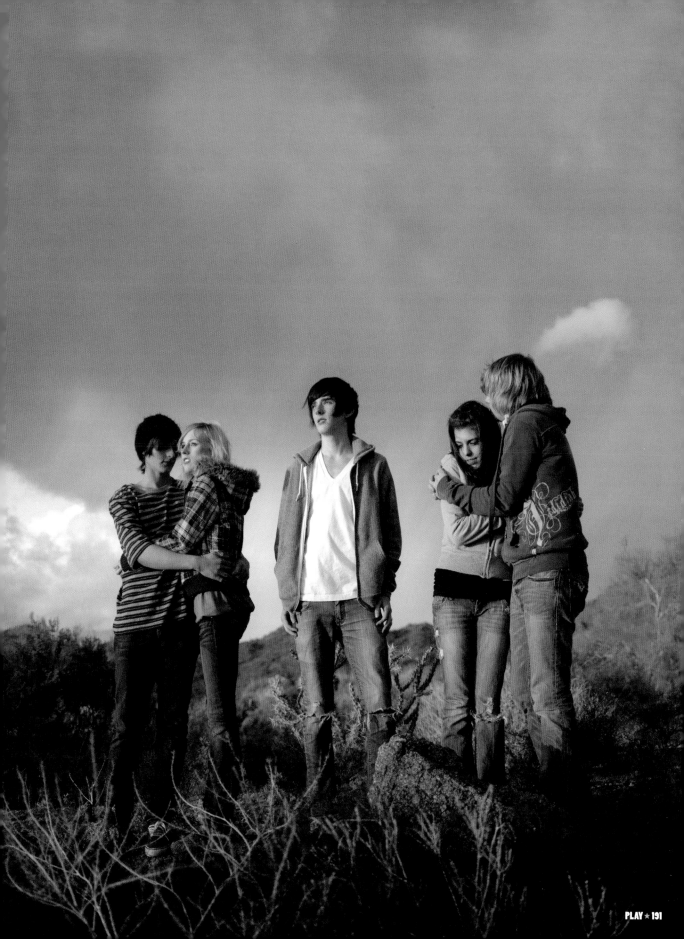

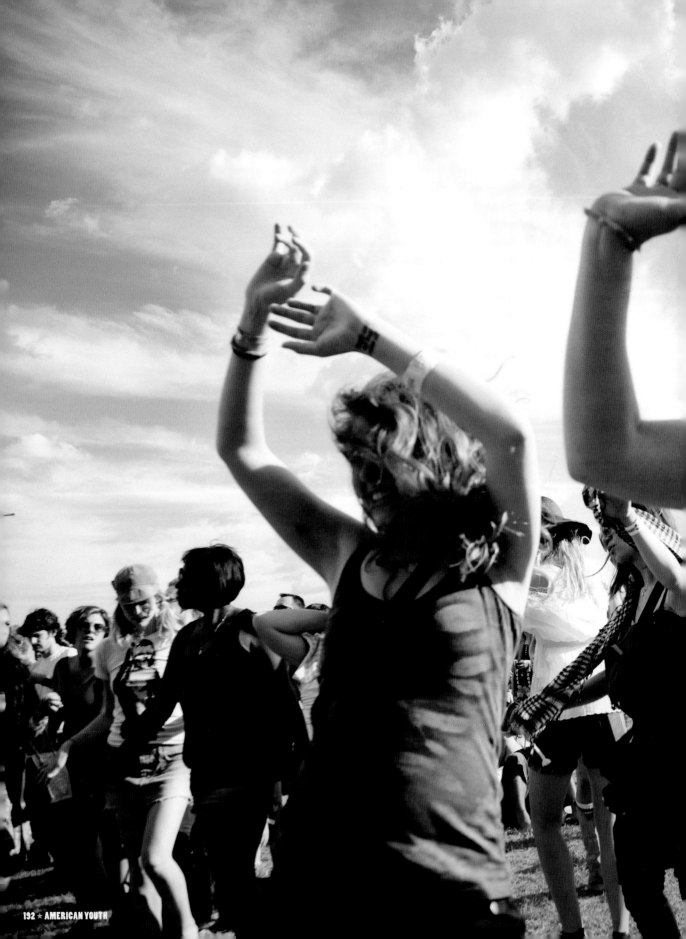

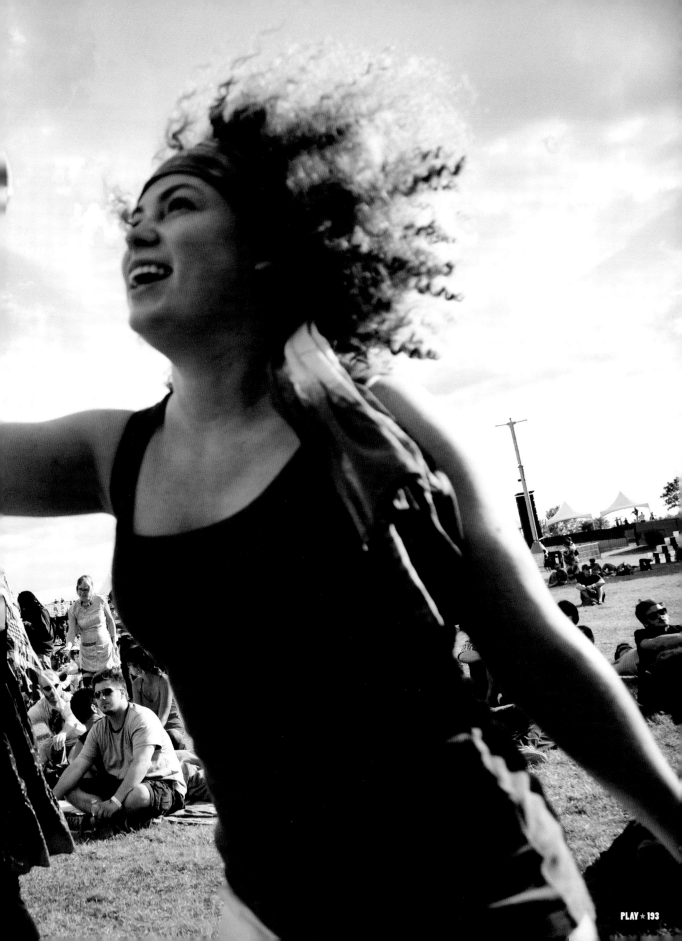

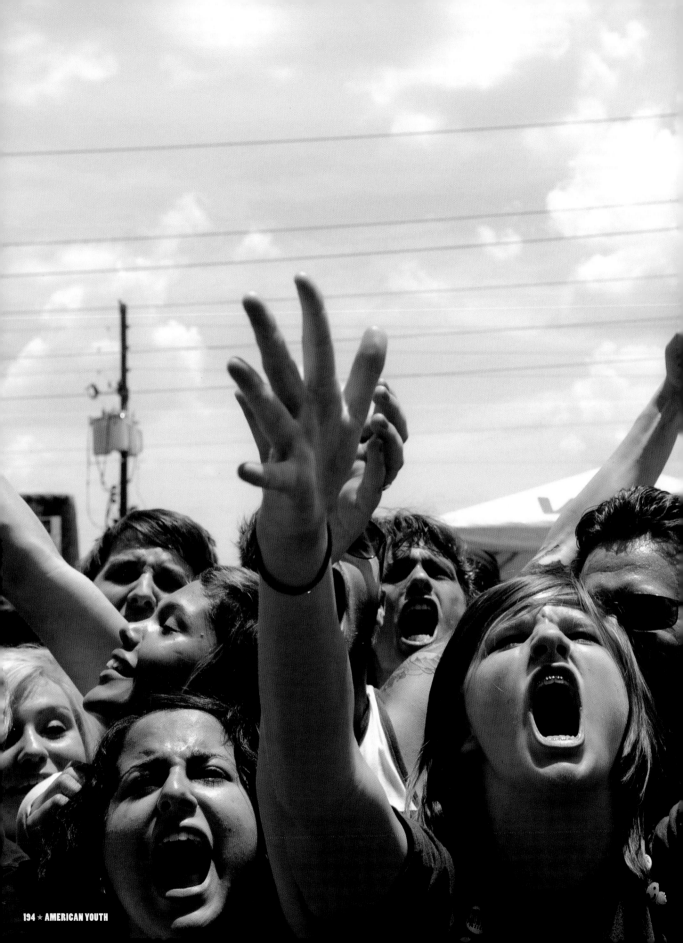

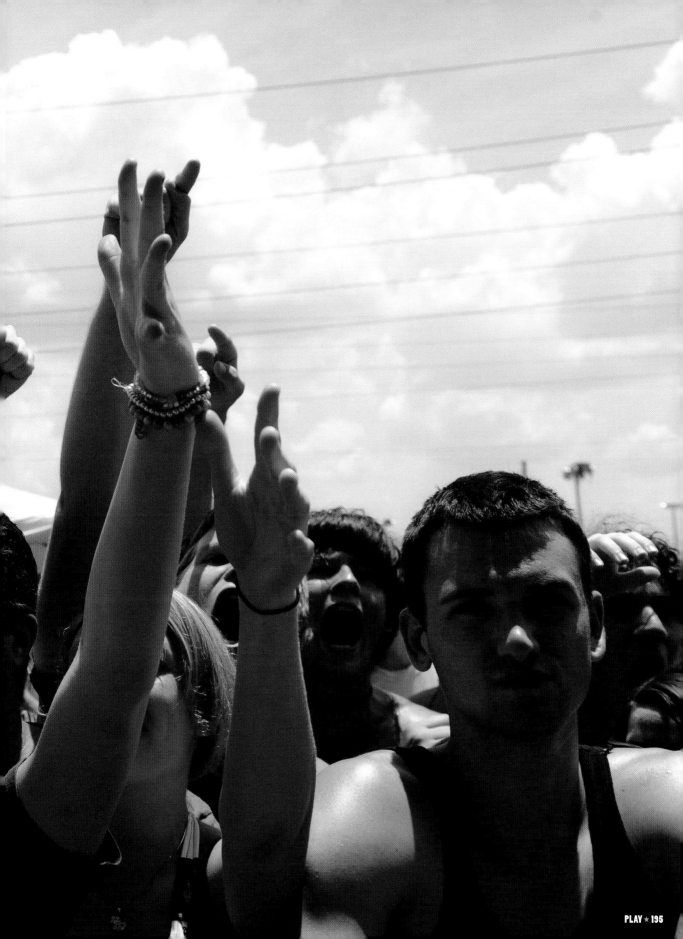

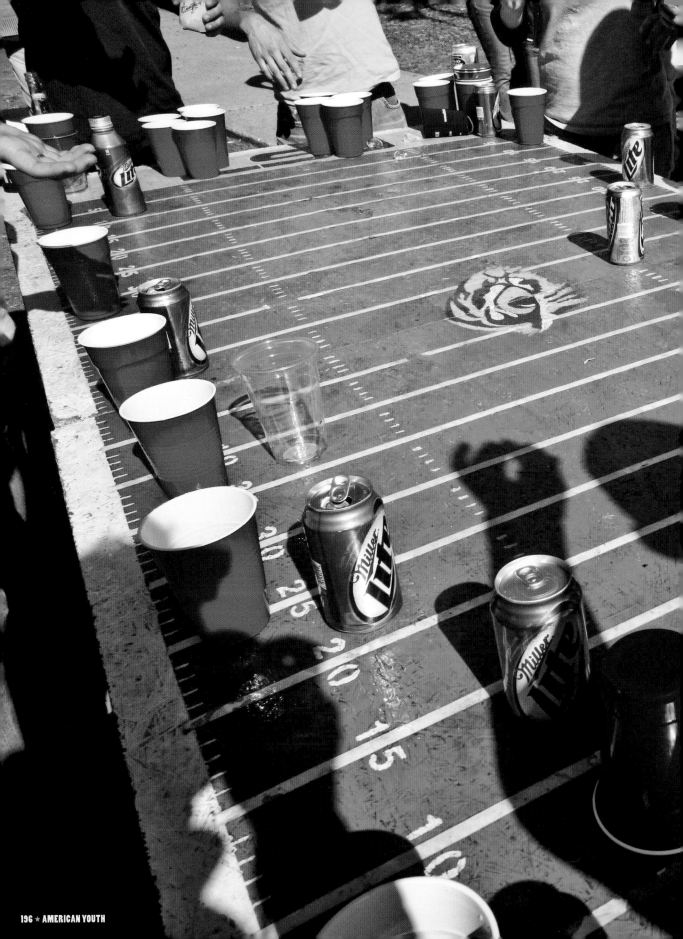

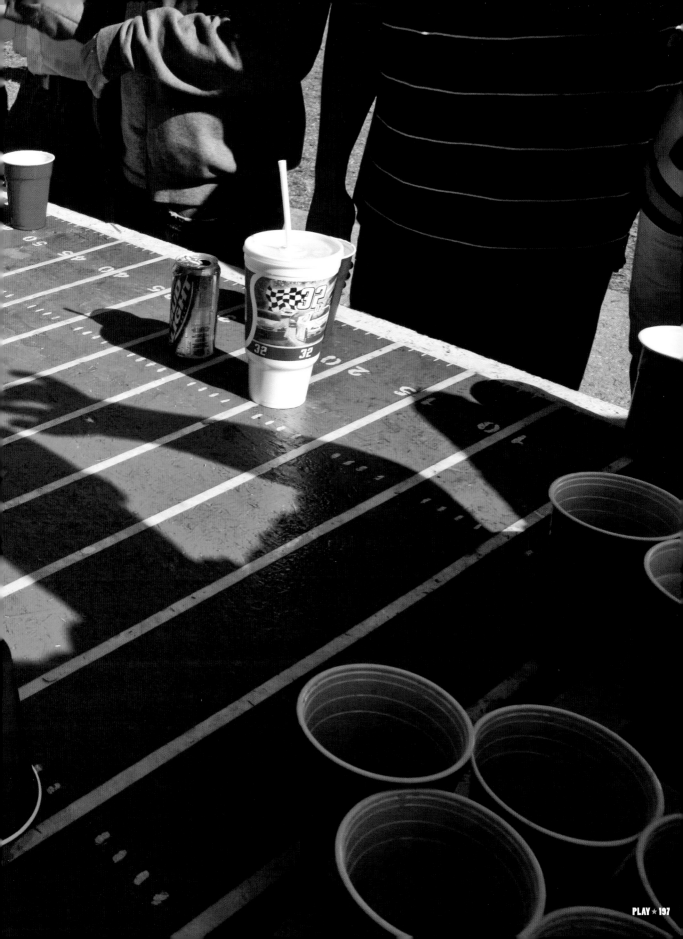

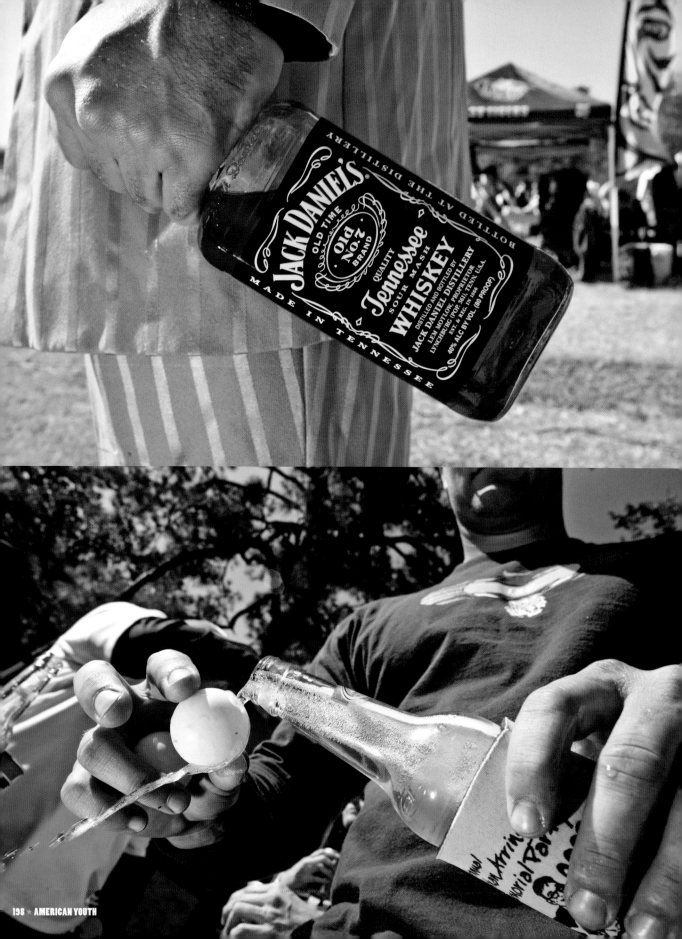

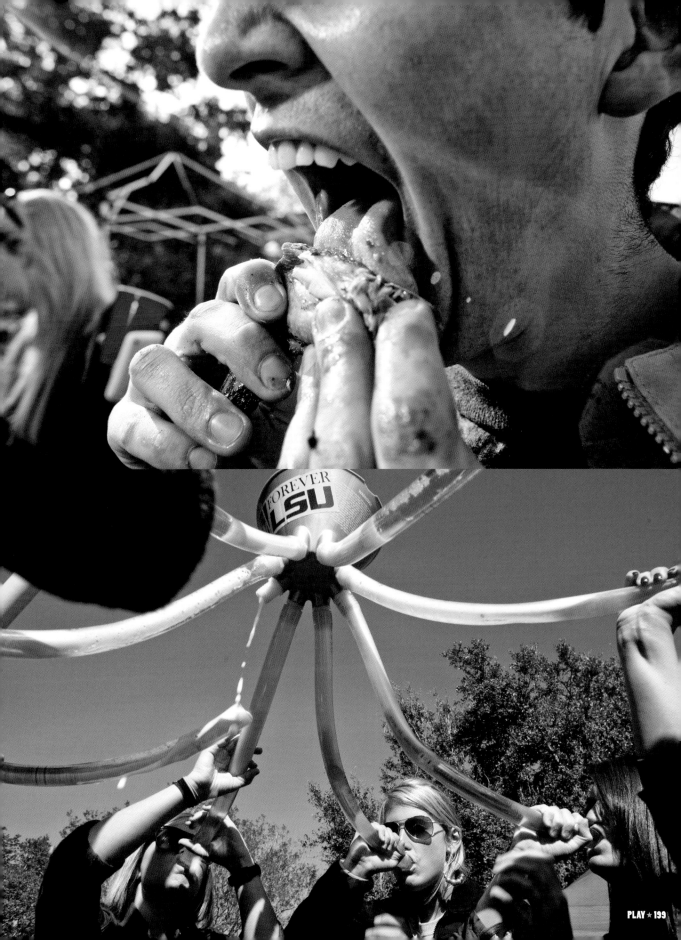

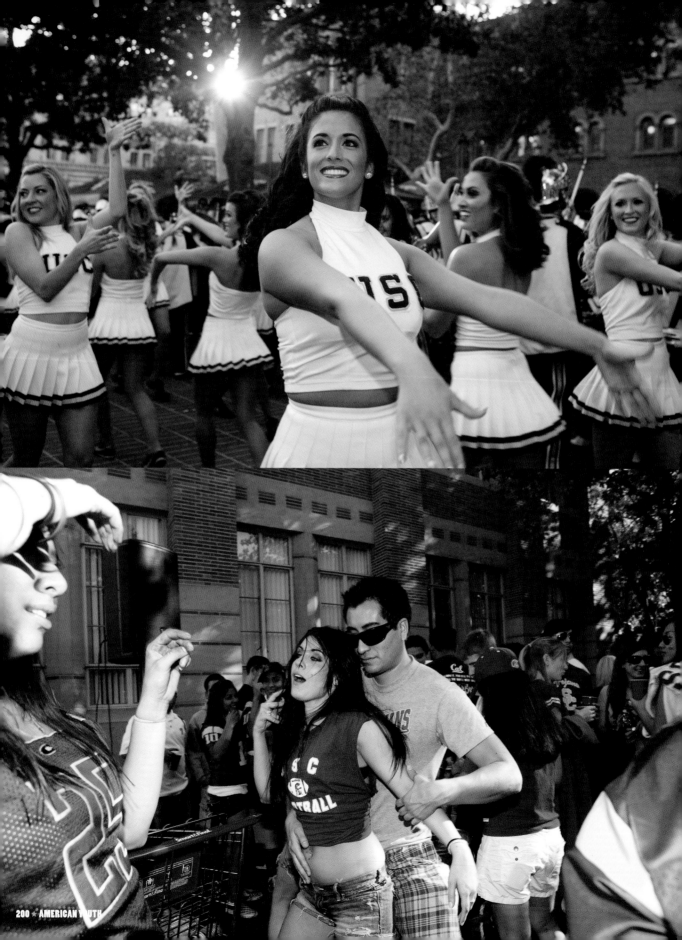

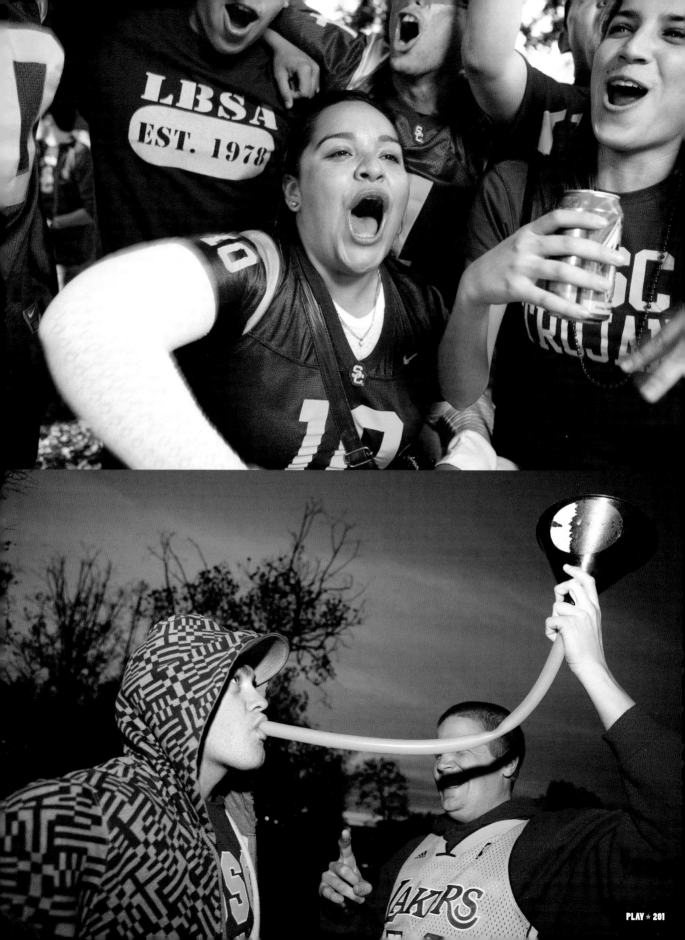

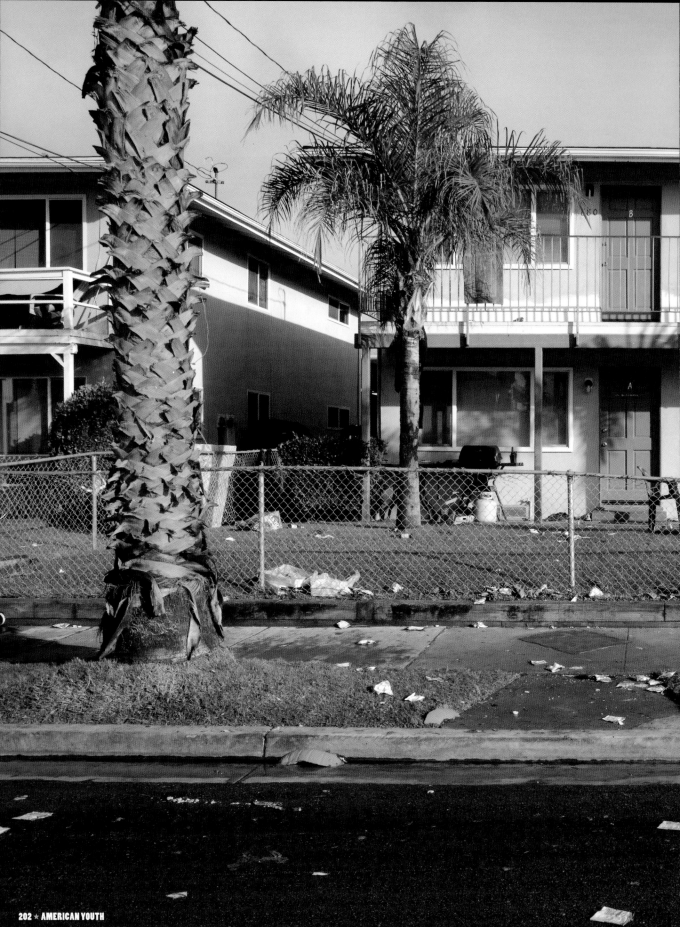

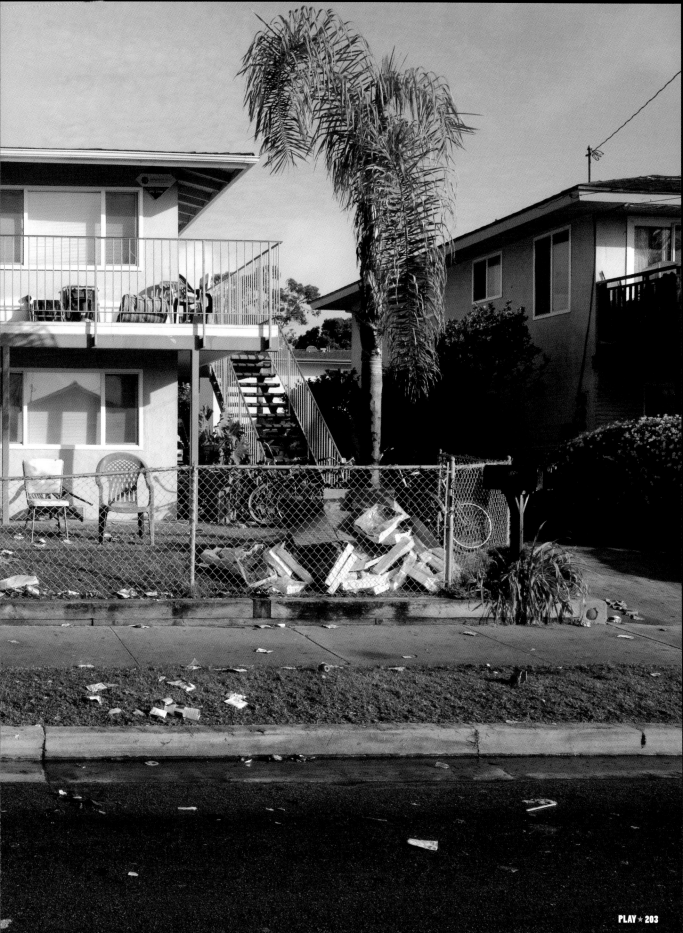

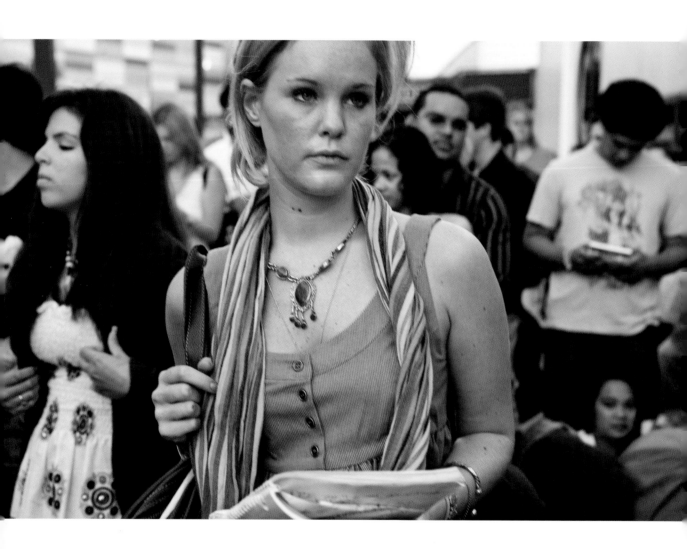

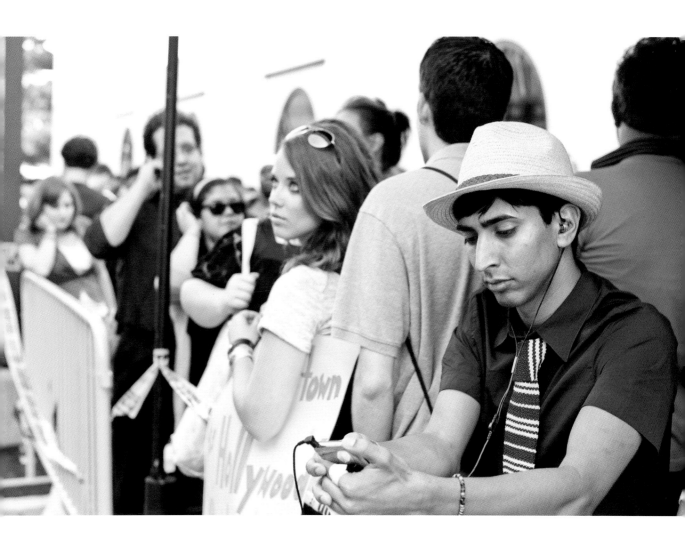

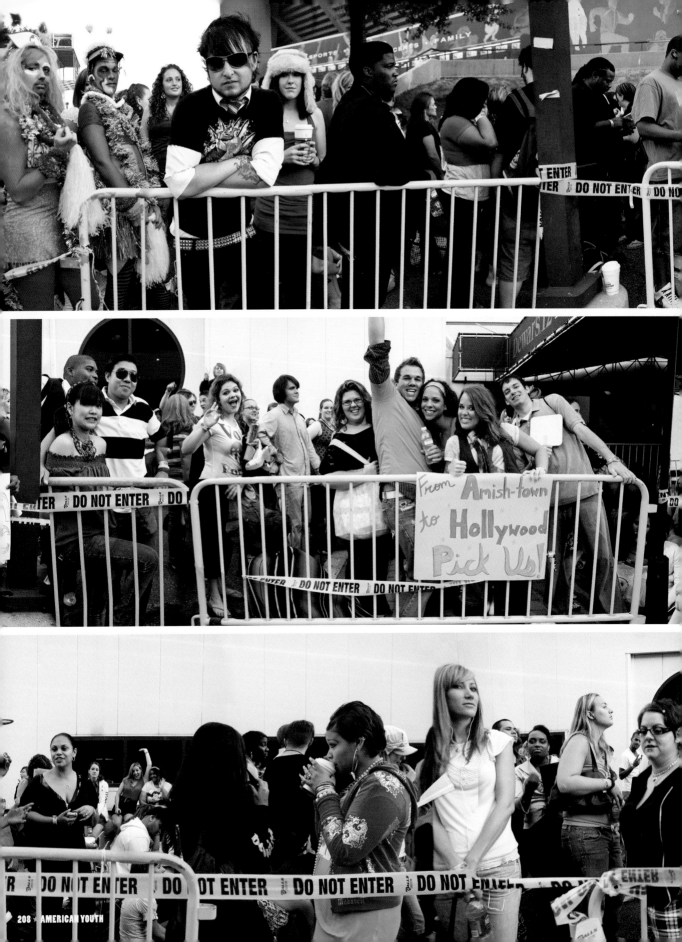

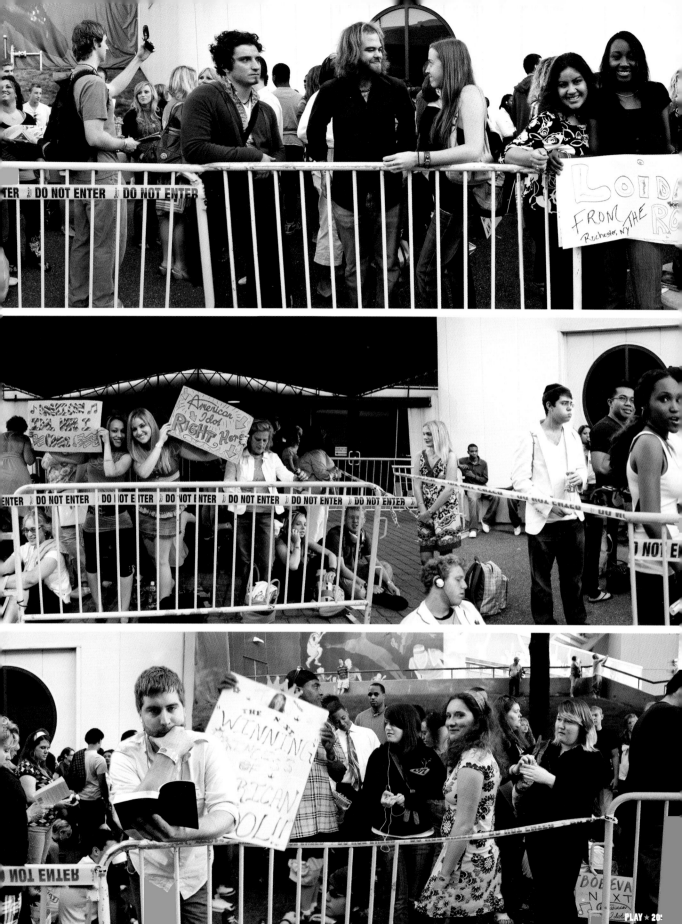

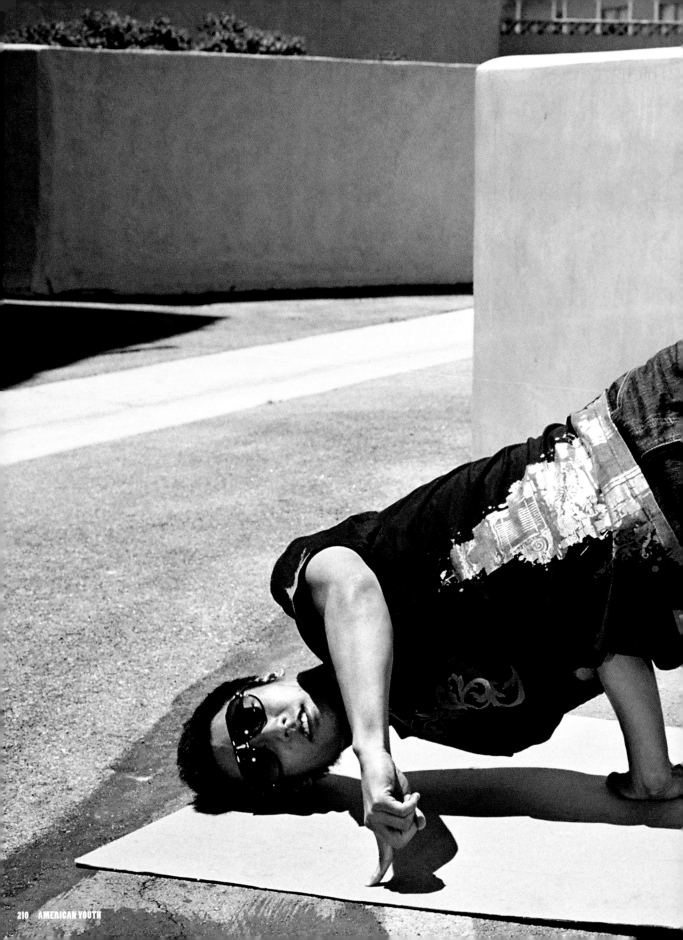

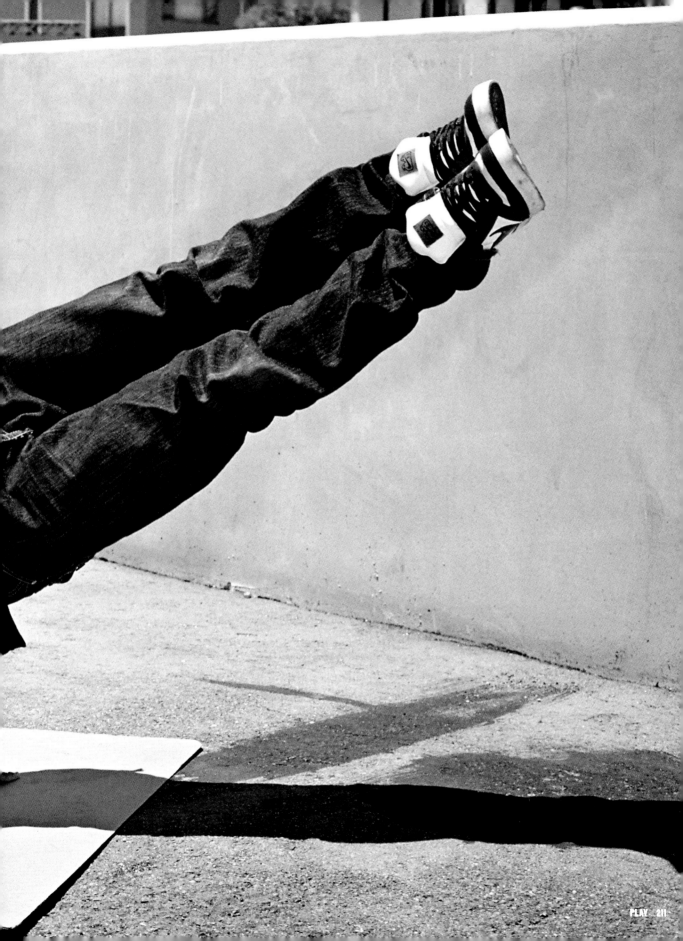

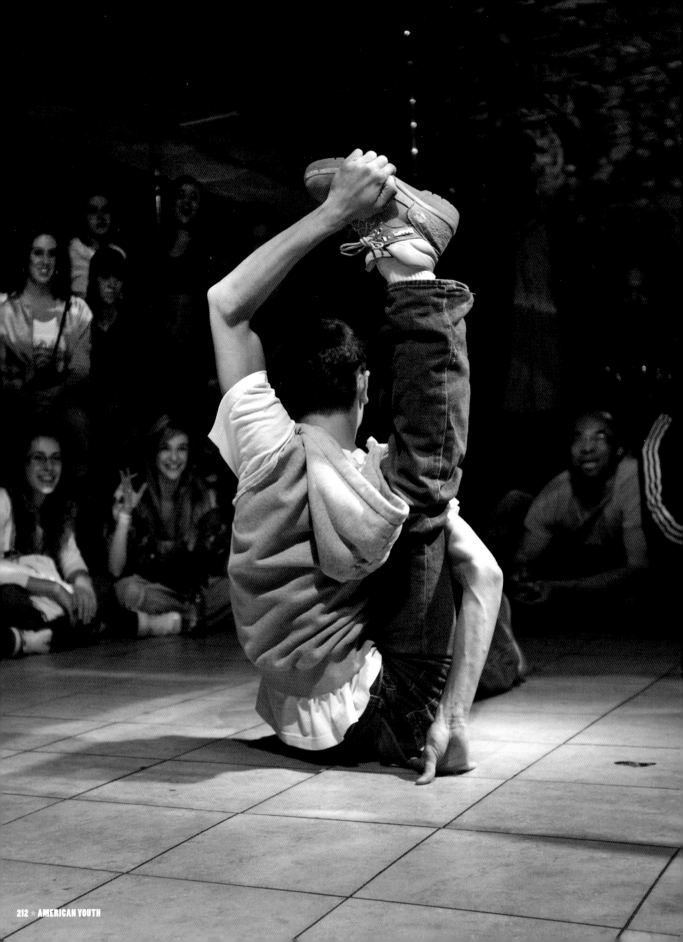

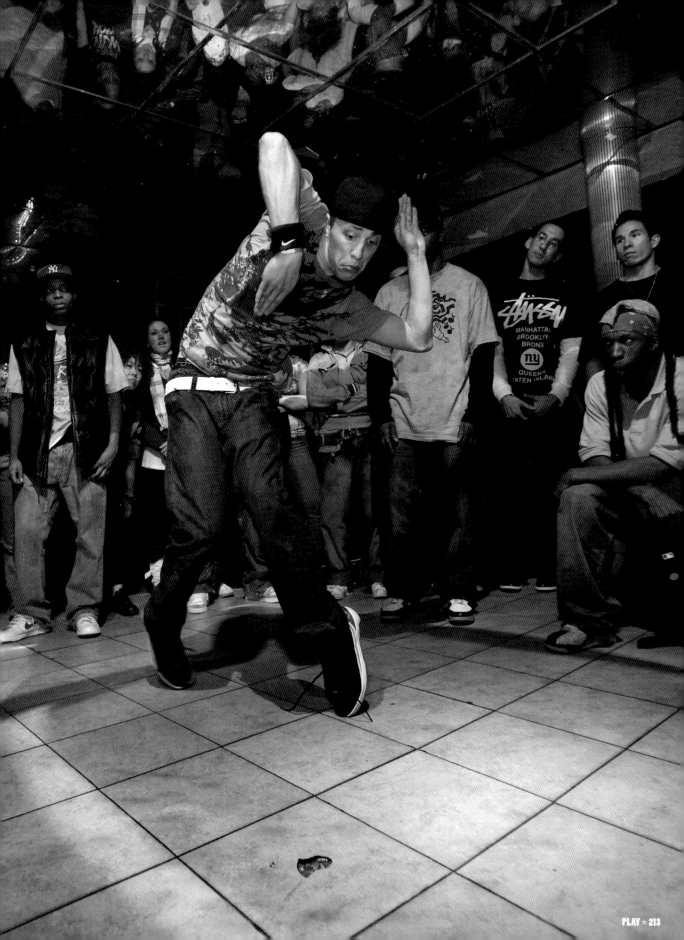

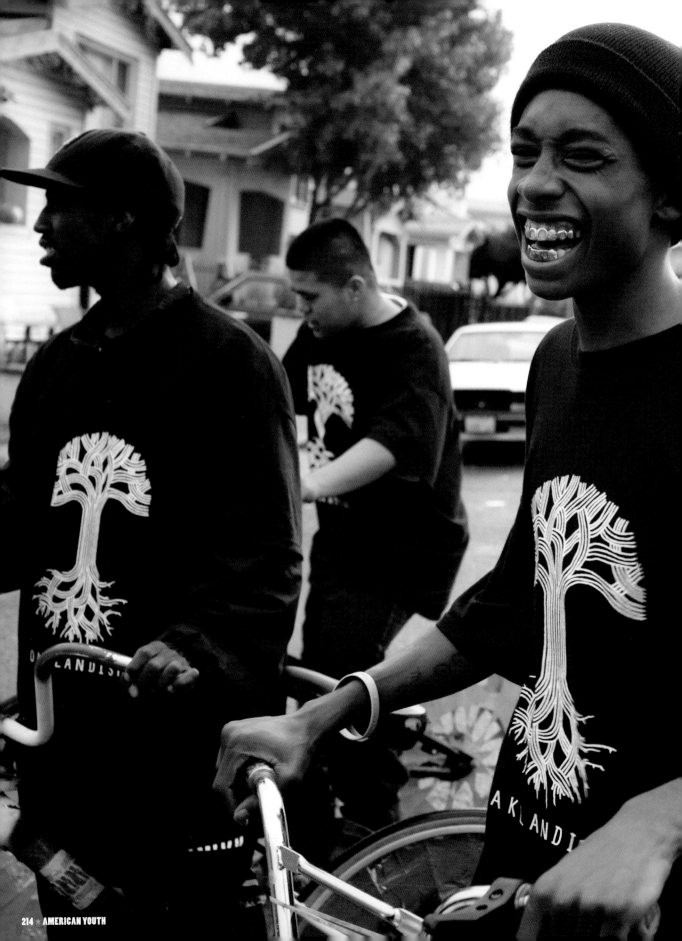

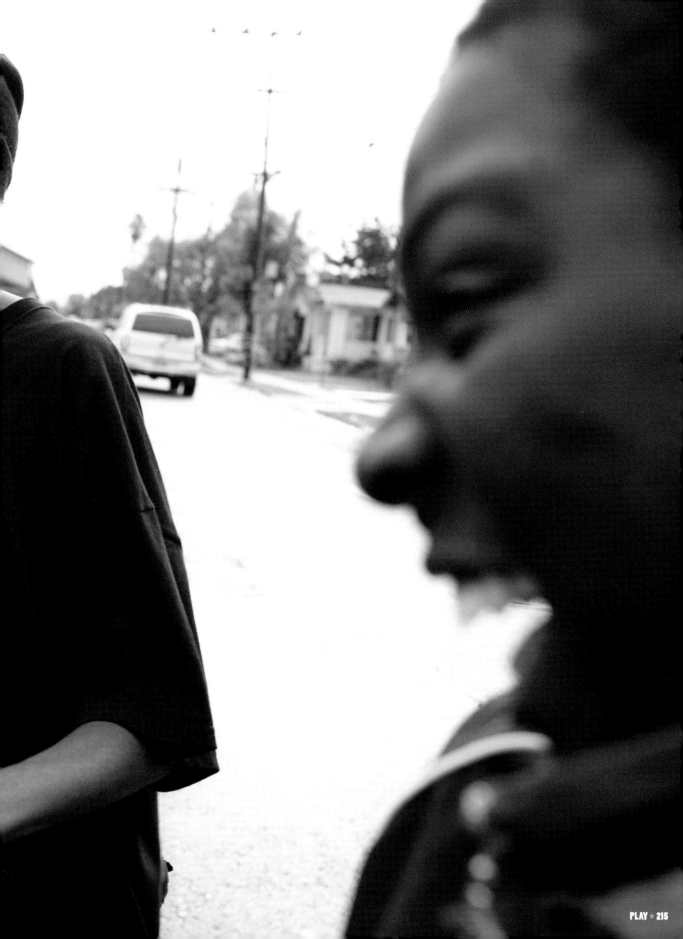

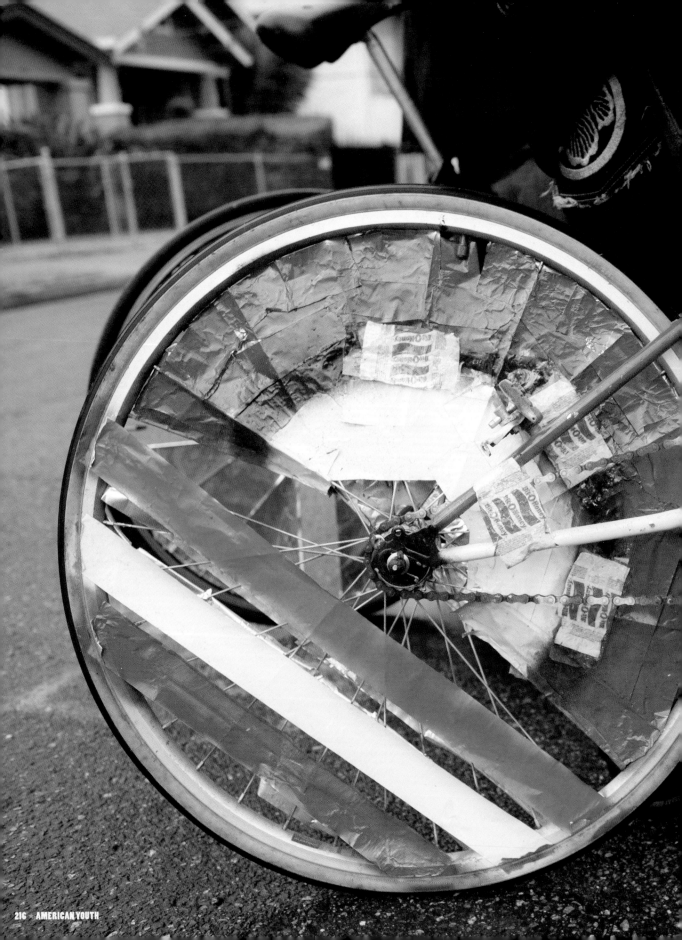

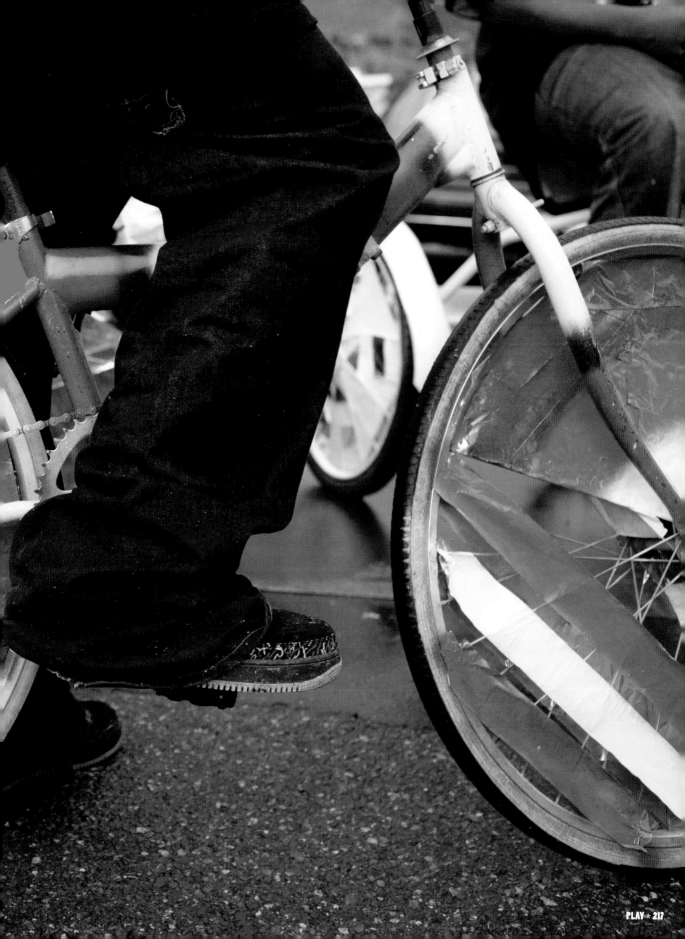

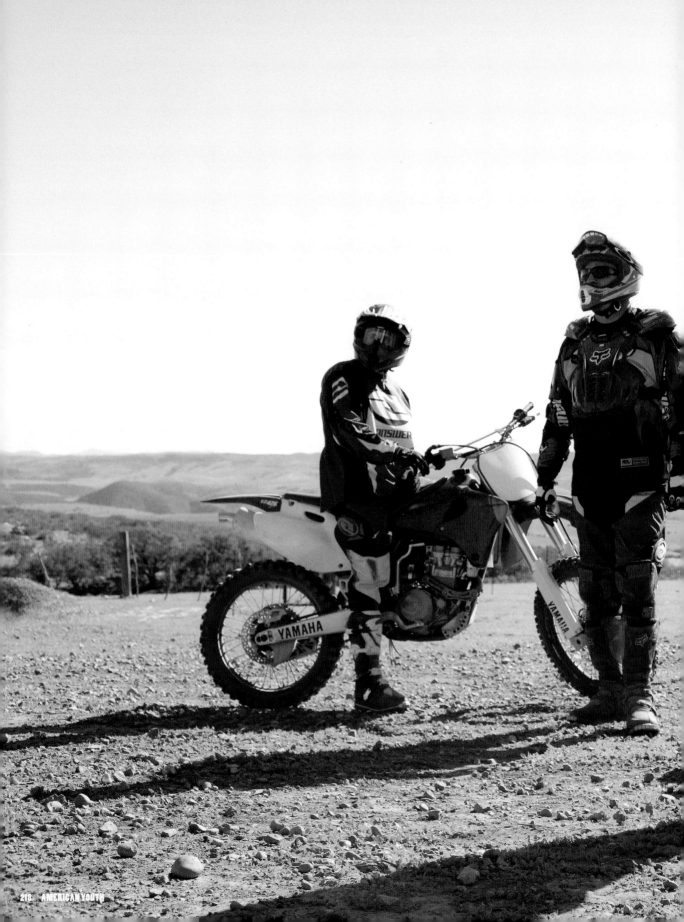

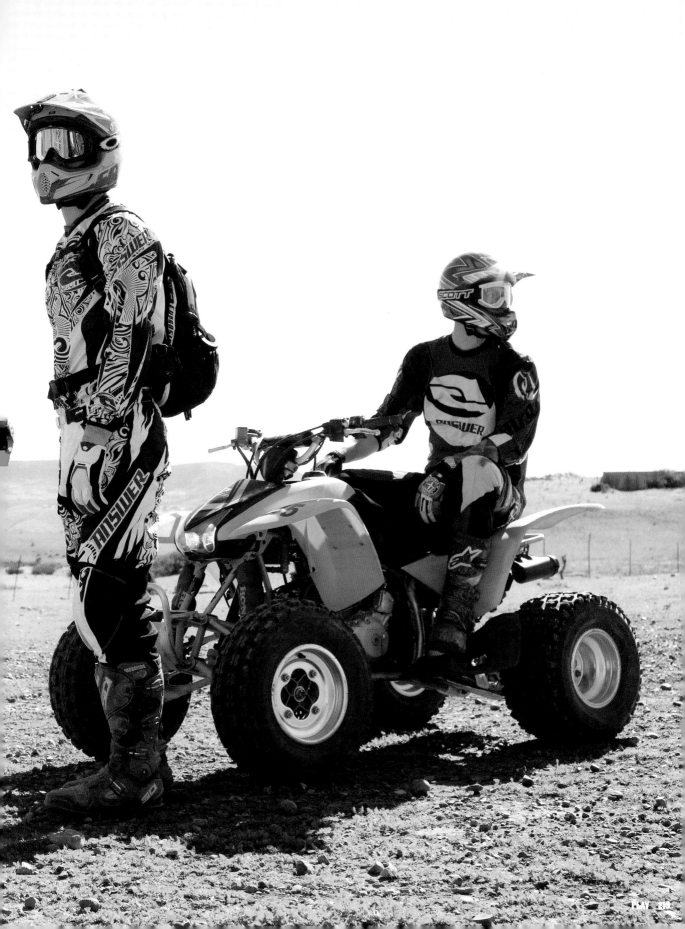

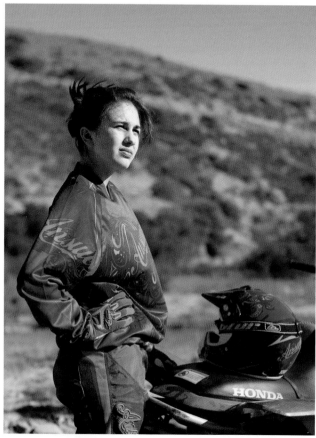

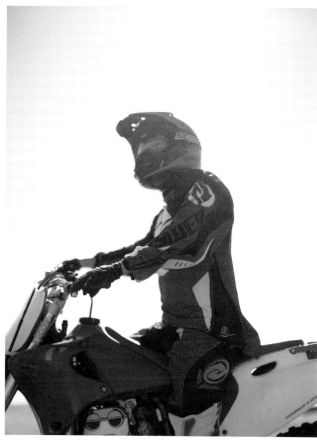
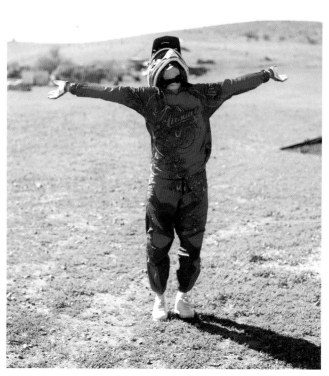

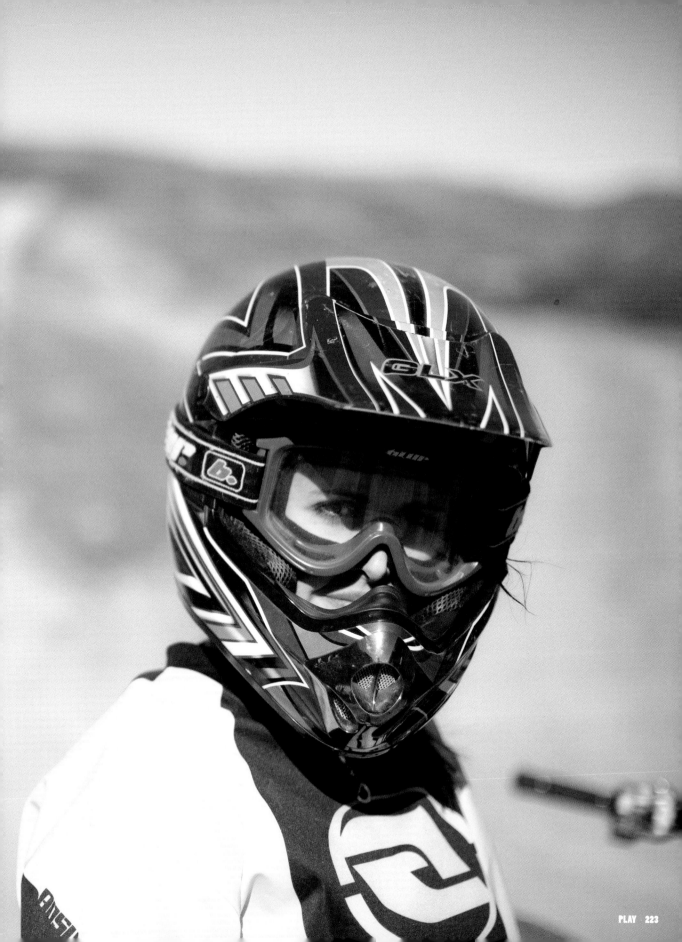

**1–3**: Jason Rae was elected to the Democratic National Committee (DNC) in June 2004, when he was just 17. At the age of 21, Jason served as a superdelegate (the youngest ever) for the party's 2008 convention in Denver, where he endorsed Barack Obama. He is a student at Marquette University in Milwaukee, Wisconsin. Photos by Kevin J. Miyazaki.

**4–5**: Tina Macri, 18, in her bedroom at her parents' house in Mesa, Arizona. She covers her wall with pictures from magazines of fashion that she likes. One day, she would like to be a photographer or a broadcast journalist. She plays guitar, takes photos and loves Guitar Hero. Photo by Erika Larsen.

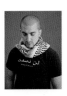

**6**: A limousine full of Xavier High School students and their dates head to the senior prom in New York City. Photo by Mark Peterson.

**11**: Rami Mikati at Case Western Reserve University in Cleveland, Ohio, where he is active in numerous Muslim and Middle Eastern student groups. Photo by Greg Ruffing.

**12**: Young debutantes at the Plaza Hotel in Manhattan. Photo by Mark Peterson.

**17**: Hanging out in Secaucus, New Jersey. Photo by Joshua Lutz.

# LiVE

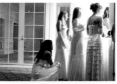

**20–25**: Young debutantes are presented at their "coming out" at Bal des Berceaux, a high-society charity event at the Plaza Hotel in Manhattan. Events at the ball—where corporate-sponsored tables cost $15,000—include a live auction of luxury items, a cocktail reception, presentation of the debutantes, dinner and dancing. The event raises money for various organizations that help the needy. Photos by Mark Peterson.

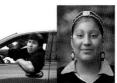

**26–29**: Portraits of the sovereign Oneida Nation, a Native Indian reservation in Northern Wisconsin. The Oneida are 1 of 11 tribes in the state of Wisconsin, and have a population of about 20,000. Their reservation is largely urban and suburban, located west of Green Bay. Photos by Kevin J. Miyazaki.

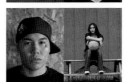

**30–35**: Pepper, 20, has lived on the streets for the past five years. Her mother, a "speed freak," kicked her out when she was 15. Pepper says she is just an alcoholic who was born on St. Patrick's Day. "For my seventh birthday, my dad gave me a Mickey [malt liquor] hand grenade," her first memory of drinking. Her father dropped her off at her custodial mom's house and told her he would be back in two days. She never saw him again. Pepper remembers things she used to do with her dad. "He taught me how to squeegee, panhandle and hitchhike. We would collect fruit, almonds, apples and apricots and sell them. I didn't know what was going on. I was a kid." Pepper recently broke up with a boyfriend who would beat her. Corduroy, her dog, has been with her for the last three years. Photos by Darcy Padilla.

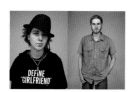

**36–39:** Seattle's U District street youth. Photos by John Keatley.

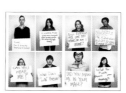

**50–53:** Young New Yorkers ask God one question. Photos by Nathaniel Welch.

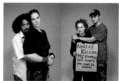

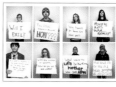

**40–43:** In his North Avenue gym in West Baltimore, Marvin McDowell, the leader of UMAR Boxing, has one room equipped with heavy bags and a boxing ring. McDowell is taking a lead in helping fight street crime and gang violence by asking that citizens support a special event by "putting the guns down and putting the gloves up, take the fight out of the street and meet us in the gym, where we all can win!" The name "Umar" is a variant of an Arabic word, *ummah,* which can be translated roughly as "community." But in the Islamic tradition, *ummah* refers to something more particular: It means "the community of believers." It's a concept roughly like the English "Christendom," but with connotations that go beyond shared faith, to embrace mutual support and obligation. Members of the ummah take care of one another. McDowell has a taste for names, slogans and mnemonics. Boxing, in his formulation, is B-O-X-I-N-G: Building On Excellence In Neighborhood Growth. Photos by Marc Asnin.

**54–59:** Members of the Cobra gang in the Window Rock jail. Cobra is the largest and most violent gang on the Navajo Reservation, home to the country's largest American Indian tribe. The gang is running amok on the Navajo Nation because of a crisis in law enforcement. A court mandate has closed many jails due to poor conditions. Gang members loiter in abandoned buildings and low-income housing developments, marking their territory with graffiti. To elude the police, some members of the gang once dug themselves underground meeting places, in the open fields where their ancestors hunted. Photos by Darcy Padilla.

**44–45:** The Future Soldiers Program at Pendleton Juvenile Correctional Facility gives selected juvenile offenders the chance for an early release, pending the completion of a boot camp-like military training. Officials in charge of the program at Pendleton hope to coordinate with area military recruiters to send graduates into active service upon their release. Photos by Andy Kropa.

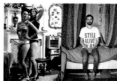

**60–65:** Gay, lesbian and transgender youth in San Francisco, California. Photos by Erin Siegal.

**46–49:** The BattleCry event at San Francisco's AT&T Park is a two-day religious gathering produced by Teen Mania, a conservative Christian youth organization. Teens worship and gather around illuminated crosses, demonstrating their Christian faith and devotion to God. Photos by Darcy Padilla.

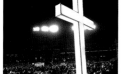

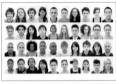

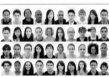

**66–69**: Photographer Ben Baker uses current demographic data to show the racial face of American youth in 2009. In the second grid, predictions of demographic trends are shown. This is the face of American youth in 2050, where the minority is now the majority.

**70–71**: Muslims in Ohio. Photos by Greg Ruffing, clockwise from top left:

Mariam Khalil (center, in pink) hanging out with friends to celebrate her 19th birthday. Khalil feels the pull of both her Middle Eastern and Western influences. Her family moved to the U.S. from Egypt, and Khalil says her parents have talked about wanting to eventually move back. Khalil is torn between staying in the U.S. and establishing a career, or moving to Egypt and being surrounded by her large, extended family.

Ahmed Aldoori, 20, playing the guitar on the back patio of his parents' home in suburban Strongsville, Ohio. He is self-taught on the guitar, where he oscillates regularly between American popular music (Metallica and Tool are among his favorites), and more traditional Middle Eastern songs, revealing the contrast of influences apparent in his creative pursuits.

Rami Mikati, 21, performs the evening prayer in his dorm at Case Western Reserve University in Cleveland, Ohio, where he is an economics major. The flag of Lebanon adorns his wall to commemorate his heritage. He was born and raised in Ohio; his parents were born in Lebanon but fled to the U.S. in the mid-1980s during its civil war.

Iman Aziz, 20, relaxing at a park in Parma, Ohio, down the street from the Islamic Center of Cleveland mosque. Born and raised in Cleveland, her family is third generation Palestinian-American. She is currently taking classes at a local community college, but ultimately wants to pursue her dreams in high fashion.

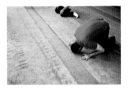

**72–73**: Muslim students at Case Western Reserve University in Cleveland pray the *Maghrib* (sunset) prayer together during Ramadan in a dormitory on campus. Photo by Greg Ruffing.

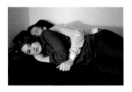

LOVE

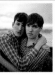

**76–77**: Sam, 20, and Erin, 19, lying in bed. They have been dating for two years. Photo by Erika Larsen.

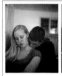
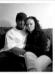

**78–79**: Rob, 19, and Angie, 18, have been married for two months, but together for three years. Rob will spend the first year of their marriage in Iraq. / Simon, 22, and Simeon, 23, have been dating for five months. Photos by Erika Larsen.

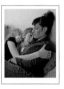

**80–81**: John, 21, and Marin, 20, have been together for four years. / Reggie, 21, and Christie, 24, have been dating for four years. Photos by Erika Larsen.

**82**: IO, 23, and Kate, 24, have been a couple for nine months. Photo by Erika Larsen.

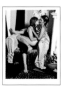

**83**: Philipe and Maren, San Francisco, Spring 2008. Photo by Erin Siegal.

**84–85**: Joseph and Stephanie Devan, both 19, attend the Rose River Farm Project Healing Waters Fly Fishing event. Joseph was wounded in central Baghdad while with the 101st Airborne. Photo by Nina Berman.

**86–93**: The American Widow Project is a support organization for the new generation of war widows who lost their husbands in Iraq and Afghanistan. Photos by Gina LeVay:

The entrance of Taryn Davis' house, the 24-year-old founder of The American Widow Project. Photographed at her home in San Marcos, where her late husband's Iraq war boots sit permanently in the entrance.

Nicole Hart, a 23-year-old widow and member of The American Widow Project, has her late husband's dog tags tattooed on her foot. Here, Nicole wears her late husband's shirt for the first time since his death.

Taryn shows off a large back tattoo she got after her husband was killed. It's from a Ralph Waldo Emerson poem titled "Threnody" and reads: *The eager fate which carried thee / Took the largest part of me: For this losing is true dying.*

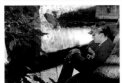

Portraits of Tara Fuerst, a 24-year-old widow who is part of The American Widow Project. Part of the military herself, she was stationed in Afghanistan with her husband when he was killed. She filed his report. Tara is seen here with his necklace and hat. The sweatshirt is hers. She left Afghanistan wearing it and didn't take it off for three months.

**94–97**: Laestadian Lutherans in Longview, Washington. Laestadians live in a few communities throughout the U.S.—Longview, Washington, Minnesota, Michigan, Phoenix and Prescott, Arizona—where most of them are based. For the most part, Laestadians fly under the radar. They are hard-working, church-going folks. They attend public school, work in the trades and in offices, and go to church several times a week. They don't drink, dance, wear makeup or listen to music—essentially, anything they believe will interfere in their relationship with God is off limits. Photos by Michael Rubenstein:

Lissa Kangas, with her son, Clay, in front of their apartment.

Vanessa Byman and her daughter, Violet.

Crista, Phil and Easton Kangas in their kitchen.

Kayla Byman in front of her family's house.

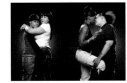

**98–99**: A weekly females-only hip hop party at underground club The Lab in Brooklyn, New York. The party drew a crowd of "AGs" (aggressive young lesbians) who are heavily influenced by the macho culture of gangsta rap and their "femme" girlfriends and admirers. The portraits are a study in the relationships and role play between the girls. Photos by David Yellen.

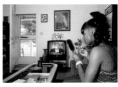

**100–107**: Javanda Williams, 18, is a senior at Norview High School in Virginia where she is very involved in the JROTC program. She is getting ready for her senior prom, which she will attend with her boyfriend. Her dad reacts with amazement at her pedicure. Photos by Mark Peterson.

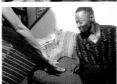

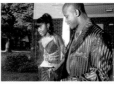

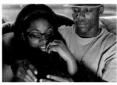

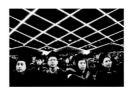

**110–111**: Baruch College students celebrate commencement at Madison Square Garden in New York on May 28, 2008. Photo by Q. Sakamaki.

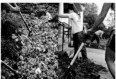

**112–117**: Ecologically-related catastrophes in recent years have begun to inspire a fresh generation of environmentally-minded youth. With discussions about global warming, climate change, food production and its effect on human and environmental health—and the rapid depletion of fossil fuels—environmental issues have come to the forefront of public discourse. In one example, more young people are getting involved with organic farming and localized agriculture, to gain more control of their food sources. In another example, eco-minded students at Oberlin College in Ohio started a group experiment in eco-friendly living when they created the SEED (Student Experiment in Ecological Design) House in Fall 2007. One of the founders, senior Lucas Brown, says it is the first eco-house in the U.S. with real-time monitoring of its full carbon footprint based on use of water, natural gas and electricity. Their concerns about climate change and global warming—and how it shapes their daily decision-making—are reflective of a larger societal trend towards environmental sustainability. Photos by Greg Ruffing.

**118–119**: Ruby, 23, is a recent graduate of University of California at Santa Cruz, with a degree in politics and history. During the day, Ruby works at a law firm, and in the evening she volunteered at the Obama campaign headquarters in San Francisco, where she helped organize events. Obama is the first candidate she had ever volunteered for and this was the first presidential election she voted in. Photo by Darcy Padilla.

**120–121**: An inspired, politically liberal Alaskan minority gathers for a pro-Obama rally near downtown Anchorage, Alaska. Photo by Eros Hoagland.

**122–125**: High school senior Javanda Williams standing in the hall outside the Junior ROTC room, waiting for the students under her command to enter the room. She also leads drills in the school and enforces rules—and pushups—on other JROTC cadets. Photos by Mark Peterson.

**126–131**: Soldiers fighting in the war in Iraq. Photos by Eros Hoagland.

**132–135**: Jerome Morgan, Jr., 24, passed the firefighter exam and began his career preventing fires while still in college. He is now a professional firefighter in Newark, New Jersey working on Truck 10. It's a poor and rough part of New Jersey, and Jerome is now one of its bravest. Photos by Marc Asnin.

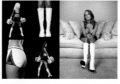

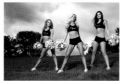

**136–139**: Professional cheerleaders for NFL team the Seattle Seahawks. Photos by John Keatley.

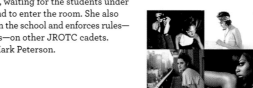

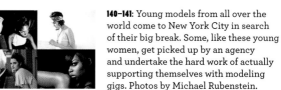

**140–141**: Young models from all over the world come to New York City in search of their big break. Some, like these young women, get picked up by an agency and undertake the hard work of actually supporting themselves with modeling gigs. Photos by Michael Rubenstein.

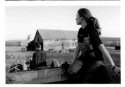

**142–147:** These photographs represent a survey of young farmers in the Champlain Valley and Adirondack region of New York. With the population of new farmers in decline, these young people represent a reverse trend. Their entry points into farming come from disparate angles, but they share an ethic and farming ideology that is both lifestyle choice and profession. In recent years, consumers have become more interested in the provenance of their food for political, economic, health and environmental reasons. Locally grown and raised food products are finding a larger market and have made small farms a viable business and integral part of the food supply. Attracted to agriculture by a new consciousness in food production, the young people in this series are in the infancy of what they hope will be long careers in agriculture. Photos by Ben Stechschulte.

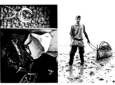

**148–151:** Lobstermen in Maine. Garrett lives with his family on Deer Isle, Maine. He pulls a canoe along the mud bank at low tide, and pulls the clams out with his hands (in long gloves), piling them into the boat. Here, a neighbor's dog follows along. A recent high school grad, Garrett was raised on the island. He was clamming along the cove behind his family's house, and said later that week he'd be launching an old lobster boat that he'd bought and fixed up. Photos by Peter Frank Edwards.

**152–155:** Working 9 to 5 doesn't seem so bad when you're doing it Southern California-style. Anthony not only runs a fixed-gear bike shop, but also has a photo blog, and designs T-shirts. Hugh is a surf instructor, surfer, and also a published surf photographer. Tyler is a singer/songwriter, but also an avid surfer. Photos by Brad Swonetz.

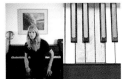

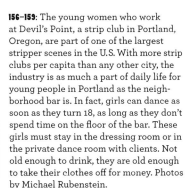

**156–159:** The young women who work at Devil's Point, a strip club in Portland, Oregon, are part of one of the largest stripper scenes in the U.S. With more strip clubs per capita than any other city, the industry is as much a part of daily life for young people in Portland as the neighborhood bar is. In fact, girls can dance as soon as they turn 18, as long as they don't spend time on the floor of the bar. These girls must stay in the dressing room or in the private dance room with clients. Not old enough to drink, they are old enough to take their clothes off for money. Photos by Michael Rubenstein.

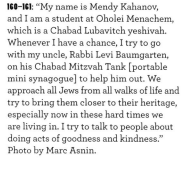

**160–161:** "My name is Mendy Kahanov, and I am a student at Oholei Menachem, which is a Chabad Lubavitch yeshivah. Whenever I have a chance, I try to go with my uncle, Rabbi Levi Baumgarten, on his Chabad Mitzvah Tank [portable mini synagogue] to help him out. We approach all Jews from all walks of life and try to bring them closer to their heritage, especially now in these hard times we are living in. I try to talk to people about doing acts of goodness and kindness." Photo by Marc Asnin.

**162–163:** "Growing up in close proximity to the world-famous Lubavitcher Rebbe (Rabbi Menachem M. Schneerson, of righteous memory), I was lucky to learn and appreciate that all of the treasures G-d grants us are meant for the human being—myself—to channel and utilize for greater good. Technology was something my family embraced, and I love applying the latest to my studies, to my work at Chabad.org, and toward helping others. We are blessed with extraordinary gifts in this world. I pray that we each utilize them for a higher purpose and make this world a kinder, gentler, better, G-dlier place." —Yisroel Piekarski Photos by Marc Asnin.

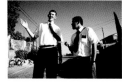
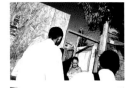

**164–169:** The Mormon missionaries spend two years living in a foreign country, where their job is to convert people to the Mormon faith. Not an easy task in Catholic Mexico. The missionaries pictured here were sent to live in a neighborhood in southeastern Tijuana called "El Florido," one of the worst gang areas in the city, and presently a major battleground for narco-traffiking wars. They said one of their members had been assaulted, but mostly people leave them alone. They have made a few converts, but also get doors literally shut in their faces, and yelled at by irate Catholics who suspect them of being in some kind of cult. Photos by Eros Hoagland.

# PLAY

172–175: Scenes of college-town drinking on a cold winter's night. Downtown Iowa City, Iowa has one of the highest concentrations of bars in the country and is home to the University of Iowa. Known throughout the country as a party school, university officials have done much to curb binge drinking, to no avail. Photos by Danny Wilcox Frazier.

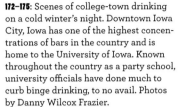

176–181: Young women text, drink, smoke and do drugs in a Portland, Oregon bar. Photos by Michael Rubenstein.

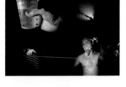

182–187: Young men and women hang out, some naked, at Jumping Rock. Jumping Rock is a notorious party spot along the Iowa River, near North Liberty, Iowa. In a state where job opportunities have long dried up, reckless abandon has overtaken many young people. Drugs and alcohol have become a permanent fixture across the rural landscape here. Iowa ranks second nationally for states losing young, well-educated adults, creating a climate of financial despair. Nearly half of the state's 99 counties lost population during the 1990s. Those left in the wake of Iowa's out-migration have little hope for the future, and a once prosperous rural economy seems lost forever. Photos by Danny Wilcox Frazier.

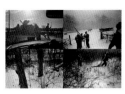

188–189: Allen Miller, his family and friends are out hunting on opening day of deer season in Iowa. Allen has eight siblings, and like other large families living in rural Iowa, the Miller family uses deer meat to offset food costs. Allen drags a young doe from the woods. Allen's brother, Freeman, takes a shot at a buck running through the timber. Photos by Danny Wilcox Frazier.

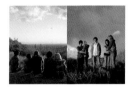

190–191: Mesa, Arizona. Kids watch the sunset in the desert. They usually hang out, play music and talk. Photos by Erika Larsen.

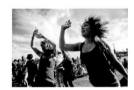

192–193: Young women dance to the sounds of the band Animal Collective at the three-day All Points West concert held in Liberty State Park, New Jersey. Photo by Q. Sakamaki.

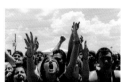

194–195: Summer concertgoers at The Vans Warped Tour. Photo by Preston Mack.

196–199: Louisiana State University fans get ready to take on rival Ole Miss in Baton Rouge, Louisiana. Tailgating is as much a part of game day as the game itself, and people gorge on food and booze for hours before kickoff. Photos by Mark Peterson.

200–201: Two autumn weekends of University of Southern California tailgating. Photos by Angie Smith.

202–203: On November 2, 2008, a littered apartment complex after an all-night Halloween party on Del Playa Drive in Isla Vista, California. University of California at Santa Barbara is infamous for the wild parties that occur over Halloween weekend. Every year, Del Playa Drive is flooded with thousands of students from Santa Barbara, visiting students, and local young people here to celebrate in costume. Photo by Angie Smith.

**204–205**: Sometimes all you want to do is just stay home and play video games. Photo by Erika Larsen.

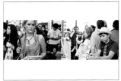

**206–209**: Contestants waiting to try out for *American Idol*. The line of contestants snakes around, hundreds of people long. Photos by Gina LeVay.

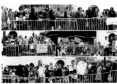

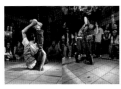

**210–211**: The hip hop art of B-boying, or breakdancing, rose out of New York City in the late 1970s and quickly spread to Los Angeles and other urban areas. It has evolved from an underground dance form into a potent means of expression, and in some ways helped to catapult hip hop into the mainstream. But as one Los Angeles B-boy, Longka Michael Lor (aka M-PACT), is quick to point out, "B-boying started in the streets…it'll always belong to the streets." B-boys speak of it as a lifestyle that incorporates all aspects of hip hop culture: the dance, the music and the fashion. "B-boying is an art," says Lor. "Every time I get down…I'm painting my art onto the floor with my moves." Shot in Los Angeles, May 2008. Photo by Greg Ruffing.

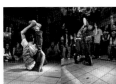

**212–213**: A clubgoer breakdances at Remix. Beneath the heart of Wall Street, urban youth let loose in a basement club directly below the crumbling remains of the U.S. financial market. On the first Thursday of every month, Remix hosts a house dance competition where B-boys, B-girls, and the younger generation of New Yorkers come to spin, break, and wack to hip hop and house beats. Photos by Erin Siegal.

**214–217**: Kids riding their "scraper" bikes, a new trend in the San Francisco Bay Area. The term was coined by the rap group Trunk Boiz of Oakland, California, who shot a video that went viral on YouTube. They are now recording an album. Photos by David Butow.

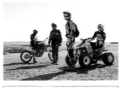

**218–223**: Tim Thomas, Andrew Kinghorn, Michel Madueno, Ashton Quillin, Blake Ribbe-Tanner and Dustin Madruga ride dirt bikes in Baja, just south of the California-Mexico Border. Photos by Brad Swonetz.

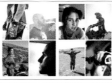

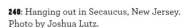

**240**: Hanging out in Secaucus, New Jersey. Photo by Joshua Lutz.

**STEVE APPLEFORD**'s writing has appeared in the *Los Angeles Times, Rolling Stone, GQ* and *Spin*. He is based in Los Angeles.

**MARC ASNIN** is an award-winning documentary photographer. His photographs have been published in numerous publications, including *Life, People, The New Yorker, The New York Times Magazine, Reader's Digest* and *Stern*. His documentary photography has received many awards, most notably the W. Eugene Smith Grant in Humanistic Photography, the Mother Jones Fund for Documentary Photography Grant, the National Endowment for the Arts Fellowship and the Alicia Patterson Fellowship.

Portrait photographer **BEN BAKER**, whose work has been collected by the National Portrait Gallery and twice recognized by the American Photography collection, is renowned for his diverse portfolio of the power elites who define our world today. Transcending national borders and spheres of influence, Ben's work includes presidents and heads of state (Presidents Mahmoud Ahmadinejad and Barack Obama) as well as pioneers of business like Warren Buffett, and screen icons like Scarlett Johansson.

**NINA BERMAN** is a documentary photographer, widely published and exhibited, with a primary interest in the American political and social landscape. She is internationally known for her images of wounded American military personnel, which received World Press Photo awards and several American foundation grants. She is the author of *Purple Hearts: Back from Iraq* and *Homeland,* both published by Trolley Books.

**DAVID BUTOW** is a California-based photojournalist who has covered a variety of news and feature assignments from Baghdad to Shanghai. His clients include international newspapers, business and travel magazines, Apple Computers and National Geographic Books. He has won awards from World Press Photo, Pictures of the Year, American Photography and other contests.

A former fishmonger and sous chef, **PETER FRANK EDWARDS**'s photography is primarily of travel, people and food. When not shooting on location, Frank splits time between his Charleston, South Carolina home and a cottage in Maine near Stonington, a coastal village he visits frequently (and where he found the subjects for the images he contributed to this book).

**DANNY WILCOX FRAZIER** is a documentary photographer who focuses on issues facing rural and other marginalized communities both in and outside of the U.S. A five-year long project documenting the challenges small towns and rural people face in his home state of Iowa, was awarded the Center for Documentary Studies/Honickman First Book Prize. Frazier's book, *Driftless*, was published by Duke University Press and CDS in 2007. His work has often appeared in *TIME* and he is a contributing photographer to *Mother Jones*.

**EROS HOAGLAND** began working as a photojournalist in 1993, covering the aftermath of El Salvador's civil war. He has continued to work in countries stained with violence and unrest across the globe, including Iraq, Haiti, Mexico and Colombia. Eros' clients include *TIME, The New York Times, Newsweek, Stern* and *FADER* among others. Corporate clients include Visa, IBM and Wells Fargo.

In addition to shooting for clients such as *Wired, TIME* and the Discovery Channel, **JOHN KEATLEY** was recently hired to photograph celebrity photographer Annie Leibovitz, something few photographers have done. Other people John has enjoyed working with include Anthony Hopkins, Tim Gunn, Andy Samberg and Sally Field. John and his wife, Nichelle, live in Seattle, and take advantage of the outdoors as much as possible, rain or shine.

**ANDY KROPA** is a New York City-based freelance photographer who studied documentary photography at the famed Institute of Design in Chicago. He has worked extensively for *The Village Voice* newspaper and has been published in major publications throughout the U.S. and abroad. Kropa frequently exhibits his work and is passionate about pursuing the art of photography.

**ERIKA LARSEN**'s work appears in magazines in the U.S. and internationally, covering a range of topics including family life, religion, and spirituality in rural America. Her most notable work to date is her immersion into the world of hunting, which began in 2003 and led to her becoming a contributing photographer to *Field & Stream Magazine*. Her work has been recognized by World Press Photo, American Society of Magazine Editors, American Photography, Society of Photographers, New Jersey State Council of the Arts and others. She is currently working on a project in the Scandinavian Arctic. Erika is based in New York City.

**GINA LeVAY** was born in Chicago and holds a master's in photography and related Media from the School of Visual Arts. Inspired by the diversity and energy of people, LeVay works both in the U.S. and abroad for editorial, advertising and music clients while pursuing independent projects. Her award-winning work, *The Sandhog Project,* was exhibited as a large-scale photo and video installation at New York's Grand Central Terminal in 2006.

**JOSHUA LUTZ** is widely exhibited and collected, and has received many awards and fellowships, including *Photo District News*'s 30 Emerging Photographers, Communication Arts Editorial Highlights, and The Tierney Fellowship. His first monograph, *Meadowlands*, released in the Spring of 2008, has been named a favorite in Photography Books of 2008 by *Photo District News* and *American Photo*. His work has been featured in numerous publications, including *Artforum, The New York Times Magazine, Harper's, The New Yorker, Newsweek* and *TIME*. In May of 2009, his most recent work, *Amsterdam*, will be exhibited in conjunction with Foam Museum at the Stadsarchief Amsterdam.

**PRESTON MACK** is a Florida-based photographer. He shoots for magazines such as *ESPN the Magazine* and *BusinessWeek,* and for companies such as Walt Disney World and Marriott.

**KEVIN J. MIYAZAKI** is an editorial and fine art photographer who lives in Milwaukee, Wisconsin. His travel and portrait work has appeared in *GQ, Entertainment Weekly, TIME* and *Travel & Leisure.* His personal project work focuses on issues of memory and architecture.

**DARCY PADILLA** is a photojournalist and documentary photographer based in San Francisco. She has received awards from the John Simon Guggenheim Foundation and the Open Society Institute.

**MARK PETERSON** is the author of *Acts of Charity,* published by powerHouse Books in 2004. He has won numerous awards and honors, including the W. Eugene Smith Grant and 1st place Feature Picture Story in the Pictures of the Year International Competition, and has been included in the World Press annual book and traveling exhibition. He is an editorial photographer based in New York who works on assignment for *The New York Times Magazine, New York Magazine, GEO* and many other publications.

**MICHAEL RUBENSTEIN** is a documentary photographer relocated from lovely Portland, Oregon to Mumbai, India. He enjoys long walks on the beach, quiet evenings with friends and horribly trite '80s movies. He enjoys working with a wide variety of clients, including *The New York Times, Monocle, Gourmet, BusinessWeek, Forbes, Art + Auction, Mix* and Weiden and Kennedy.

**GREG RUFFING** is a portrait and documentary photographer working in the Midwestern U.S. and beyond. His photographs have appeared in a wide range of publications, including *TIME, Newsweek, U.S. News & World Report, Mother Jones, Stern, Der Spiegel, Spin, Rolling Stone, Reader's Digest* and *Forbes.* His work has been recognized by the PDN Photo Annual and the Eddie Adams Workshop.

**Q. SAKAMAKI** has covered both U.S. and international issues, with special attention to violent conflicts. His photographs have appeared in books and magazines worldwide and have been exhibited in solo shows in New York and Tokyo. He has received the Olivier Rebbot Award from the Overseas Press Club and a World Press Photo Award. He holds a master's in international affairs from Columbia University. His latest book, *Tompkins Square Park,* has been published by powerHouse Books.

**ERIN SIEGAL** is a New York City-based freelance photographer, and a 2009 Fellow at the Toni Stabile Center for Investigative Journalism at Columbia University. She has shown her photo work at the Jen Bekman Gallery in New York City, and her clients include the United Nations, *The New York Times,* Human Rights Campaign and more. She is currently writing her first book, and daydreams about moving to Latin America with her pug.

**ANGIE SMITH** is a freelance photographer based in Los Angeles. Angie currently exhibits her work in galleries in New York and Los Angeles. She shoots for *The New York Times Magazine, New York Magazine, Forbes, Budget Travel* and Nike.

**BEN STECHSCHULTE**'s interest in young farmers stems from broader interests in the food industry, agrarian landscapes, and the integrity of those who work the land. Ben is a frequent contributor to *The New York Times Magazine*. Based in New Haven, Connecticut with his family, Ben travels widely for projects and assignments.

Born and raised in Encinitas, California, **BRAD SWONETZ** attended the University of California at Santa Barbara where he pursued two of his great passions—surfing and sculpture. After finishing in Santa Barbara, he moved to Los Angeles to start assisting photographers and learn the trade. Now, Brad lives with his wife/assistant/CFO/producer in a beach town in Southern California. He loves to surf, play ping-pong, and pool and the occasional round of Wii.

**NATHANIEL WELCH** is a New York City-based photographer specializing in portraits for magazines, advertising and record covers in the U.S. and abroad. His favorite movie is *Star Wars*; his favorite food is the famed "Runza" from Nebraska.

**DAVID YELLEN** was born and raised in Flushing, Queens. After brief stints as a musician, fashion designer and fishing boat mate, he discovered his true passion for photography. So far, his assignments have covered five continents, and subjects have varied from Richard Branson and Jay-Z to Terrell Owens and a Guns N' Roses cover band in Ohio. David has published two books: *Too Fast for Love* (2004) and *Hair Wars* (2007). His client list includes *Fortune, TIME, People, BusinessWeek,* ESPN, *Best Life, O Magazine,* The History Channel, Sci-Fi Network, Under Armour and A&E.

## ACKNOWLEDGMENTS

Thank you to photographers Marc Asnin, Ben Baker, Nina Berman, David Butow, Peter Frank Edwards, Danny Wilcox Frazier, Eros Hoagland, John Keatley, Andy Kropa, Erika Larsen, Gina LeVay, Joshua Lutz, Preston Mack, Kevin J. Miyazaki, Darcy Padilla, Mark Peterson, Michael Rubenstein, Greg Ruffing, Q. Sakamaki, Erin Siegal, Angie Smith, Ben Stechschulte, Brad Swonetz, Nathaniel Welch and David Yellen. We appreciate you contributing work and setting aside time to shoot new stories for this book. Thanks also to Jesi Bevis for helping produce the Ben Baker shoots.

This book would not have been possible had Roberto Koch at Contrasto not seen the potential in the idea and agreed to publish it. His encouragement and feedback along the way were also invaluable.

We were fortunate to collaborate with an amazing roster of photo editors, who took time out of their busy schedules to lend their eye to our project. Thank you Bill Black (*Reader's Digest*), Karen Frank (*Condé Nast Portfolio*), Jeanne Graves (*BestLife*), Armin Harris (*Fortune*), Katherine Harris (The Daily Beast), Jane Hwang (ABCNews.com), Michelle Jackson (freelance art buyer, owner of Snap Indigo), Nadja Masri (*GEO*), Brenda Milis (*Men's Health*), Bruce Perez (*Redbook*) and Dora Somosi (*GQ*). Special thanks to Allyson Torrisi (*Popular Mechanics*) who helped edit and produce some of the shoots in this book. Thank you also to Maria Avitabile, Jesi Bevis, Michael Massmann, Lori Reese, Laura Reid, Linda Romero and Perrie Wardell of Redux for gathering this group of editors together in one place.

Most importantly, thank you to the young subjects of the book, who let us into their worlds and taught us something about their generation. It is inspiring to hear your stories.

Marcel Saba and Jasmine DeFoore
New York, January 2009

This book was designed by
The Office of Gilbert Li

Produced by
Jasmine DeFoore

Co-Produced by
Myles Ashby

Text edited by
Michael Massmann and Joey Meyer

Exhibition prints generously donated by
White House Custom Colour
whcc.com

For exhibition dates and venues, visit
www.americanyouthbook.com

All photos are copyrighted by the individual
photographer. Images are available for
licensing at www.reduxpictures.com

Cover photos © Erika Larsen/Redux
Introduction © 2009 Steve Appleford

© 2009 Contrasto due srl
Via degli Scialoia, 3
00196 Rome, Italy
ph (39) 06 32 82 81
fax (39) 06 32 82 82 40

www.contrastobooks.com

Printed and bound in Italy

ISBN 978-88-6965-157-1

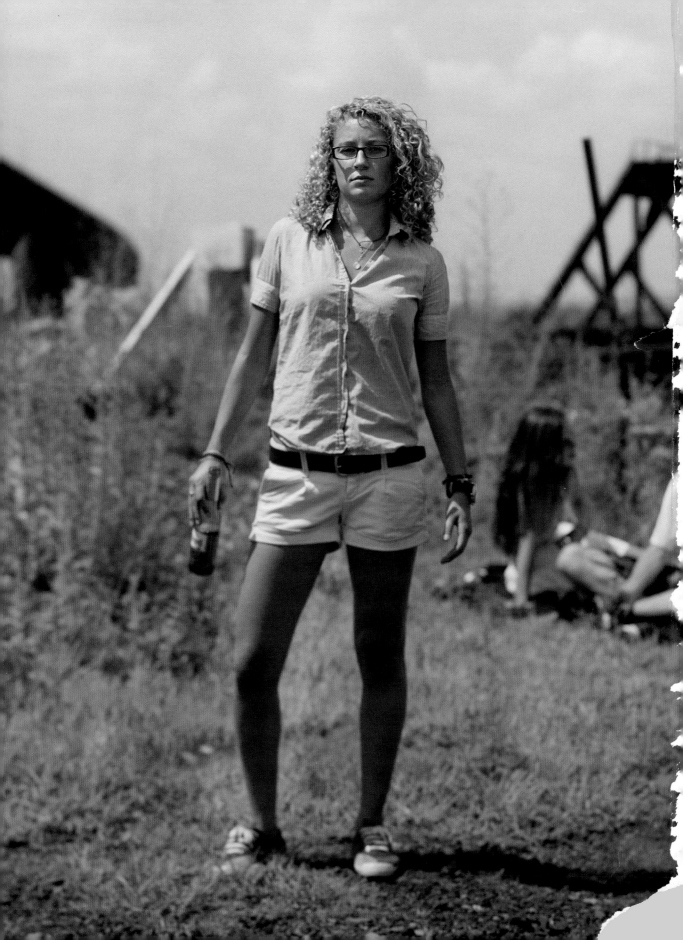